The Lower Chattahoochee Valley in Alabama and Georgia 1860

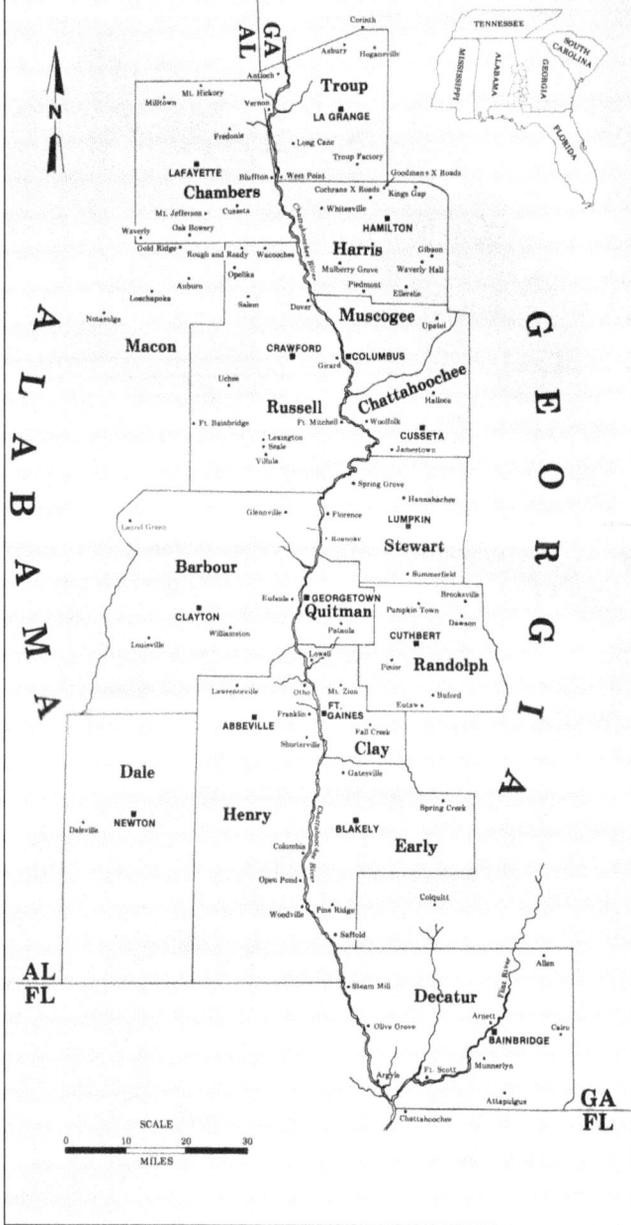

N

TENNESSEE

MISSISSIPPI · ALABAMA · GEORGIA · SOUTH CAROLINA · FLORIDA

Corinth

Asbury · Hogansville

Antioch

Mt. Hickory
Milltown · Vernon

Troup

LA GRANGE

Fredonia

Long Cane

Troup Factory

LAFAYETTE · Bluffton · West Point · Goodman · X Roads

Chambers

Cochrans X Roads · Kings Gap

Mt. Jefferson · Cusseta · Whitesville

Waverly · Oak Bowery

HAMILTON

Gold Ridge · Rough and Ready · Wacoochee

Harris · Gibson

Opelika · Mulberry Grove · Waverly Hall

Auburn · Piedmont

Loachapoka · Salem · Ellerslie

Notasulga · Dover

Muscogee · Upatoi

Macon

CRAWFORD · **COLUMBUS**

Girard

Uchee

Russell · **Chattahoochee**

Ft. Bainbridge · Ft. Mitchell · Woolfolk · Holiwa

Lexington

Seale · **CUSSETA**

Vibula · Jamestown

Spring Grove

Hannahachee

Glennville · Florence · **LUMPKIN**

Laurel Green · Rosnoke

Stewart

Summerfield

Barbour

Eufaula · **GEORGETOWN** · Brooksville

CLAYTON · **Quitman** · Pumpkin Town

Williamston · Patsula · Dawson

Louisville · **CUTHBERT**

Lowell

Pinor · **Randolph**

Lawrenceville · Otho · Mt. Zion · Buford

Franklin · **FT. GAINES** · Eutaw

ABBEVILLE

Shorterville · Fall Creek

Clay

Gatesville

Dale

Spring Creek

Daleville · **NEWTON** · **Henry** · **BLAKELY**

Columbia · **Early**

Open Pond

Woodville · Pine Ridge · Colquitt

Saffold

AL
FL

Steam Mill · Allen

Decatur

Olive Grove · Arnett · Cairo

BAINBRIDGE

Argyle · Ft. Scott · Munnerlyn

Attapulgus

Chattahoochee

GA
FL

ALABAMA

GEORGIA

SCALE

0 10 20 30

MILES

This map depicting the portion of the lower Chattahoochee River Valley featured in this publication originally appeared in Ray Mathis and Douglas Purcell's *The Land of the Living: Wartime Letters by Confederates from the Chattahoochee Valley of Alabama and Georgia.* (Courtesy of the Historic Chattahoochee Commission.)

ON THE COVER: This image, *c.* 1910, shows the *Queen City* and other steamers moored at the busy Columbus, Georgia, port. The largest and most industrialized city along the lower Chattahoochee, Columbus owes a great deal of its economic development to the river. (Courtesy of Ed Mueller.)

IMAGES
of America

LOWER
CHATTAHOOCHEE
RIVER

The Columbus Museum and the
Historic Chattahoochee Commission

A™

ARCADIA
PUBLISHING

Published by Arcadia Publishing
Charleston SC, Chicago IL, Portsmouth NH, San Francisco CA

Library of Congress Catalog Card Number: 2006939681

For all general information contact Arcadia Publishing at:
Telephone 843-853-2070
Fax 843-853-0044
E-mail sales@arcadiapublishing.com
For customer service and orders:
Toll-Free 1-888-313-2665

Visit us on the Internet at www.arcadiapublishing.com

*This publication is dedicated to the citizens of the Chattahoochee Valley,
whose vision and industry have shaped the history and future
of this river corridor.*

CONTENTS

ACKNOWLEDGMENTS

The authors are indebted to numerous individuals for their kind assistance and advice during the compilation of this volume. F. Clason Kyle, John Lupold, Lynn Willoughby, and Ed Mueller provided invaluable assistance through their previous research and by making images of life on the Chattahoochee available. Dr. Thomas Foster helped write labels for many of the images detailing information on the Chattahoochee Valley's native groups, and James Mullins of the DeWitt Wallace Decorative Arts Museum assisted in unearthing new information on a rare Colonial-era British sword hilt featured in this publication. Dozens of people associated with institutions throughout the region helped obtain images: Miriam Syler and Wayne Clark at the Cobb Memorial Archives; Frank Hanner and Aaron Noble at the National Infantry Museum; John Lyles at the Columbus Library; Reagan Grimsley, Dalton Royer, and Giselle Remy at the Columbus State University Archives; Kathryn Braund at Auburn University; Trena Evans at Florence Marina State Park; Becky Butts at the Columbus Water Works; Bruce Smith and Matt Young at the Port Columbus National Civil War Naval Museum; Dr. Marty Olliff of Troy University, Dothan; William Holman at Dothan Landmarks Foundation; Larry Smith at the Henry County Historical Group; Brenda Broome at the Donalsonville-Seminole County Chamber of Commerce; Corey Kirkland at the Eufaula–Barbour County Chamber of Commerce; and Beth Morton, formerly of the Eufaula Heritage Association. The staffs of the Troup County Archives, the Georgia Archives, the Georgia Department of Natural Resources, the Alabama Department of Archives and History, the *Columbus Ledger-Enquirer*, the Florida State Archives, and the Hargrett Rare Book and Manuscript Library at the University of Georgia were also extremely helpful. In addition, several private individuals graciously made images from their collections available, including Jim Cannon, Dennis Jones, Karan Pittman, Susan Reames, Susan Waldrop, Neal Wickham, Rob Schaffeld, Mary Gray, Doug Purcell, Mary Thomas, Maisie Pugh, Hank Johnson, Reid Smith, Wendell Stepp, L. H. Adams, James E. Coleman, and John Hines.

The authors also wish to recognize the employees of the Columbus Museum and the Historic Chattahoochee Commission who contributed their time in assisting with some of the more technical aspects of this project. Mellda Alexander and volunteer Amanda Shaw spent an inordinate amount of time helping select and photograph artifacts from the museum's collection featured in this volume, and Jessica McCarty provided crucial assistance in scanning many images. The museum's public relations coordinator, Alicia Niles, edited the final copy. Deborah Shaw, secretary/treasurer of the commission, helped assemble and process images secured from a variety of sources in Eufaula and points south.

INTRODUCTION

More than any other single factor, the Chattahoochee River has played a major role in the heritage of the lower Chattahoochee Valley of east and southeast Alabama and west and southwest Georgia. From the stream's role as one of the South's busiest trade routes to the dynamic array of water-powered industry it made possible, the river has been at the very center of the forces that have shaped the unique character of the area. A vital part of the community's past, present, and future, the river binds the Chattahoochee Valley together as a distinctive region.

This volume begins by chronicling the path of the river, which originates in the mountains of north Georgia and empties into the Gulf of Mexico at Apalachicola, Florida, as it flows through the lower Chattahoochee Valley region. In addition to historic and modern photographs, this chapter includes images of some of the numerous types of artwork inspired by the river. As the Chattahoochee was for centuries the main transportation artery for the region, the second chapter of the book focuses on the history of navigation of the river. The steamboat era on the Chattahoochee was launched in the 1820s, and by the 1850s, the river was one of the South's busiest in terms of cotton trade. At one point, there were over 150 steamboat landings along the section of the stream covered in the book. The book's third chapter contains over two dozen images of the bridges that have facilitated travel across the river over the past century and a half.

The river's role as a recreational resource is investigated in the fourth chapter. Just as did the region's earliest inhabitants, those living along the river today enjoy a variety of types of recreational activities on the Chattahoochee. The creation of lakes along the river in the 20th century, especially nationally known fishing attractions such as Lake Eufaula/Walter F. George, West Point Lake, and Lake Seminole have only enhanced its well-established recreational opportunities. Today recreation is one of the major economic benefits the region derives from the Chattahoochee River.

The region's dominant geographic feature, the Chattahoochee has for centuries served residents of the area as an engine for commerce. The role of the river in the industrialization of the Chattahoochee River Valley, especially in the Columbus, LaGrange, and West Point, Georgia, and Lanett and Valley, Alabama, regions, is investigated in chapter five. By capitalizing on the tremendous power yielded by the river as it flowed over the fall line, this corridor became one of earliest in the Deep South to industrialize. By the time of the Civil War, the city of Columbus ranked as one of the South's leading industrial centers. Though devastated by the war, this concentration of water-powered industry only accelerated after the conflict, both in that city and other towns in the region. The river's importance as a source of hydroelectric power will also be chronicled in this chapter. First developed in the Chattahoochee Valley in the 1880s, hydroelectricity quickly became so prolific in the region that by the 1920s, the area was as recognized for its role in power generation as its other long-standing manufacturing capabilities.

A few of the significant floods and disasters that have had a profound impact on the development of the region are discussed in the sixth chapter. Chapter seven details some of the important military outposts that have been built along the stream, as well as many of the most crucial conflicts that

have taken place near the river. The final chapter features images associated with the history of human inhabitation of the lower Chattahoochee, dating from prehistoric settlements to some of the more interesting stories from the modern communities on the river's banks. In addition, images of a few of the most notable individuals to visit and write about the river are included.

Capturing the essence of what the Chattahoochee means to the region it flows through in a limited selection of images is a difficult task, and telling all of the stories associated with the river in one volume is impossible. The authors acknowledge that others could have easily chosen to tell the lower Chattahoochee's story differently. The authors hope, though, that this book will help residents of the Chattahoochee Valley see more clearly the wide variety of ways the stream has influenced its past and informs its future. Further, they hope it will serve others not familiar with the river as an introduction to the natural and cultural treasure that is the Chattahoochee River.

One

RIVER SCENES

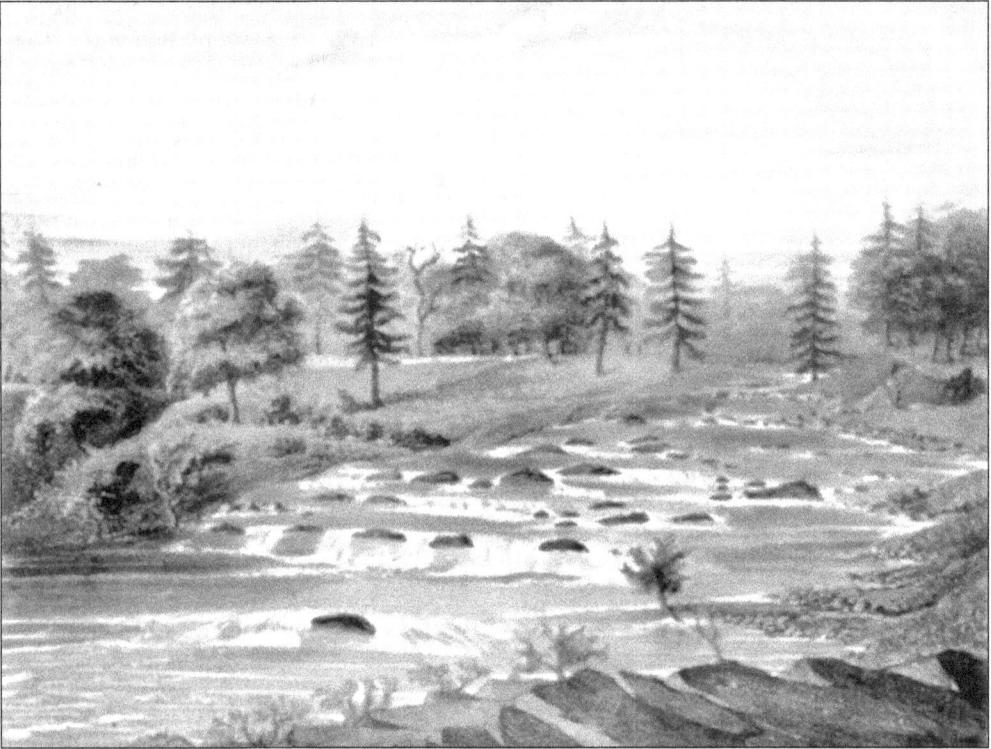

Francis de la Porte, Comte de Castelnau, made this painting, which depicts the rapids of the Chattahoochee River near Columbus, during his visit to the area in the late 1830s. Born in London, the artist led several scientific expeditions to North and South America in the 1830s and 1840s. (Courtesy of the Columbus Museum.)

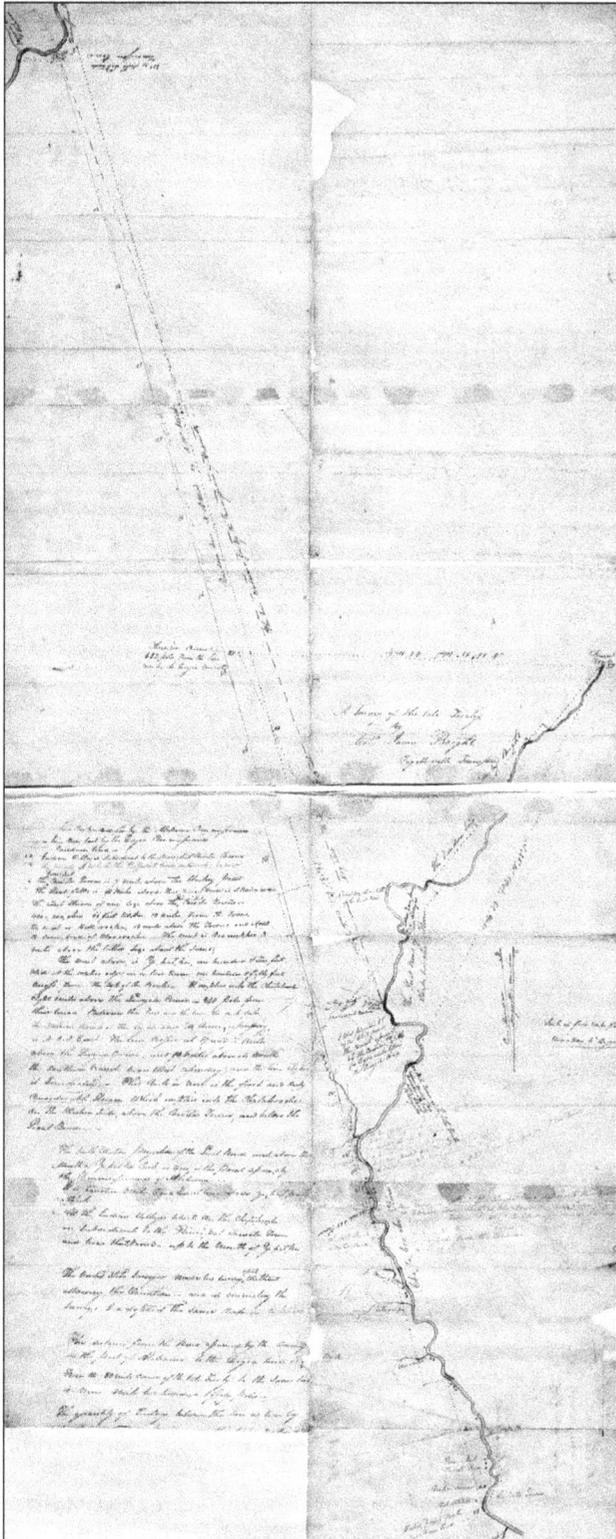

When Alabama was admitted into the Union in 1819, much of the lower portion of the river was specified as the boundary between that state and Georgia. The boundary between the states is not in the middle of the stream as many have assumed, however. A hotly contested issue throughout the region's history, the boundary was not officially settled until 1859, when the United States Supreme Court affirmed that the western boundary of the lower portion of the state of Georgia was the normal high water mark of the river's western bank. In other words, the Chattahoochee is entirely contained in the state of Georgia. This map was produced during a survey of the boundary prior to the founding of Columbus. The areas now occupied by the towns of Phenix City, Alabama, and Columbus, Georgia, are at the spots marked Coweta Town and Cusseta Town. (Courtesy of the Georgia Archives, Vanishing Georgia Collection.)

Though the region experiences occasional snow and ice storms, winter in the lower Chattahoochee River Valley is generally relatively mild. This unique image depicts an extremely rare sight; the Chattahoochee near West Point nearly frozen over. The photograph was taken during a period of exceptionally low temperatures in January 1940. (Courtesy of the Troup County Archives.)

Whereas floods receive much more attention for their dramatic disruptions of life along the river, periodic drought has been a significant problem as well. Low water levels particularly impacted river-borne trade and transportation as they made stretches of the already-treacherous river virtually impassable by any but the smallest of boats. This image shows the river near West Point, Georgia, in 1925 during a period of very low water. (Courtesy of the Troup County Archives.)

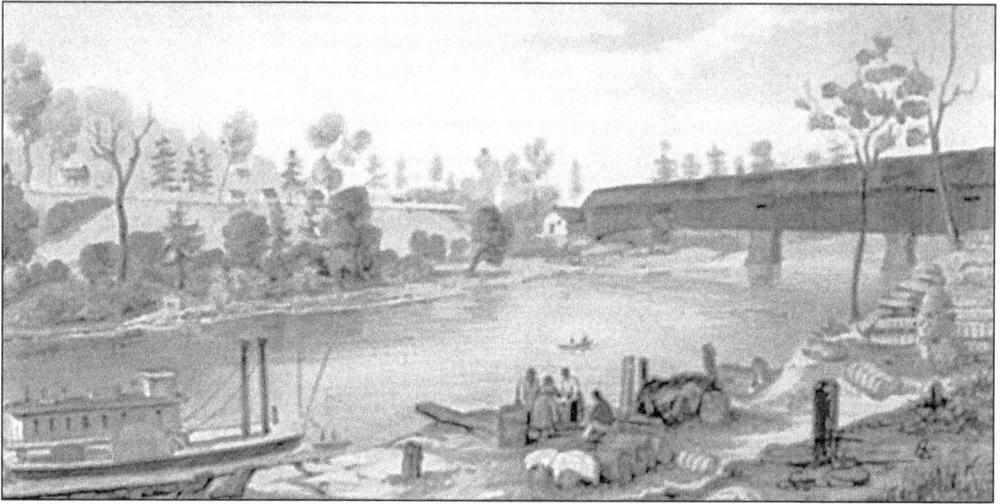

This hand-tinted lithograph by Francis de la Porte depicts a scene on the Chattahoochee River at Columbus in the 1830s. It encapsulates the story of the town and the river in the era as few other single images do by featuring several of the things that define the antebellum period in regional history: a riverboat, slaves, cotton, and a bridge connecting the town to the rich cotton lands of Alabama. (Courtesy of the Columbus Museum.)

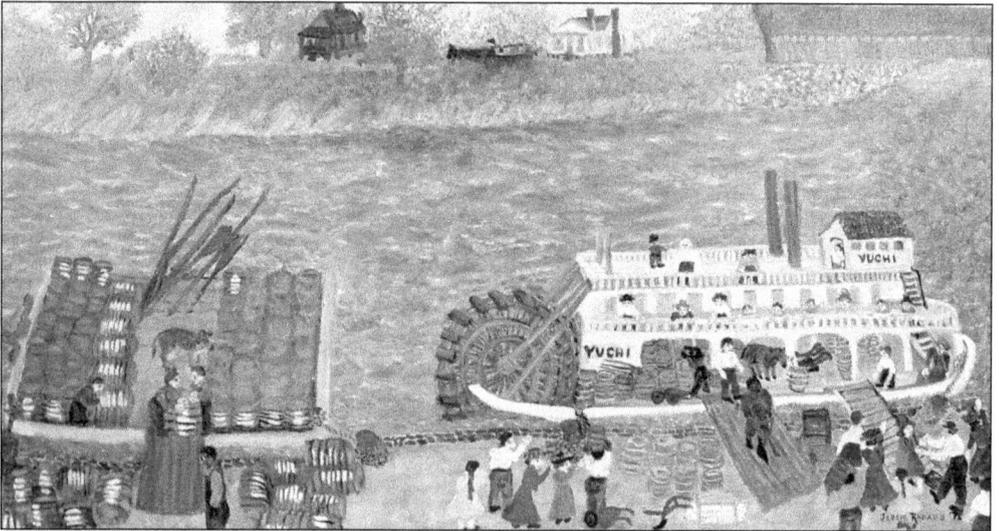

Jessie Dubose Rhoads, from Coffee County, Alabama, created over 150 paintings depicting life in the lower Chattahoochee Valley region in the early 1900s. This painting, *Riverboat on the Chattahoochee*, represents a typical scene from life on the Chattahoochee at the beginning of the 20th century. (Courtesy of the Columbus Museum.)

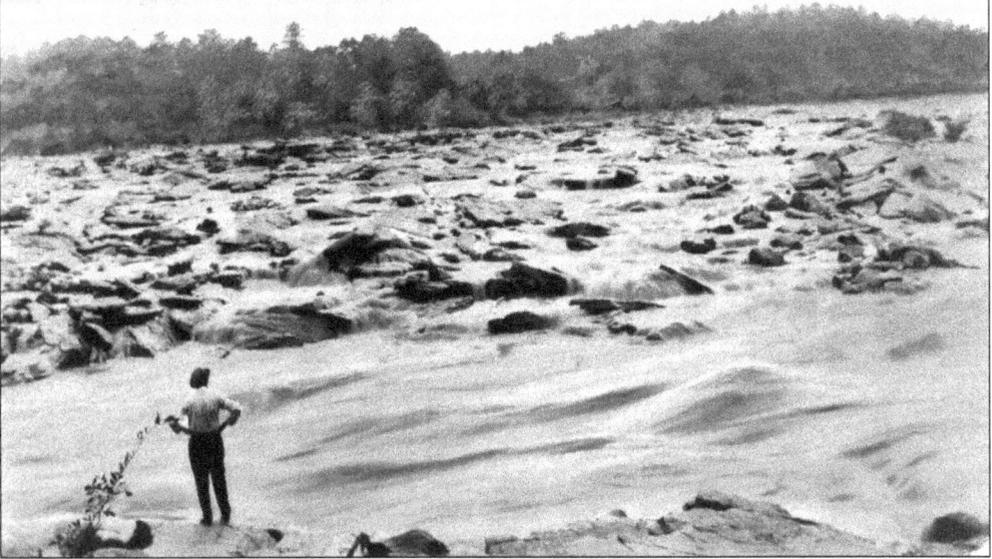

The Rapids, Chattahoochee River, Columbus, Ga.

This image, c. 1910, shows the river in its natural state as it approaches Columbus. It graphically illustrates the river's encounter with the fall line, which is the geographic boundary between the Piedmont region and the Coastal Plain. The fall line is characterized by a sudden drop in land elevation and outcroppings of rock. The resulting power created by waterfalls at this location facilitated the development of water-powered industry in Columbus. (Courtesy of the Columbus Museum.)

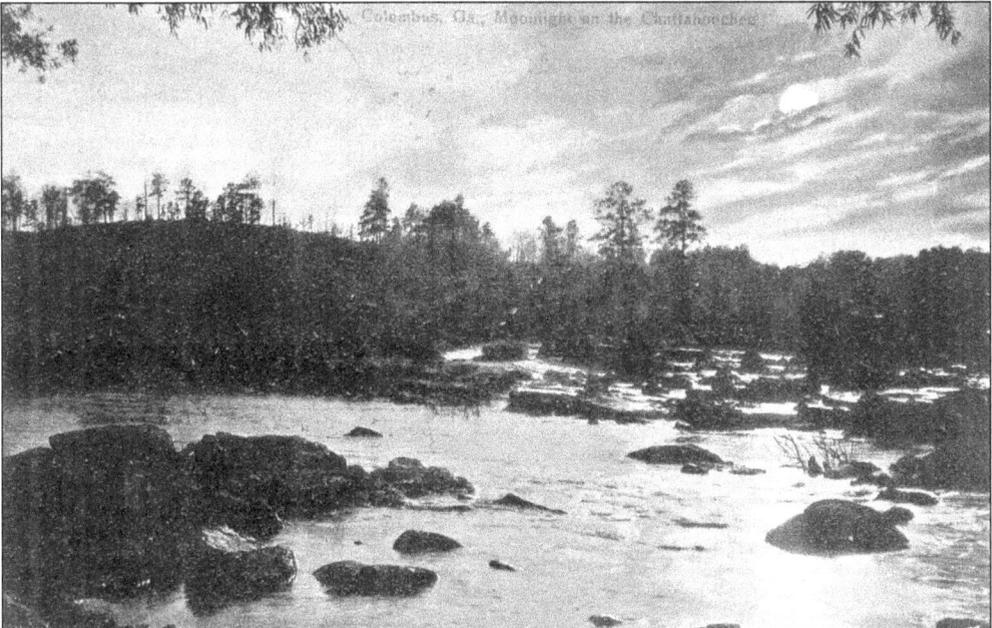

This unusual postcard depicts a nighttime image of the Chattahoochee. Postcards such as this one became very popular in the first few decades of the 20th century and were widely distributed by businesses as a form of advertisement. (Courtesy of the Columbus Museum.)

13

The Chattahoochee River has served as an inspiration for a wide variety of both professional and amateur artists. This photograph, entitled *February Morning on the Chattahoochee*, was part of a juried photography exhibition organized by Columbus State University in November 2005. It captures the power and majesty of the river as it rushes over the fall line in Columbus. (Photograph by Susan Waldrop.)

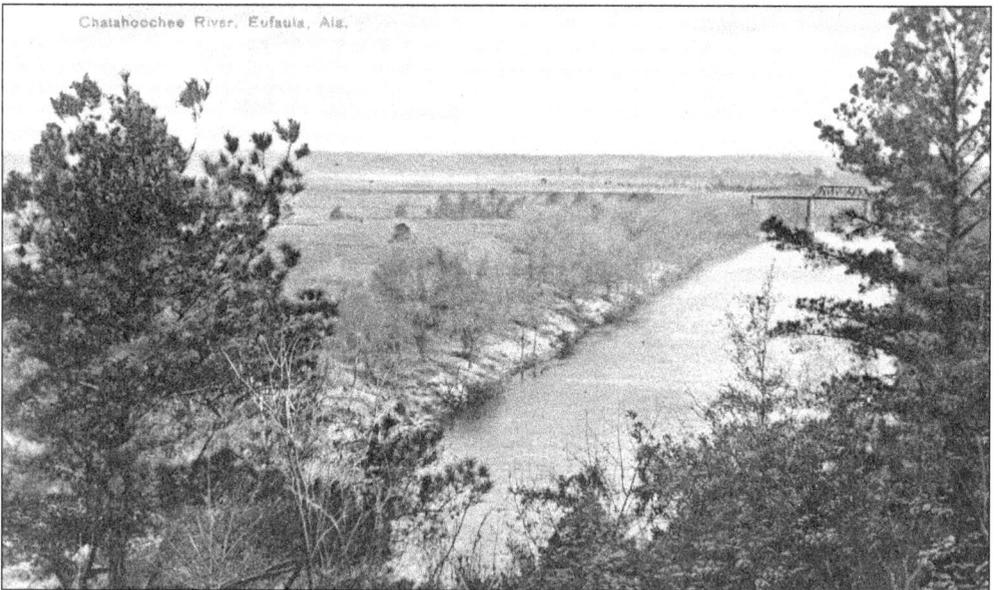

The natural wild beauty of the Chattahoochee River in Barbour County, Alabama, is showcased on this card. The Barbour County area and the entire Chattahoochee Valley owe much to the river. A system of locks and dams was placed along the river in the mid-1900s, breathing a new life of recreation into the area. (Courtesy of Hank Johnson.)

This view of the Franklin Landing was taken from the covered-bridge tollhouse at Fort Gaines, Georgia. Franklin, Alabama, was located in Henry County across from Fort Gaines and was the first pioneer town in that county. (Courtesy of the Henry County Historical Group.)

The old covered-bridge tollhouse sits atop the bluff at Fort Gaines, Georgia, in this modern-day view taken from Franklin Landing in Henry County, Alabama. (Courtesy of the Henry County Historical Group.)

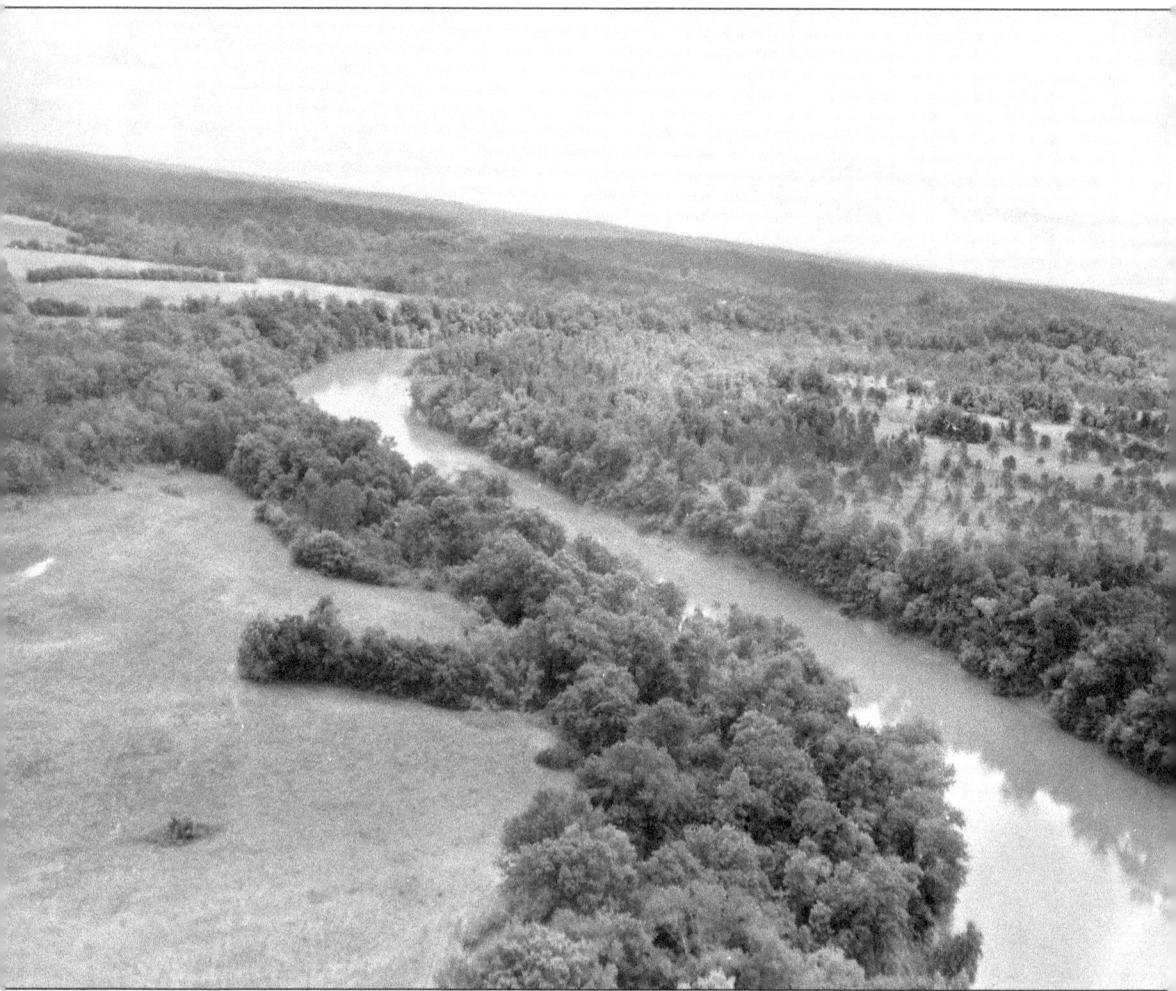

This modern aerial photograph shows the Chattahoochee as it winds its way through Russell County, Alabama, and Stewart County, Georgia. As has most of the lower river valley, this part of the region has witnessed many different eras of occupation by Native American tribes. Native American inhabitants frequently abandoned residential areas after a few years or seasons and resettled only a short distance downriver. Thus one group of people or a town could create multiple settlements over periods of thousands of years in the same area. (Courtesy of Thomas Foster, Ph.D.)

Two

NAVIGATION

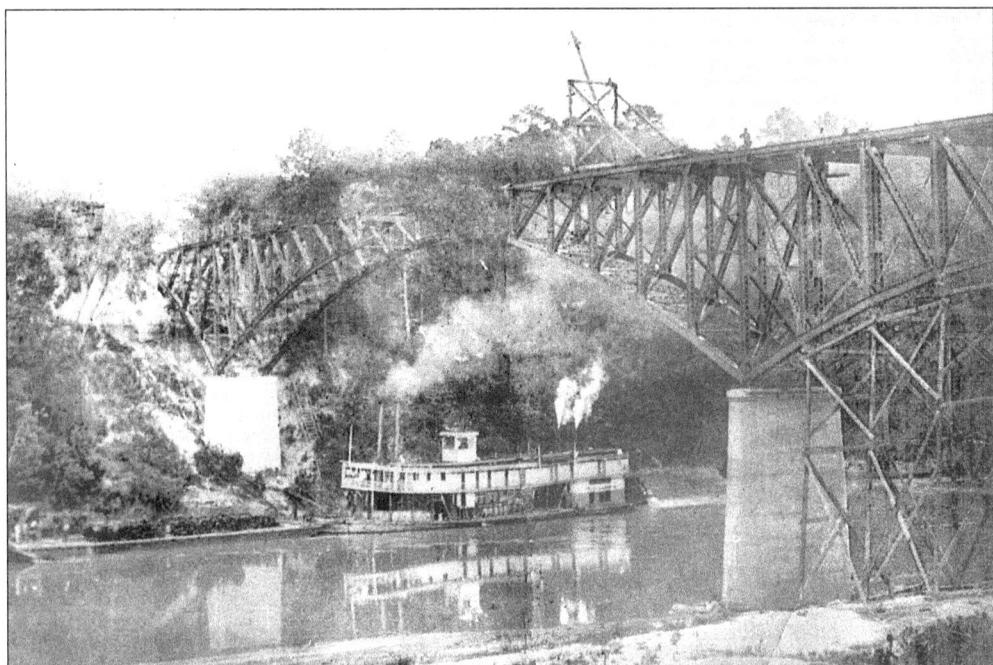

This picturesque *c.* 1925 image shows a riverboat and barge at the landing in Fort Gaines framed by a span of the new iron bridge under construction. (Courtesy of the James E. Coleman Collection.)

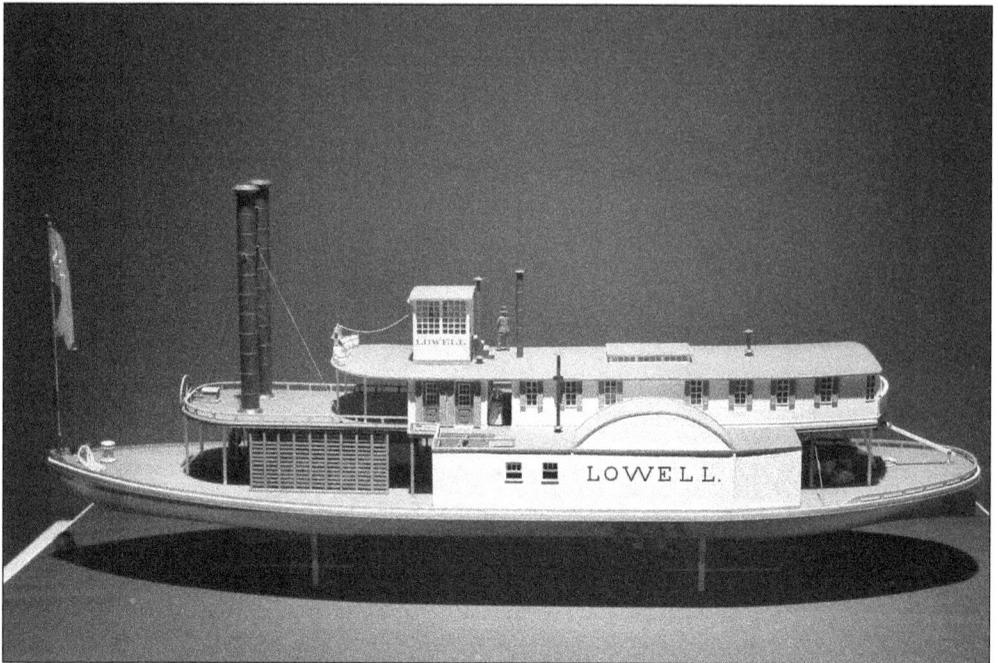

The *Lowell*, launched in 1839 and named after the prominent Massachusetts textile manufacturing town, was owned by Columbus businessman and Massachusetts native Henry T. Hall. The side-wheel steamer sunk when it stuck a snag near Fort Gaines in March 1845. This model of the boat, in the Columbus Museum's collection, was constructed by nationally known model builder John Fryant in 1998. (Courtesy of the Columbus Museum.)

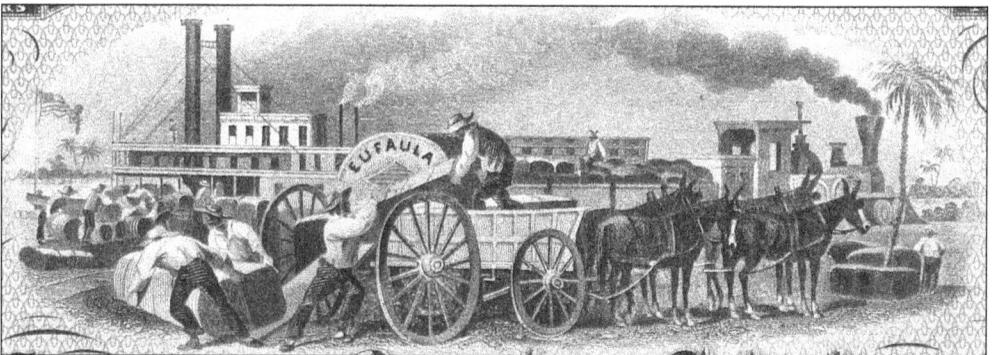

This image of slaves loading cotton onto the steamboat *Eufaula* appeared on the front of a $10 banknote issued by the Eastern National Bank of Alabama. The bank, founded in Eufaula by John McNab in the late 1850s, was one of several organized in the antebellum era to fund the lucrative cotton trade in the lower Chattahoochee Valley. The *Eufaula* was built in its namesake city in 1845. (Courtesy of the Columbus Museum.)

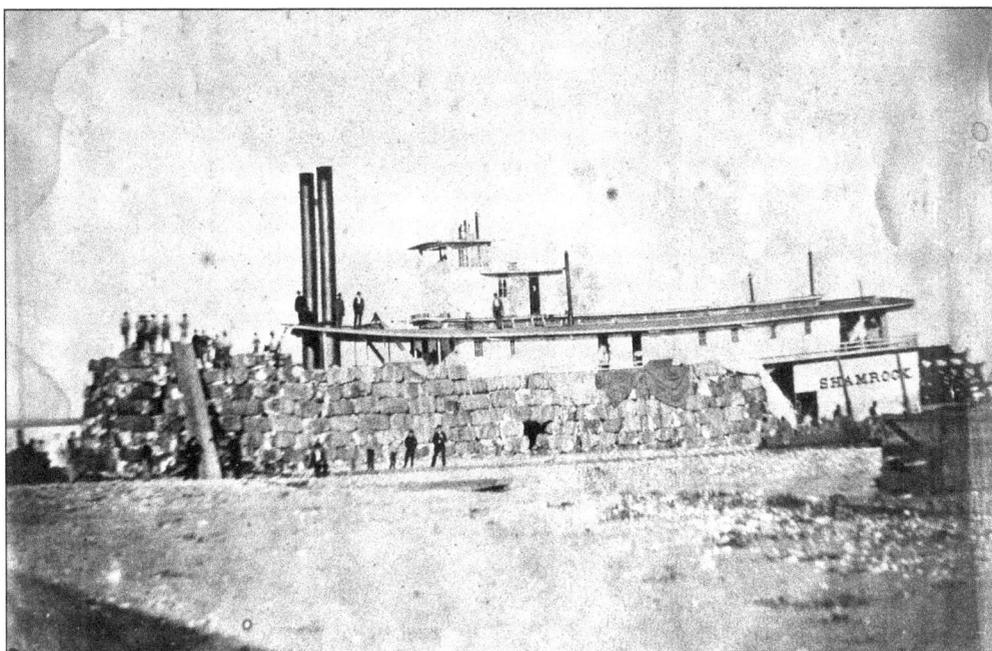

The *Shamrock* was built during the Civil War by the Confederate Naval Ironworks to serve as a supply transport. The boat, launched in the spring of 1864, became a favorite of the staff of the Columbus *Daily Enquirer* in the postwar years due to its crew's gift of barrels of oysters to the newspaper employees. After eight years of service, the boat was sold to the Columbus Iron Works and presumably salvaged. (Courtesy of Ed Mueller.)

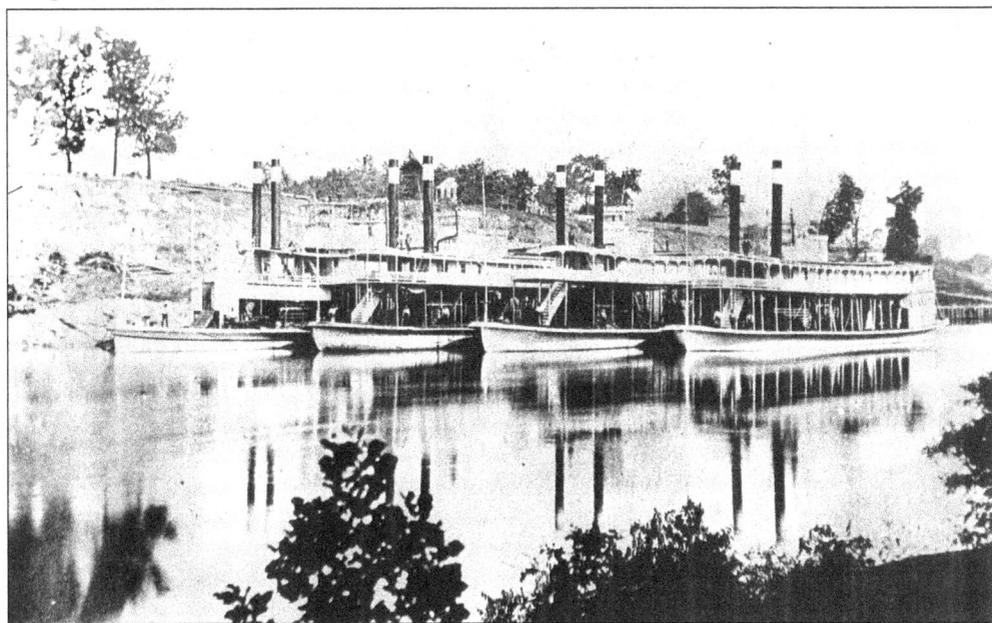

Shown from left to right in this c. 1867 photograph are the steamers of the Barnett Line, the *Shamrock*, the *C. D. Fry*, the *New Jackson*, and the *Barnett*, at Columbus. The four boats operated all along the lower river, making primary stops at Columbus, Eufaula, Bainbridge, Chattahoochee, and Apalachicola. (Courtesy of Ed Mueller.)

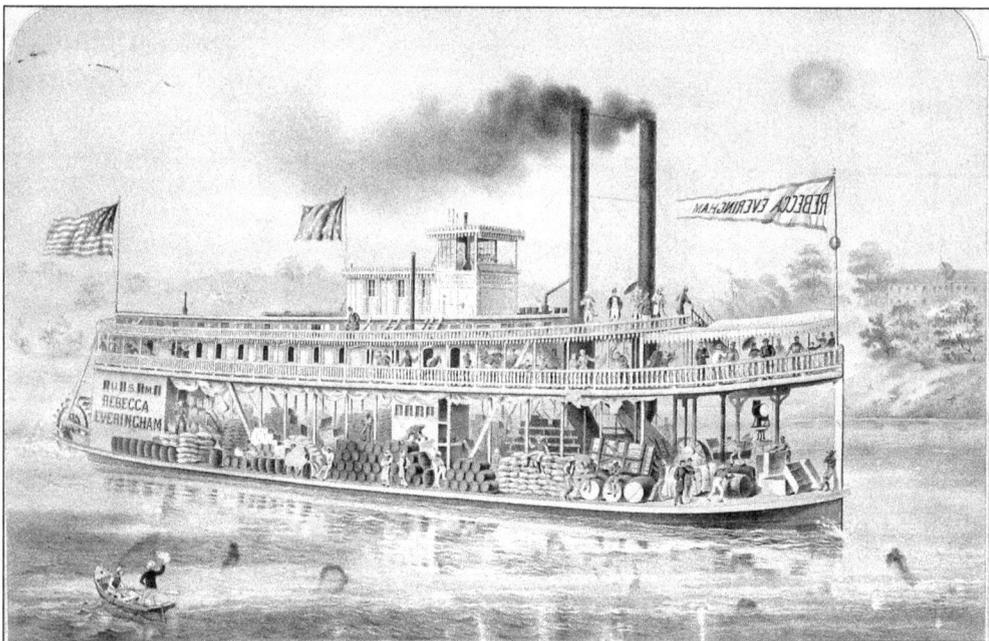

THE NEW AND ELEGANT STEAMER

REBECCA EVERINGHAM

Able to accommodate over 150 people and nearly 1,000 bales of cotton, the *Rebecca Everingham* was one of the most well-known and elegant steamers to ever ply the Chattahoochee. It was unfortunately destroyed on April 3, 1884, near Fitzgerald's Landing, about 40 miles below Columbus, when her cotton cargo caught fire. Twelve people, four passengers and eight crew members, died in the tragedy. (Courtesy of D. Neal Wickham.)

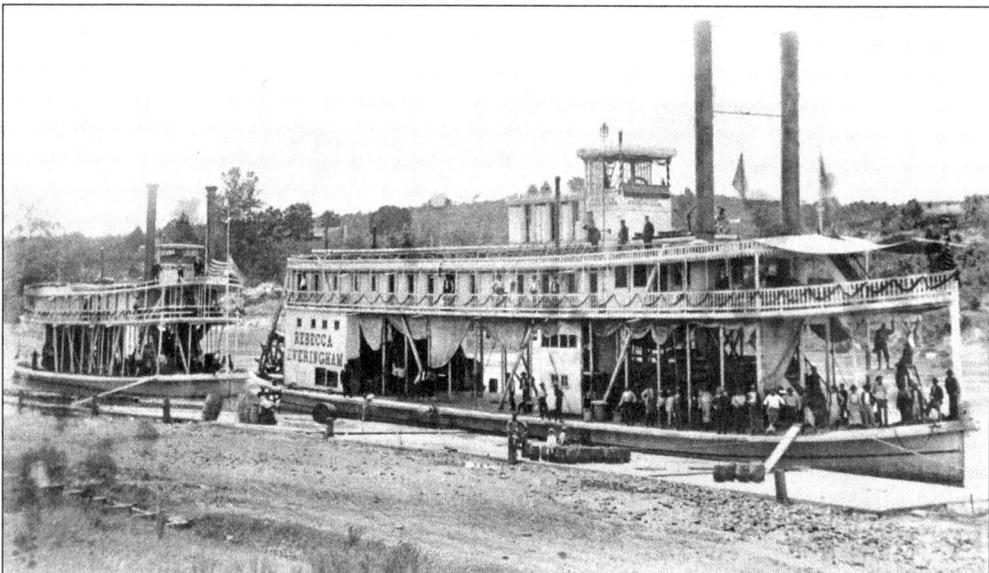

Built in 1880 in Columbus, the *Rebecca Everingham* was named after the wife of Central of Georgia Railroad president Col. William M. Wadley. She is shown here draped in black, mourning the death of the colonel. (Courtesy of Ed Mueller.)

At the height of steamboat navigation on the Chattahoochee River, there were well over 200 steamboat landings between the cities of Columbus and Apalachicola in the states of Alabama, Georgia, and Florida. While many were located at some of the Chattahoochee Valley's major population centers, others were located on the private property of some of the region's large landholders to facilitate the shipping of cotton and other agricultural products produced on nearby land. Goods to be delivered to individuals who resided near these landings were unloaded at many of these locations as well. The list of landings shown here was likely used as promotional material for the steamer *Shamrock*. The Columbus-built steamer operated on the Chattahoochee until removed from service in 1872. Note that the few landings where warehouses were located, listed in bold, were at the larger riverside communities. (Courtesy of the Columbus Museum.)

TABLE OF DISTANCES.

CHATTAHOOCHEE RIVER LANDINGS.

Landing	State	Dist.	Landing	State	Dist.	Landing	State	Dist.
Columbus	Ga.		Alexander's	Ala.	97	Pulliover's, Upper	Ala.	158
Abercrombie's	Ala.	6	Lokey's	Ga.	98	Speight's	Ga.	159
Indian Mound	Ga.	7	Cauthon's	Ala.	99	Calumet	Ala.	163
Woolfolk's	Ga.	9	Rick's	Ga.	100	Shackelford's	Ga.	164
Florence's	Ala.	10	Wash's	Ala.	103	Gordon, Upper	Ala.	167
Hall's, Upper	Ga.	13	Lockhart's	Ala.	104	Gordon, Middle	Ala.	167
Hall's, Lower	Ala.	14	Catchen's	Ga.	104	Porter's Ferry	Ga.	166
Burden's	Ala.	15	Wilcox's	Ala.	104	Gordon, Lower	Ala.	170
Boland's	Ga.	16	Hobbs'	Ga.	104	Haysville	Ga.	171
Chamber's, Upper	Ala.	19	Peacock's	Ga.	105	Forbes	Ala.	171
Rooney's or Jefferson's	Ga.	20	Otho	Ala.	106	Sheffield	Ga.	171
Sherling's	Ga.	20	Norton's	Ala.	107	*Alaga	Ala.	172
Bon Acre	Ala.	21	Berry's	Ga.	108	*A. C. L. Railway	Ala.	172
Myrick's	Ga.	22	Morris'	Ala.	108	Bryan's	Ala.	176
Cody's or Adam's	Ga.	23	Starke's Clay	Ga.	109	Saffold's	Ala.	177
Chinaberry Bluff	Ga.	55	Hobues'	Ala.	110	Navy Yard	Ala.	177
Fitzsimmons	Ala.	57	Turnipseed's	Ga.	111	Sitsemake's	Ga.	179
Brannou's	Ga.	30	Spann's	Ala.	112	J. D. Perry's	Ala.	180
G. Y. Banks'	Ga.	32	Mandyville	Ga.	116	Donaldson's	Ga.	181
McMillan's	Ga.	32	Franklin	Ala.	118	Reardon's	Ga.	182
Lawson's	Ga.	33	*Fort Gaines	Ga.	118	Gibson's	Ga.	184
Bradley's, Upper	Ga.	35	Gunn's	Ga.	120	Willoughby's	Ala.	185
Cottonton	Ala.	36	Farmer's	Ala.	121	Berry Williams'	Ala.	186
Harden's	Ga.	38	Wolf's	Ala.	122	Hamilton's	Ga.	186
Blufftown	Ga.	39	Farmer's, Lower	Ala.	123	Midland Crossing	Ala.	186
Gillis'	Ga.	41	Grimsley's	Ga.	123	Ely's	Ga.	187
Willis'	Ala.	41	Bennett's	Ala.	125	Harvey's	Ga.	188
May's	Ala.	43	Colomokee	Ga.	125	Millport	Ga.	190
Towns	Ala.	44	Chitty's	Ga.	125	Planter's	Fla.	190
Tillman's	Ga.	44	Humphries	Ga.	127	Neal's	Fla.	191
Loflin's	Ala.	44	Barnett's	Ala.	128	Bartow	Ga.	191
Thompson's	Ala.	45	King's	Ala.	121	Bermuda	Ga.	192
Fitzgerald's D. B.	Ga.	49	Womack's	Ga.	131	Steam Mill	Ga.	193
East Bank	Ga.	50	Gilbert's	Ga.	131	Curtis	Fla.	195
Burts	Ala.	51	Chamber's, Lower	Ala.	131	Godwin's	Fla.	197
Fontaine's, Lower	Ga.	52	Zornoville	Ala.	132	Tennille's	Fla.	198
Jernigan	Ala.	53	Wingate's	Ala.	133	Rambo's	Ga.	198
Blackstock's	Ala.	54	Howard's	Ala.	135	Pittmmon's	Fla.	199
Shepherd's	Ga.	55	T. T. Smith's	Ga.	136	Barkley's	Fla.	100
Florence	Ga.	58	North Abbey	Ala.	138	Fry's or Mirhen's	Ga.	200
Q. D. Williams'	Ala.	60	South Abbey	Ala.	138	Port or Owen's	Fla.	200
Turner's	Ga.	60	Powell's	Ga.	139	Forrister's	Fla.	203
Bradley's, Lower	Ga.	62	McDaniel's	Ala.	140	King Rocks	Ga.	204
Roanoke	Ga.	64	Paulk's	Ga.	141	Haywood's	Fla.	202
Woolbridges	Ala.	65	Richardson's	Ala.	142	Smart's	Ga.	205
Blackman's	Ala.	66	Espey's	Ala.	143	Dunovsely's	Fla.	203
Rood's	Ga.	66	Freeman's	Ga.	144	Fairchild's	Ala.	204
Rankin's	Ga.	60	Purcell's	Ala.	147	Port Jackson	Fla.	204
Hill's	Ala.	70	Alford's	Ala.	148	Haines'	Fla.	205
Allen's	Ala.	73	Grier's	Ga.	149	Trawick's	Fla.	208
Johnson's	Ga.	74	Jones'	Ala.	149	Butler's	Fla.	210
Stewart's	Ga.	77	Rawls	Ala.	149	Hare's	Ga.	212
Flournoy's	Ala.	79	Auglin's	Ala.	149	Rock Island Point, Kemp's	Fla.	214
*Eufaula	Ala.	85	*Columbia	Ala.	152	Gambling's	Fla.	217
Foy's	Ala.	91	*Central of Ga. R. R	Ala.	152	Liblton's	Fla.	220
Wm. Burnett's	Ga.	94	Koonce	Ga.	153	Hawley's	Fla.	220
McTyer's	Ala.	95	Shivers' Bar	Ala.	156	Orange Point	Ga.	221

Freight to all Landings except Columbus, Apalachicola, Bainbridge and Eufaula must be prepaid. Warehouse Landings are marked thus* and appear in bold type.

TABLE OF DISTANCES—Continued.

APALACHICOLA RIVER LANDINGS.

Landing	State	Dist.	Landing	State	Dist.	Landing	State	Dist.
*Chattahoochee	Fla.	223	Bristol, Upper	Fla.	253	Slough	Fla.	313
*A. C. L. Railroad	Fla.	224	Bristol, Lower	Fla.	253	Fields	Fla.	314
*L. & N. R. R.	Fla.	224	Calhoun	Fla.	255	Robinson's Camp	Fla.	316
*S. A. L. R. R.	Fla.	224	Blountstown	Fla.	256	Mouth Chipola	Fla.	325
Ferrell's	Fla.	224	West Wynnton	Fla.	259	Kennedy Creek	Fla.	328
Pank's, Lower	Fla.	225	Griffin	Fla.	261	Naiad's Landing	Fla.	330
Sampson's	Fla.	227	Point Poloway	Fla.	263	Ramsey's Camp	Fla.	331
Coe's	Fla.	230	Riverside	Fla.	264	Owl Creek	Fla.	332
Aspalaga	Fla.	232	Baker's	Fla.	266	Brick Yard Island	Fla.	333
Sugar Mill	Fla.	236	Hughs	Fla.	268	Brick Yard	Fla.	334
Cooper's Point	Fla.	236	Jack Woods	Fla.	271	Hardee's	Fla.	334
Howard's Cane Mill	Fla.	236	Estiffanulga, Upper	Fla.	276	Marchant's	Fla.	335
U. S. Landing	Fla.	237	Carter's	Fla.	276	Patrick's	Fla.	335
Ochesee	Fla.	239	Estiffanulga, Lower	Fla.	276	Fort Gadsden	Fla.	335
Rock Bluff	Fla.	241	Muscogee Bluff	Fla.	281	Russell's	Fla.	340
Wayside	Fla.	242	Musquito	Fla.	282	Bloody Bluff	Fla.	342
Caraway's	Fla.	243	Mary's	Fla.	283	Randlett's	Fla.	343
Atkins	Fla.	244	Stanfill's	Fla.	283	Three Brothers	Fla.	348
Dawsons	Fla.	245	Shingle	Fla.	284	Floyd's Camp	Fla.	350
O. K. Landing	Fla.	245	Ricoe's Bluff	Fla.	286	Hoffman's Camp	Fla.	350
Yon's	Fla.	245	Coon	Fla.	286	Apalachicola Lumber Co.	Fla.	354
Watson's	Fla.	246	Gunn's	Fla.	289	Franklin	Fla.	354
Hally's	Fla.	249	Porter's	Fla.	297	Old Woman's Bluff	Fla.	354
Alum Bluff	Fla.	249	Iola	Fla.	301	Loxley's Mills	Fla.	354
White Oak	Fla.	250	Silver Lake	Fla.	302	*Apalachicola	Fla.	360
Shuler's	Fla.	252	Chipola Cut Off	Fla.	305			

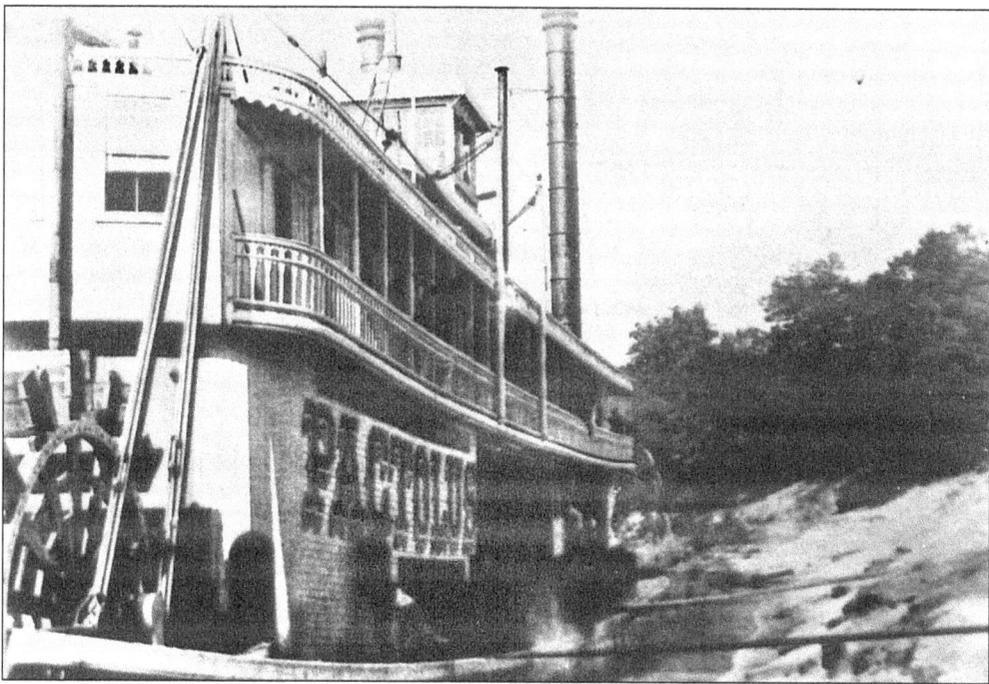

Built in Jeffersonville, Indiana, in 1886, the *Pactolus* was reputed to be the largest steamer operating on the Chattahoochee when it first arrived on the lower river in October of that year. The over-135-foot-long boat was built at a cost of over $20,000 and featured over 30 cabins and a capacity of 800 bales of cotton. (Courtesy of F. Clason Kyle.)

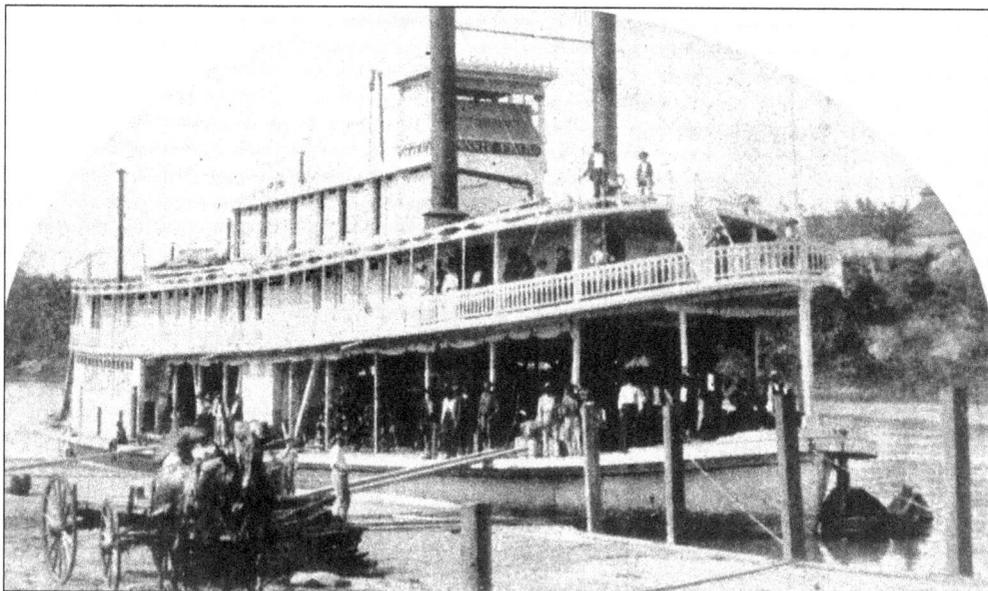

Built for the Ohio River trade, the *Fannie Fearn* was purchased by the Columbus and Gulf Navigation Company in May 1887. At the beginning of the 1891 cotton shipping season, the boat was involved in one of the many celebrated steamboat races of the time period, as it raced the *William D. Ellis* to Columbus. It led the *Ellis* until it grounded at Woolfolk's Bar. It reached the city an hour and a half later. (Courtesy of Ed Mueller.)

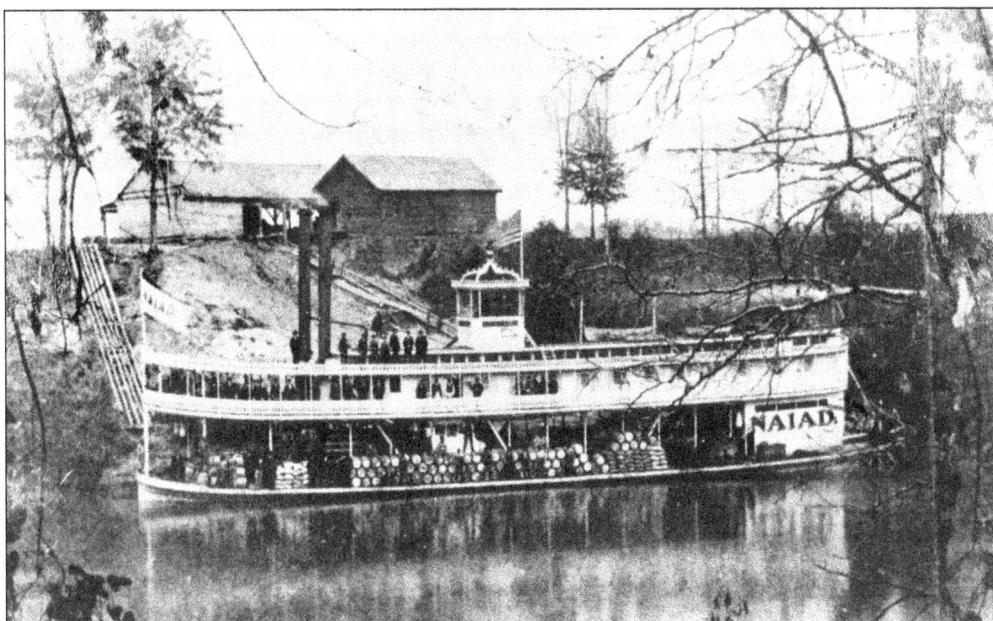

A Columbus-built stern-wheeler whose homeport was Apalachicola, the *Naiad* was launched in September 1884. Named after the mythological figures that were supposed to give life to bodies of water, the boat served 18 years on the river before burning at Blountstown, Florida, in 1902. The fact that her period of service was the longest of any steamer to operate on the Chattahoochee reveals much about the hazards of steamboat navigation. (Courtesy of Wendell Stepp.)

This pre-1902 image depicts the *Naiad* anchored to take on passengers and/or freight at the old W. H. Purcell Wharf, also known as Purcell Landing or the Upper Columbia Landing. The photograph was taken from the Columbia, Alabama, highway bridge looking north toward the Central of Georgia Railway Bridge. Note the man in the bateau at the rear of the boat. William Henry Purcell (1845–1910) was the great-grandfather of Douglas C. Purcell, one of the compilers of this publication. (Courtesy of Doug Purcell.)

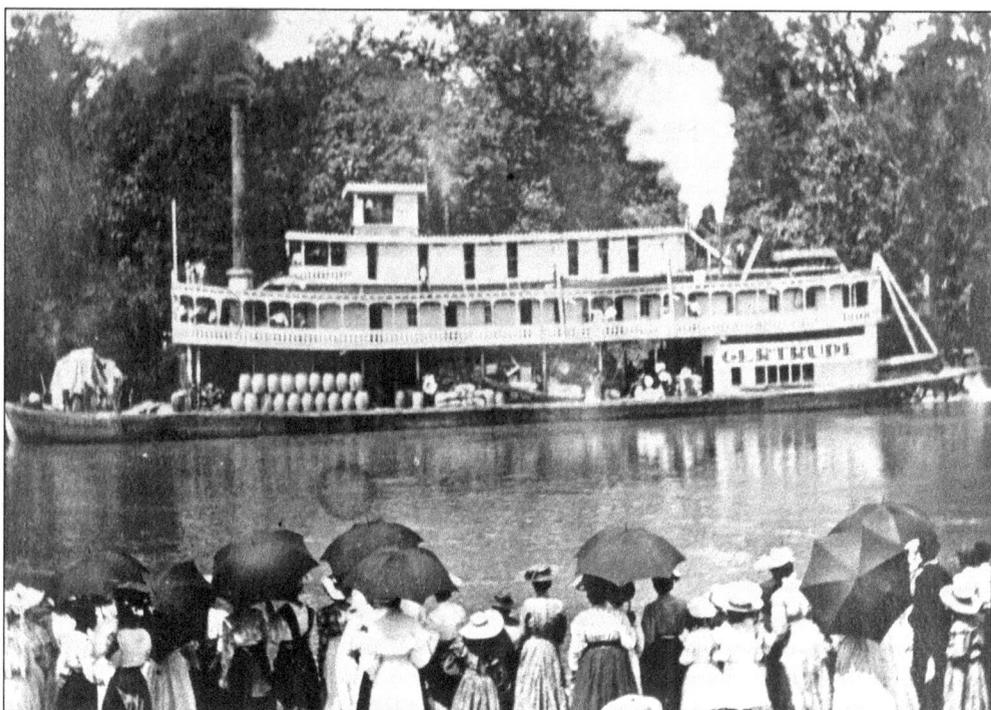

The *Gertrude*, built in 1895 in Kentucky, featured 31 staterooms lighted by electricity produced by a dynamo in the engine room. The ill-fated boat sank in 1904 near Eufaula, was raised, and sank again in 1906. Much of the boat was salvaged for use in the *John W. Callahan*. (Courtesy of Ed Mueller.)

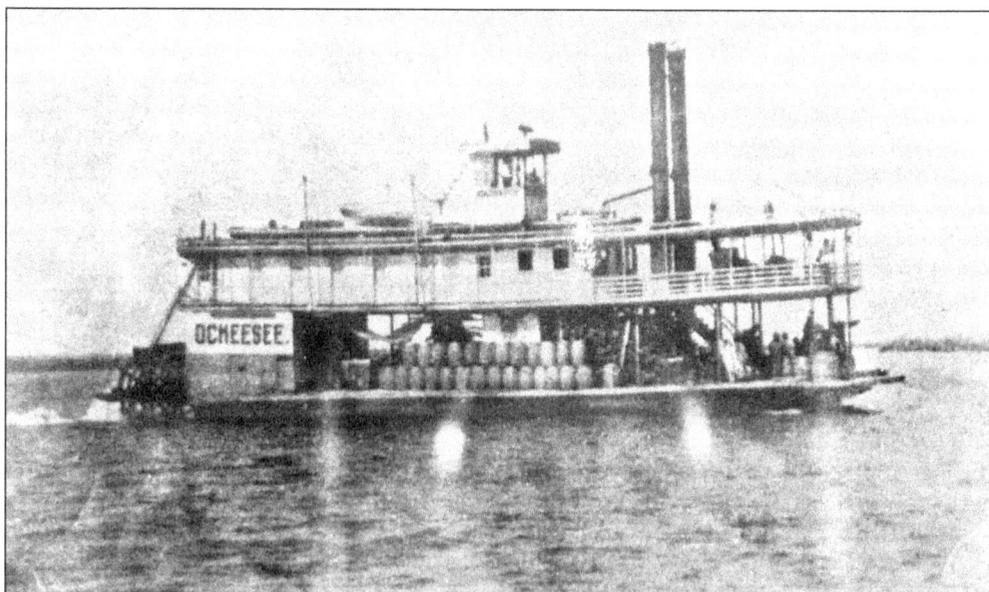

The steamer *Ocheesee* was constructed in Columbus in 1904 and called Apalachicola its first homeport. The stern-wheeler, 84 feet long with a depth of just over 6 feet, had a cargo capacity of 82 tons. The boat sank in Oak Creek, a tributary of the Apalachicola River, in 1907. (Courtesy of F. Clason Kyle.)

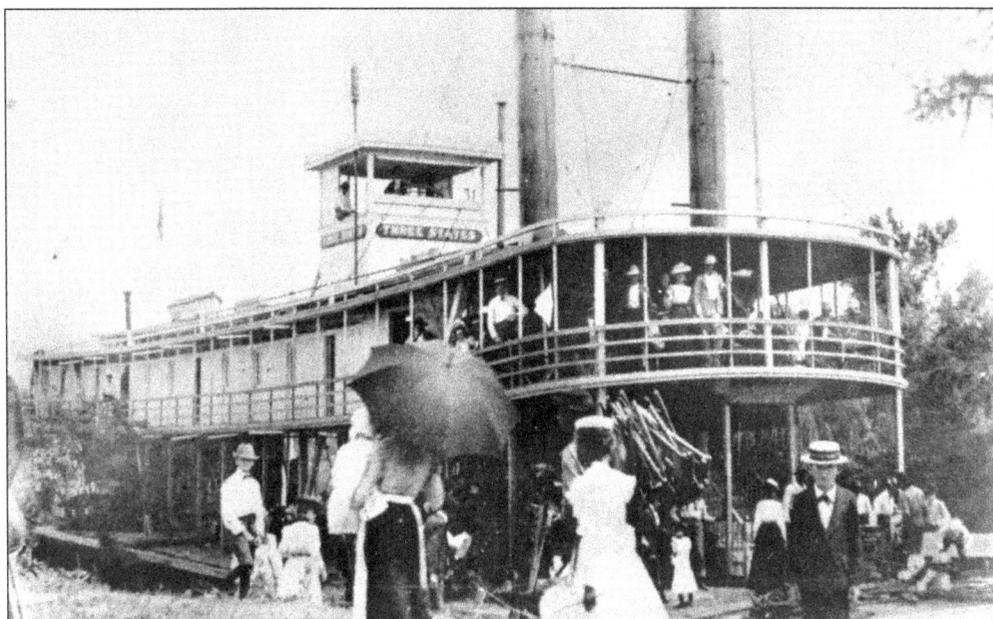

Named in honor of Alabama, Georgia, and Florida, which it served, the *Three States* was built in 1898 at Apalachicola. The vessel's period of service was typical in many ways, but two unusual interruptions in its operation give it a unique place in the history of the steamboat era on the Chattahoochee. In June 1899, the boat's schedule was interrupted when five deckhands were arrested and convicted of gambling en route to Apalachicola. Nine years later, the boat broke loose from its moorings in Columbus and floated some four miles downstream before it was recovered and placed back in service. (Courtesy of Wendell Stepp.)

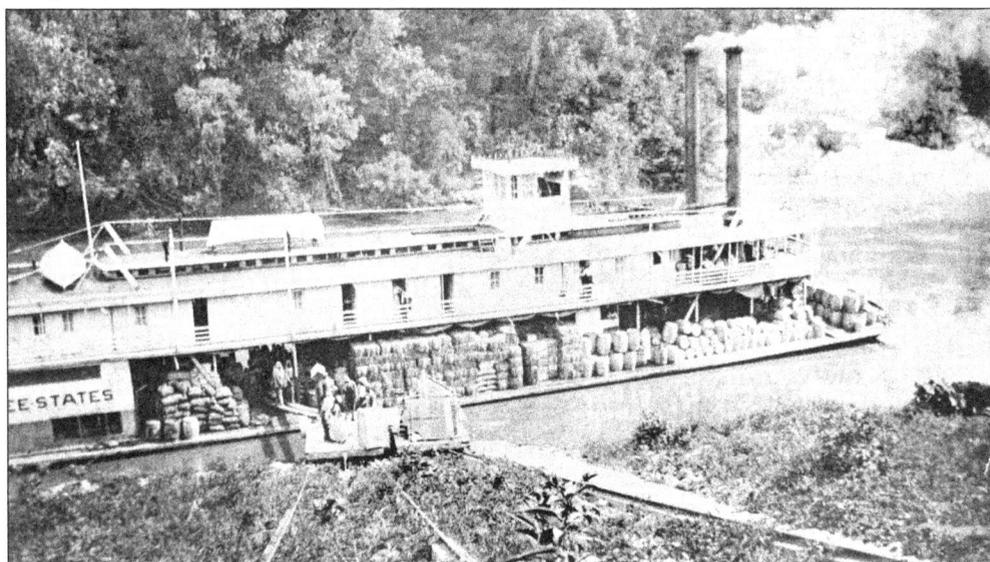

Loading and unloading cotton on Chattahoochee River steamboats was hard work, made all the more difficult by the many steep banks along its course. In this photograph showing the steamer *Three States*, bales are loaded by means of a ramp. Several landings throughout the lower Chattahoochee featured devices such as this, built according to the local terrain, to facilitate the handling of cargo. (Courtesy of the Georgia Department of Natural Resources.)

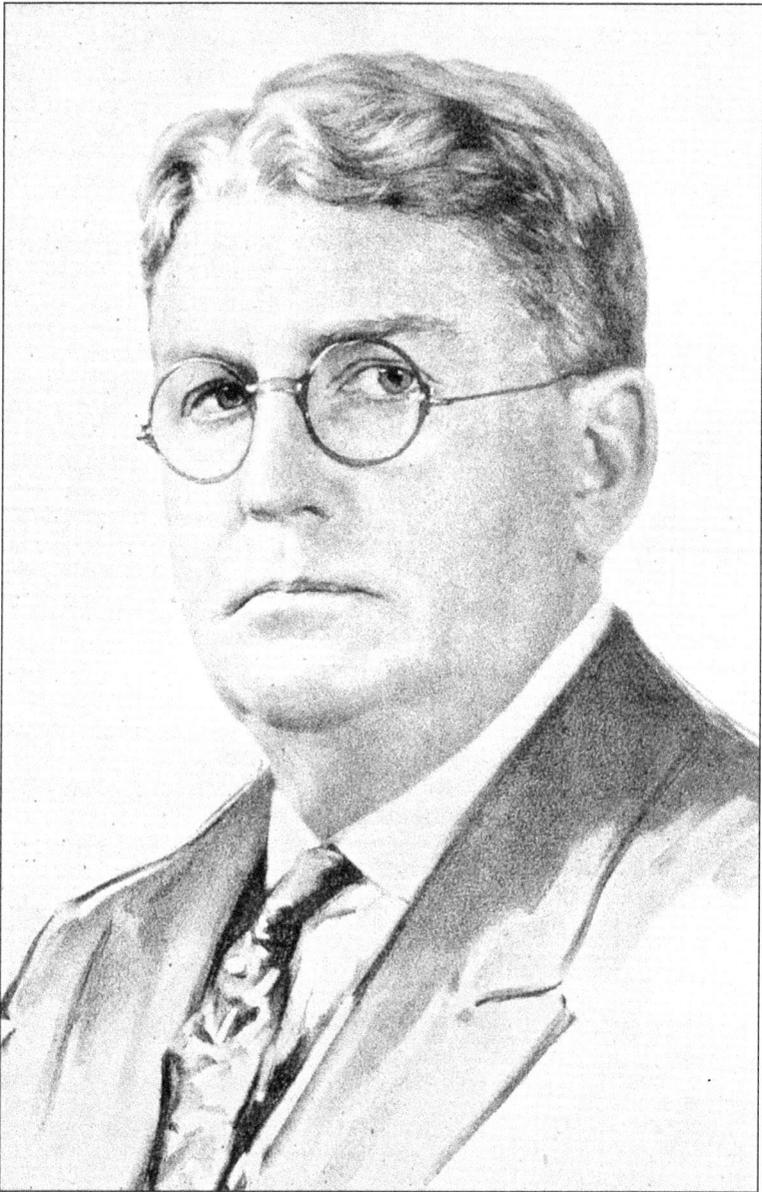

It is difficult to overstate the importance of William Clark Bradley to the economic development of the city of Columbus and the Chattahoochee Valley as a whole. Born near the Chattahoochee in Russell County, Alabama, in 1863, Bradley became one of the most prominent and wealthy men in the region's history. At various times, he operated a diverse array of business interests connected to varying degrees with the river, including several plantations, steamboat lines, a textile mill, a hydroelectric power production facility, and two banks. He accumulated his greatest fortune, however, from his involvement with the Coca-Cola Company. The leader of a group of investors that purchased the company in 1919, he served as chairman of the board of directors for over two decades. After his death in 1947, his estate in the Wynnton area was given to the city of Columbus and later was used by the Columbus Museum, the city library, and the Muscogee County School System. This image, based on a portrait, originally appeared in Nancy Telfair's *A History of Columbus, Georgia.* (Courtesy of the Columbus Museum.)

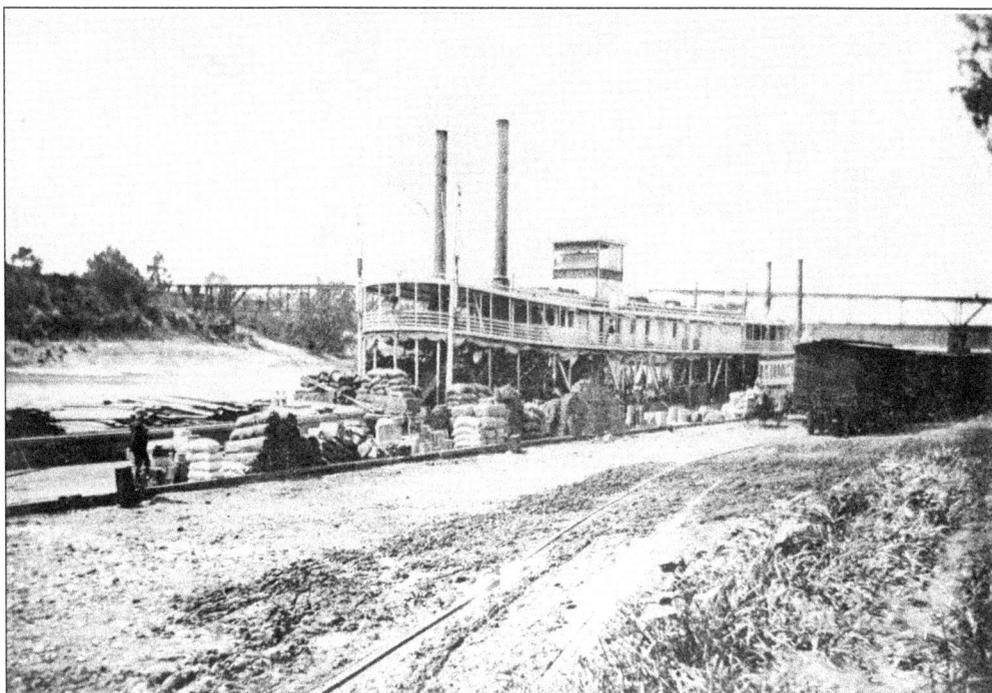

A Columbus-built, 163-foot-long stern-wheel steamboat, the W. C. Bradley was named for the lower Chattahoochee Valley's premier businessman. The boat, one of the most well known to ever serve on the river, was a longtime mainstay of Bradley's Merchants and Planter's Steamboat Company. (Courtesy of the Georgia Department of Natural Resources.)

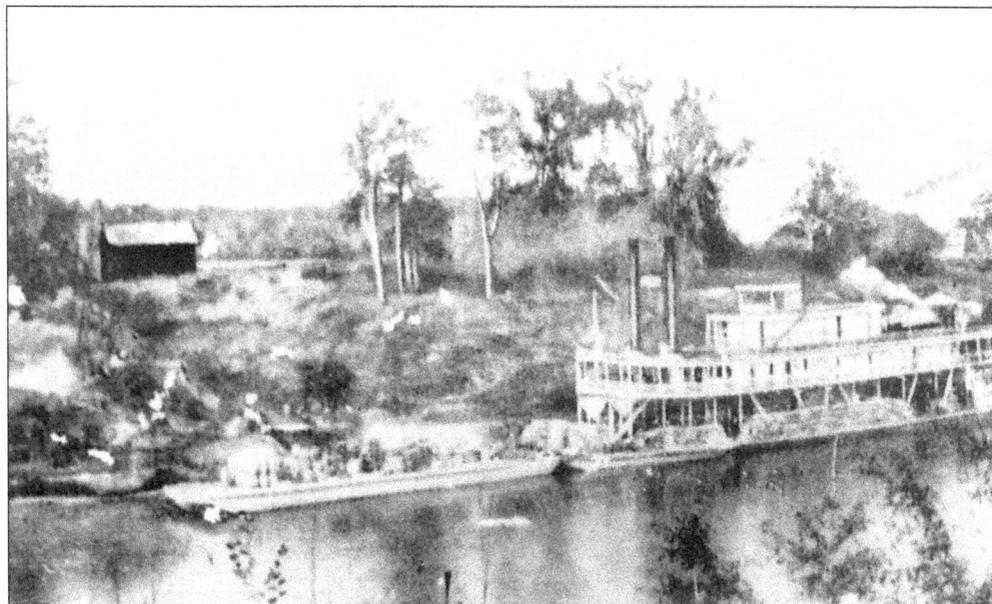

Among the many steamboats that plied the Chattahoochee River, the W. C. Bradley is shown here at the Middle Landing, one of three boat landings located along the river at Columbia, Alabama. Settled in 1820, the old town was a prominent trading center in southeast Alabama during the steamboat era. (Courtesy of the L. H. Adams Collection.)

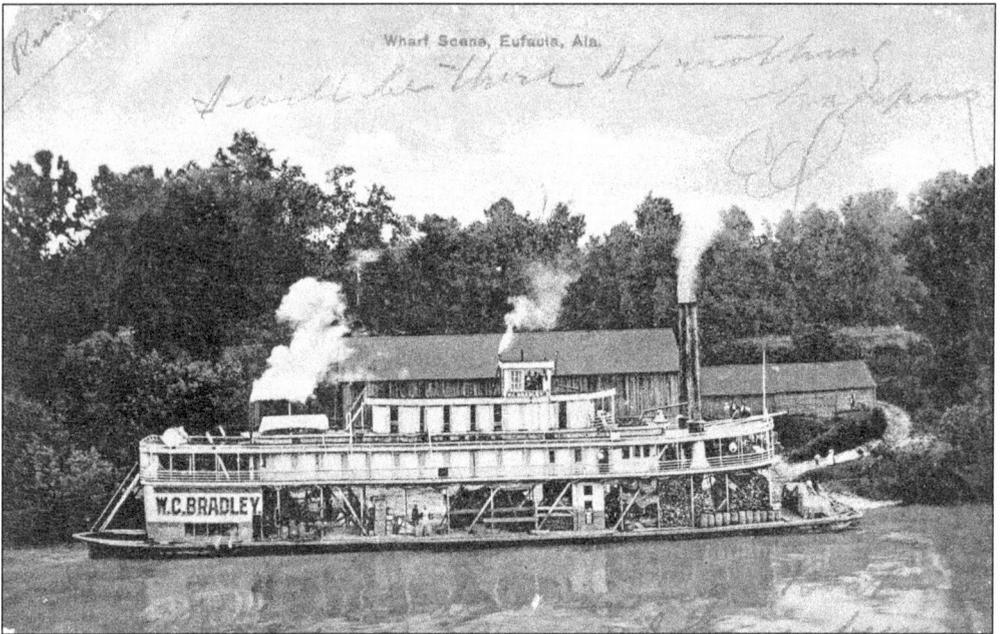

Eufaula's prosperity was in large part due to its location on the Chattahoochee River. Steamboats brought goods from all over and took the wares of area farmers to the world. The *W. C. Bradley* was one of those steamboats. In 1924, the Eufaula Grocery Company (owned by W. C. Bradley) gave their wharf at Eufaula to the city of Eufaula. This postcard is postmarked January 13, 1910. (Courtesy of Doug Purcell.)

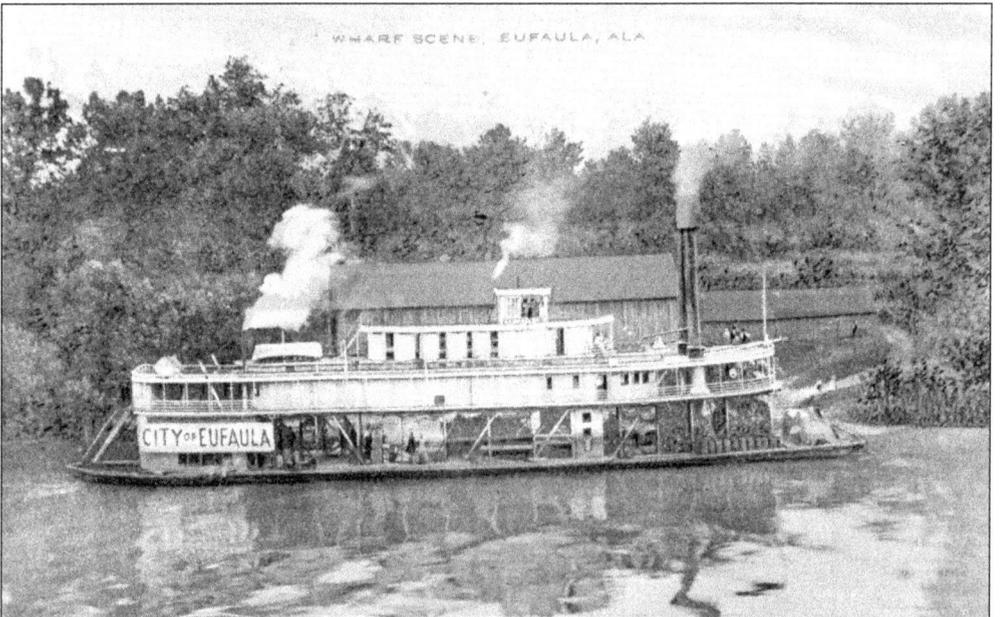

The *City of Eufaula* traversed the treacherous Chattahoochee River delivering goods to the area and shipping cotton to Apalachicola, Florida, then to ports such as New Orleans, New York, and the world. W. C. Bradley owned the *City of Eufaula*. Despite the name on the side of the boat, this image appears to actually be of the *W. C. Bradley*. (Courtesy of Eufaula Heritage Association.)

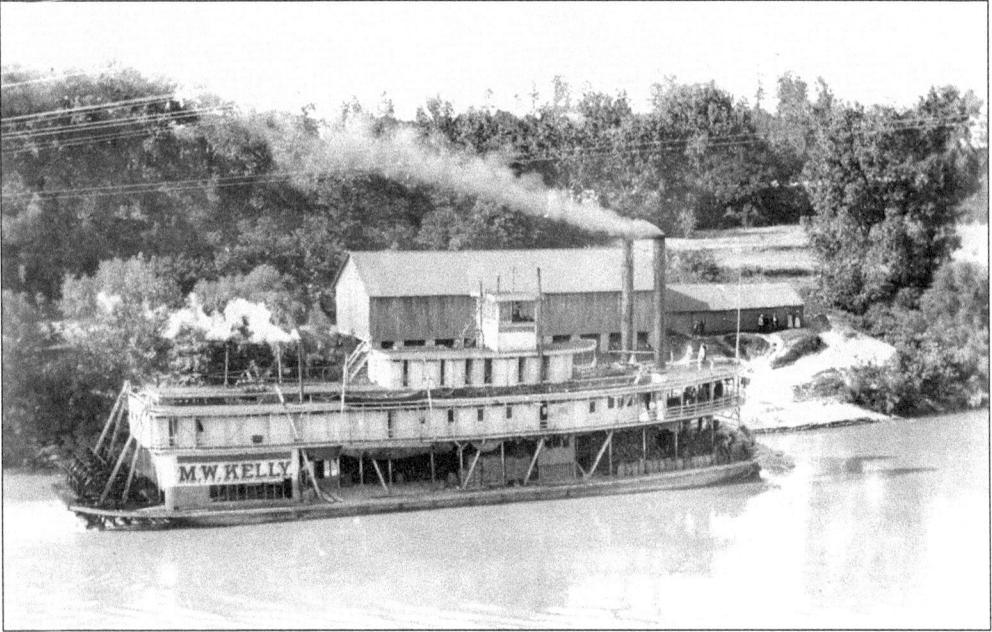

Built at the Howard Shipyard in Jeffersonville, Indiana, in 1900, the shallow-drafted M. W. Kelly was made specifically for use on the Chattahoochee. The ill-fated boat had one of the most eventful service records of any to serve on the lower river, as it was raised after sinking in 1902 and 1906 before going under for the final time at the Columbus wharf in 1908. Fittingly, it lived on by having its cabin installed on another boat. (Courtesy of F. Clason Kyle.)

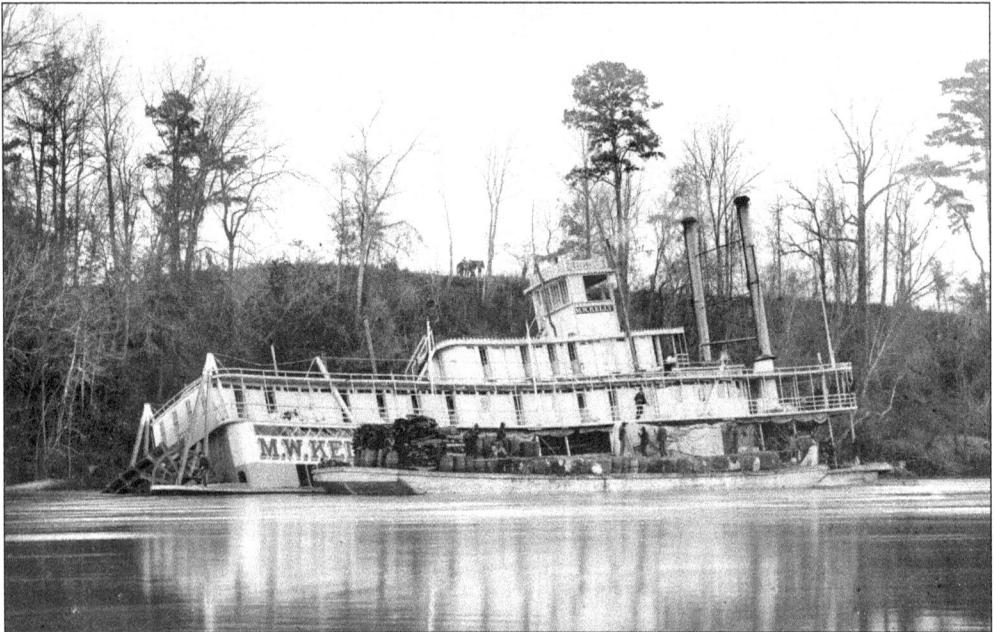

The waters of the Chattahoochee could be quite treacherous at times. They were swiftly moving and shallow in places. Like many others, the M. W. Kelly met its demise on these waters. Here goods are shown being transferred off the wrecked steamboat. (Courtesy of Mary Gray.)

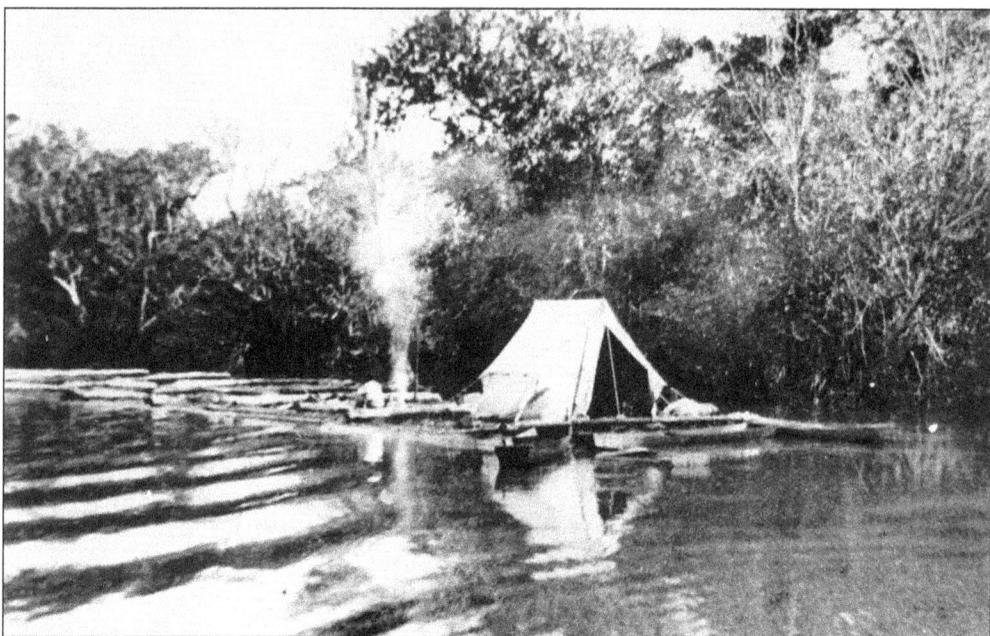

Steamboats weren't the only form of transportation used on the river during the late 1800s and early 1900s. This image, c. 1900 and believed to have been taken in the Omaha, Georgia, vicinity, shows a traveler who had set up a temporary camp on a raft of logs being floated down the river. (Courtesy of the Georgia Department of Natural Resources.)

Working on Chattahoochee River steamboats was hard and dangerous. Stevedores, often called roustabouts or deckhands, handled most freight carried on steamers. Their work at the docks or on steep banks loading and unloading heavy barrels or bales of cotton in all types of weather was challenging. It was life aboard the steamboats, though, where they were often quartered near boilers, that proved most hazardous statistically. (Courtesy of the Columbus Museum.)

30

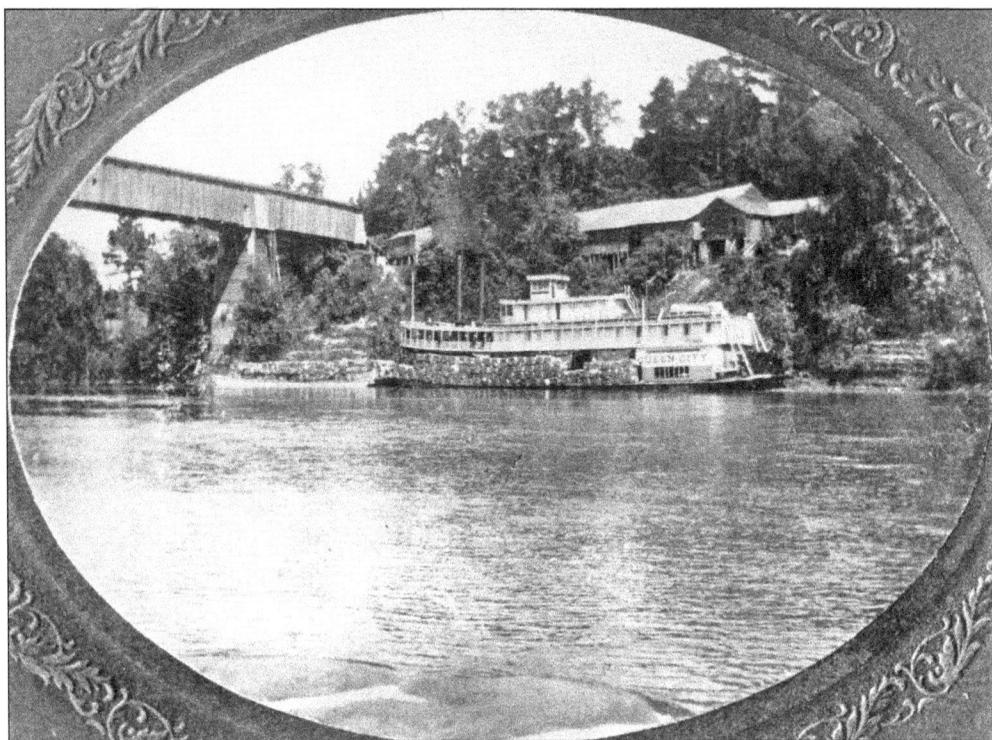

Laden with bales of cotton, the *Queen City* takes on cargo in this undated photograph. The east end of the Fort Gaines covered bridge is pictured along with the storage warehouse on the bluff and the tollhouse near the bridge entrance. (Courtesy of the James E. Coleman Collection.)

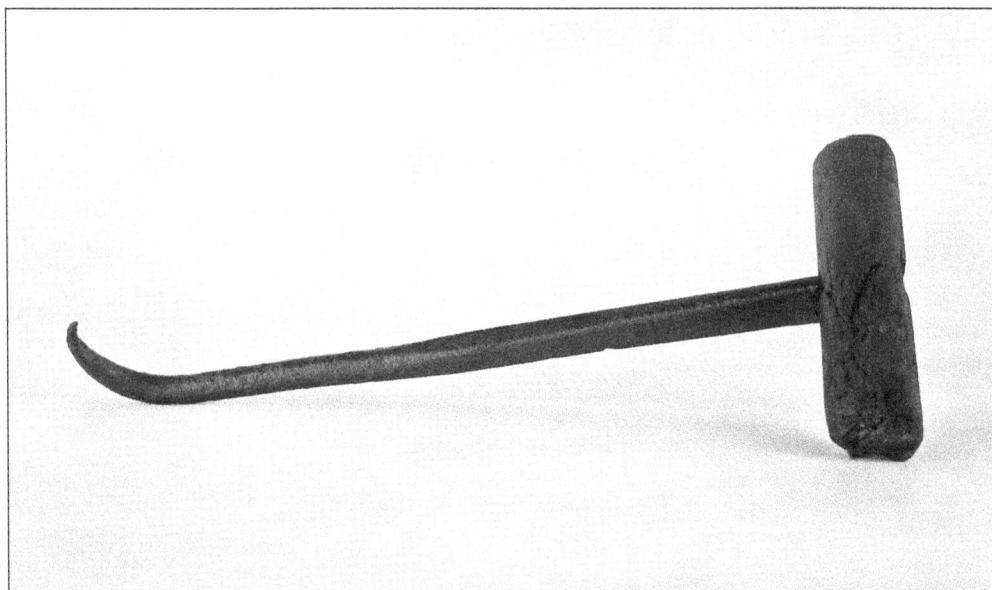

Stevedores used cotton hooks like this one, used aboard the *Queen City*, to load and stow heavy bales of cotton, commonly weighing about 400 pounds, onto steamboats. Cotton was the chief cargo of many Chattahoochee River steamers, most of which were designed to accommodate several hundred bales. (Courtesy of the Columbus Museum.)

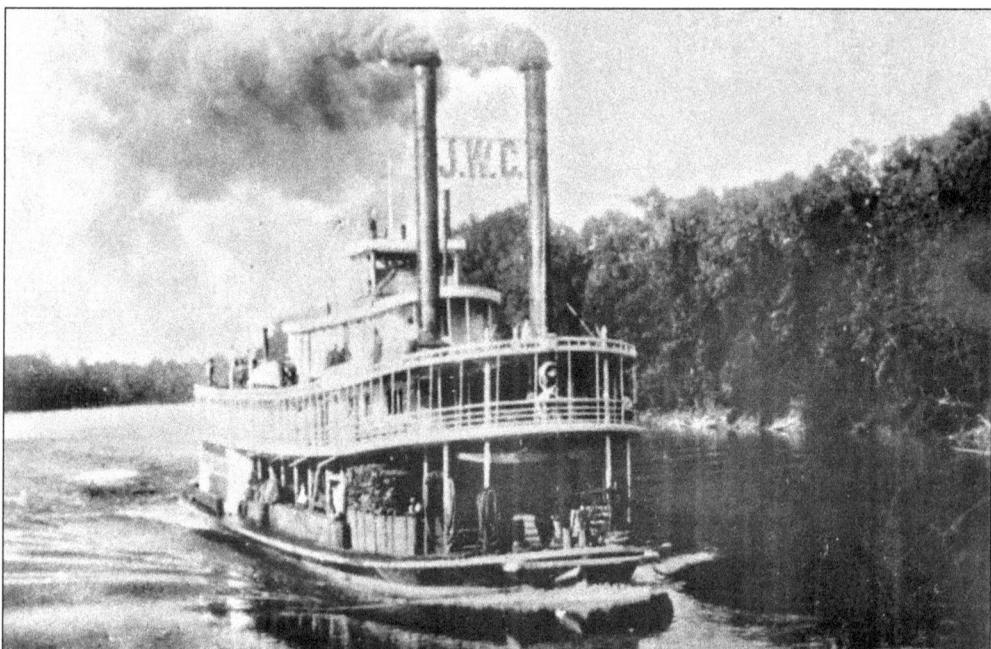

The *John W. Callahan* was one of the last steamboats to operate regularly on the Chattahoochee River. The boat was built in 1907 and sank in 1923, when it struck a snag near Wewahitchka, Florida. It was named after John W. Callahan of Bainbridge, the owner of the Callahan Line, which operated on the lower Chattahoochee and Apalachicola Rivers. (Courtesy of the Florida State Archives.)

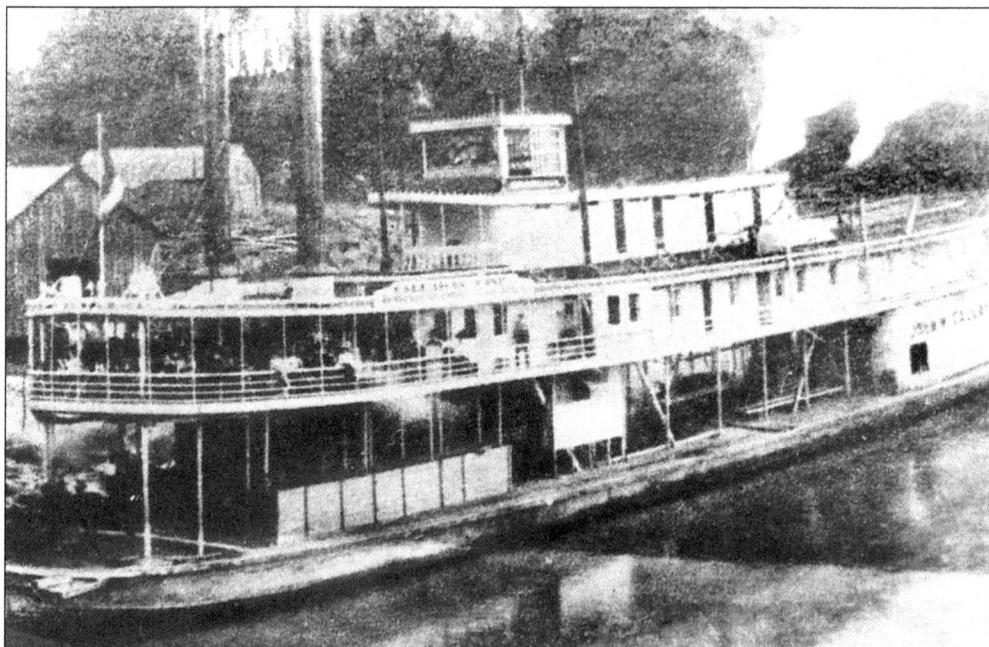

The steamboat *John W. Callahan*, pictured here at Columbia's Middle Landing, not only carried freight, but was also one of the most popular vessels on the Chattahoochee River for passengers to and from points north and points in between. (Courtesy of the L. H. Adams Collection.)

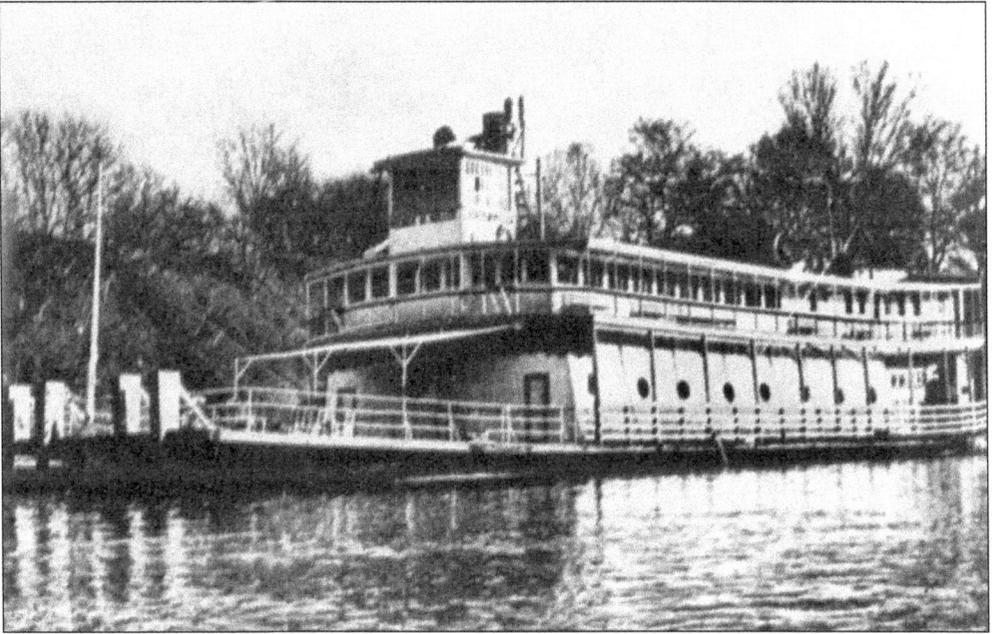

Originally used as a ferryboat on the Mississippi River, the *George W. Miller* was brought to the lower Chattahoochee in 1939 by Thurston Crawford to operate as an excursion boat. Initially, business was brisk for the 730-person-capacity steamer. After a relatively short period of service, though, the boat was dismantled and its hull recycled as a barge. (Courtesy of F. Clason Kyle.)

James W. Woodruff was the leading champion of navigation improvements on the lower Chattahoochee from the 1930s to the 1950s. A cofounder of the Tri-Rivers Waterway Development Association, he lobbied extensively for the construction of locks and dams on the river that would make it navigable as far north as Atlanta. Jim Woodruff Dam near Bainbridge is named in his honor. (Courtesy of the Columbus State University Archives.)

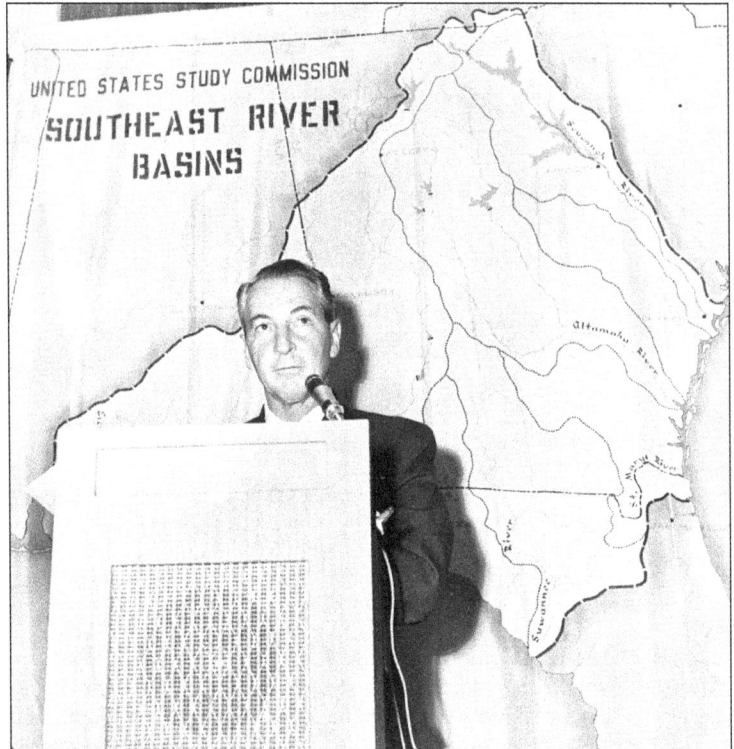

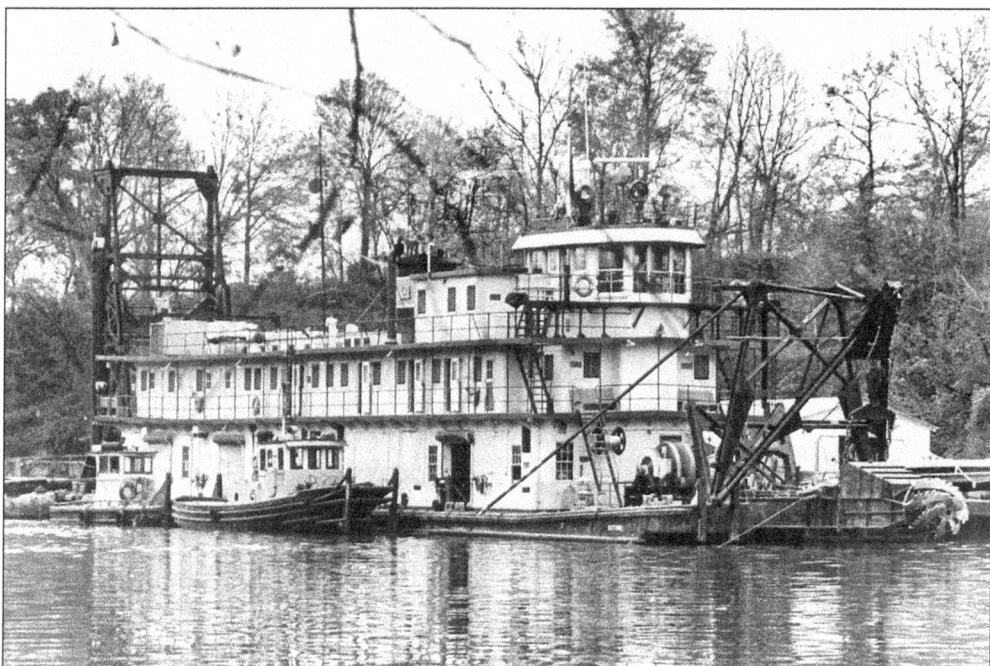

Though the technology that powered river travel changed significantly over 150 years, the dangers of navigation on the Chattahoochee have remained constant. Even the most advanced boats could be damaged or destroyed in an unfortunate encounter with a snag. One of the last boats charged with removing snags on the river, as well as one of the last steam-powered vessels to operate on the Chattahoochee, was the *Guthrie*. (Courtesy of the Columbus Museum.)

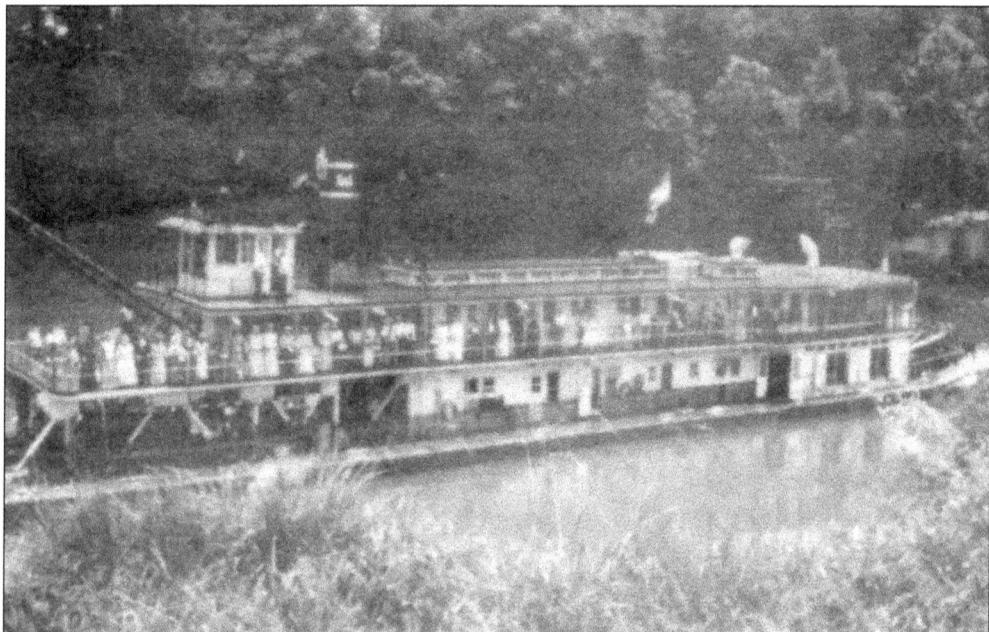

The U. S. Army Corps of Engineers snag boat *Montgomery* was the last steamboat to operate on the Chattahoochee River. Costumed members of the Henry County Historical Society are shown on the boat prior to an excursion in 1975. (Courtesy of the Henry County Historical Group.)

Three

BRIDGES

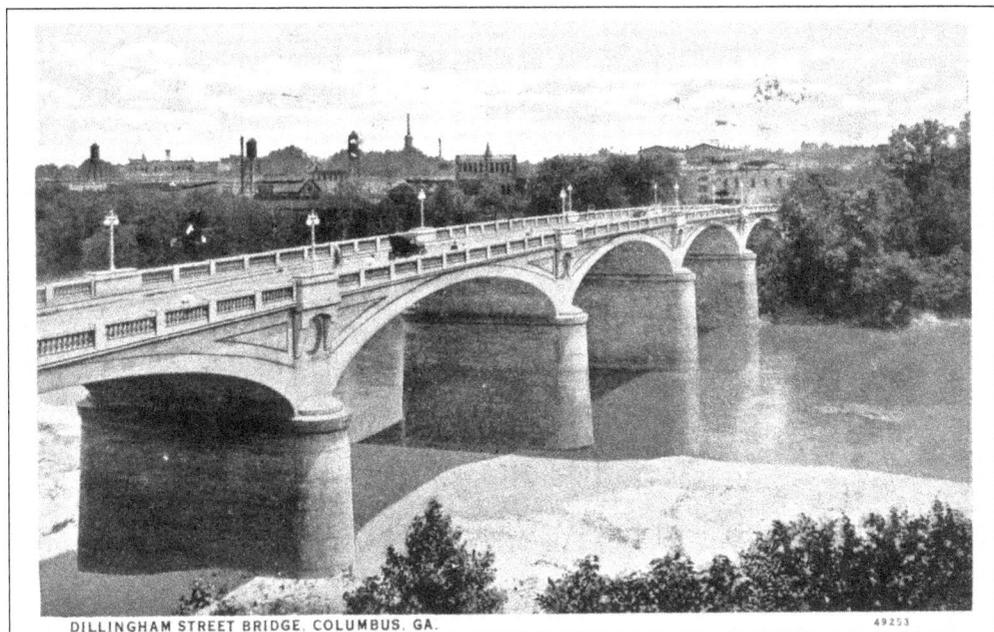

DILLINGHAM STREET BRIDGE, COLUMBUS, GA. 49253

This postcard shows the new Dillingham Street bridge in Columbus in the late 1920s. The structure had been built a few years earlier by the locally owned Hardaway Company. The bridge is still in use today. (Courtesy of the Columbus Museum.)

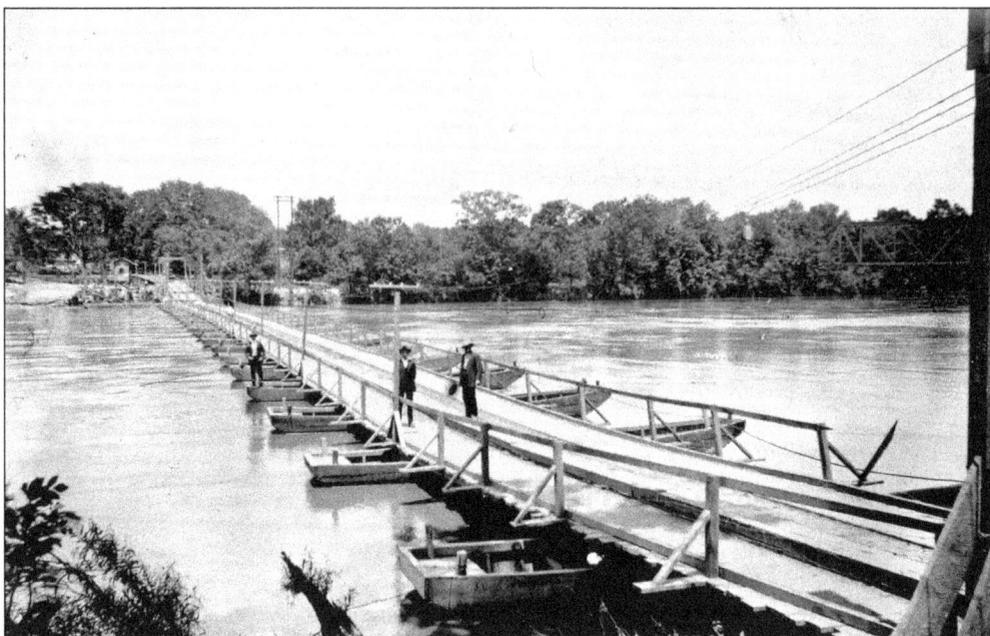

As a result of a bill introduced in Congress by Sen. W. J. Harris of Georgia, the federal government authorized the construction of a pontoon bridge over the Chattahoochee at West Point after the disastrous flood of 1919 destroyed the iron bridge. Ironically this pontoon bridge was heavily damaged by a tornado in March 1920. It was soon repaired, however, and continued to be used until a permanent bridge was constructed in 1921. (Courtesy of the Troup County Archives.)

The Eighth Street iron bridge in West Point was constructed by the Virginia Foundry and Ironworks of Roanoke, Virginia, in 1921 to replace an earlier bridge that had been destroyed in the flood of 1919. Known as the Eighth Street Bridge, it was used until the rerouting of U.S. Highway 29, when it was replaced with a more modern structure. (Courtesy of the Troup County Archives.)

This image shows some of the first stages of construction of the John C. Barrow Bridge over the Chattahoochee in West Point around 1976. The structure, which replaced an iron span that had been used since 1921, was needed after the rerouting of U.S. Highway 29. The bridge was completed in 1977. (Courtesy of the Troup County Archives.)

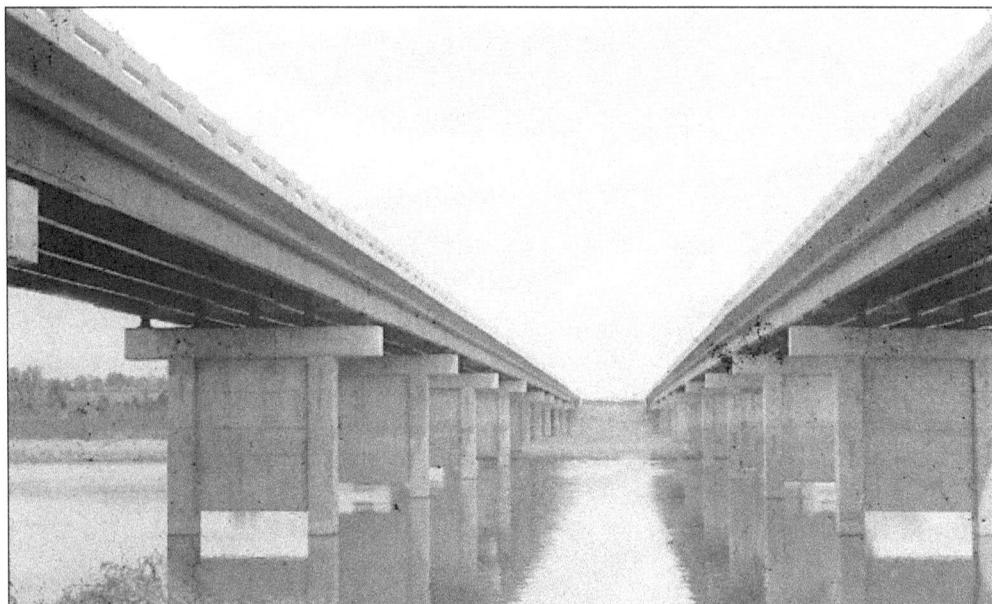

This image shows the Interstate 85 bridges over the Chattahoochee River near LaGrange shortly after their completion in the early 1960s. Few of the drivers of the thousands of automobiles that cross the river on these bridges every day likely realize how formidable an obstacle the river was to travel at the time the larger cities in the lower Chattahoochee Valley were founded. (Courtesy of the Troup County Archives.)

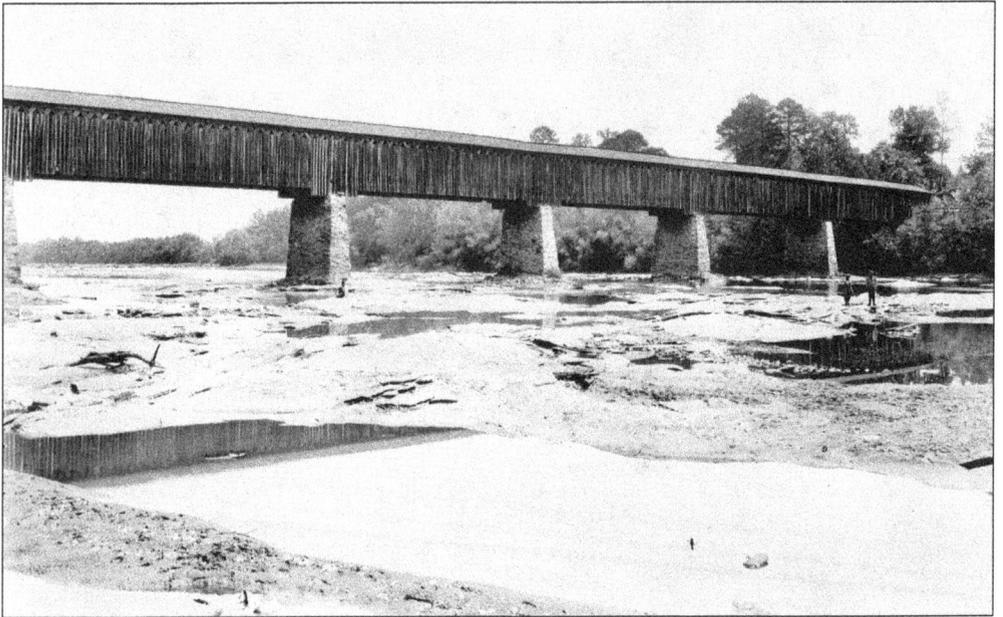

Named after a local family, the Glass Bridge near West Point, Georgia, was the last major wooden bridge across the Chattahoochee River. The bridge was completed in the 1890s by sons of former slave and master bridge-builder Horace King. The bridge was used until 1956. At the time it was destroyed to make way for a modern bridge, the structure was the longest covered bridge in Georgia. (Courtesy of the Troup County Archives.)

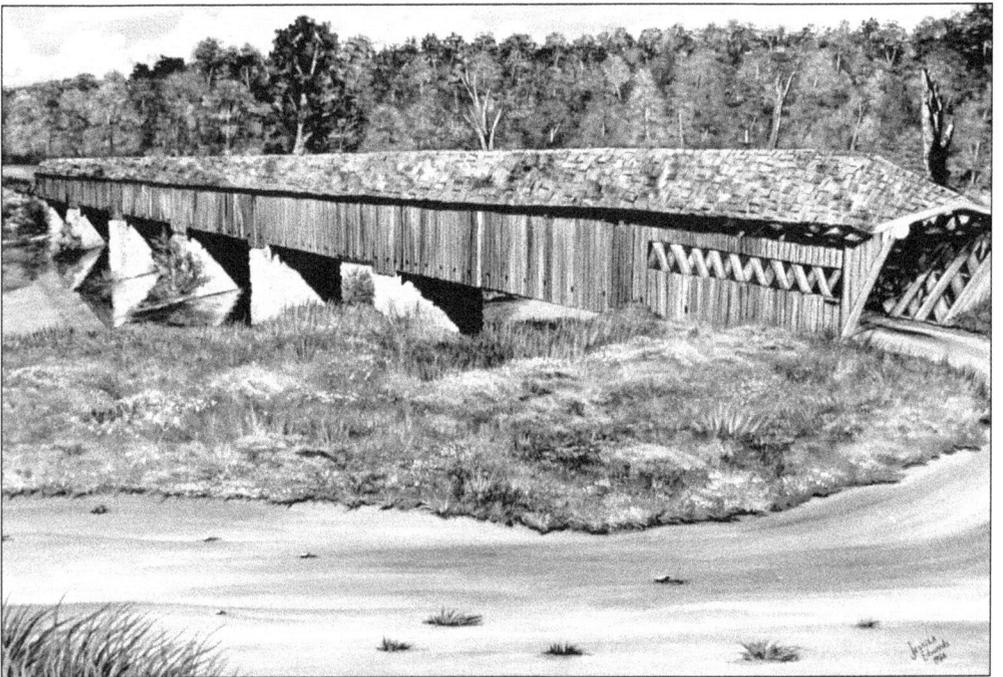

This painting by artist Jessica Edwards depicts the Glass Bridge in Troup County during the early 1900s. Originally built for horse-drawn traffic, the structure survived well into the era of motorized vehicles. It was replaced by a concrete span in 1956. (Courtesy of the Troup County Archives.)

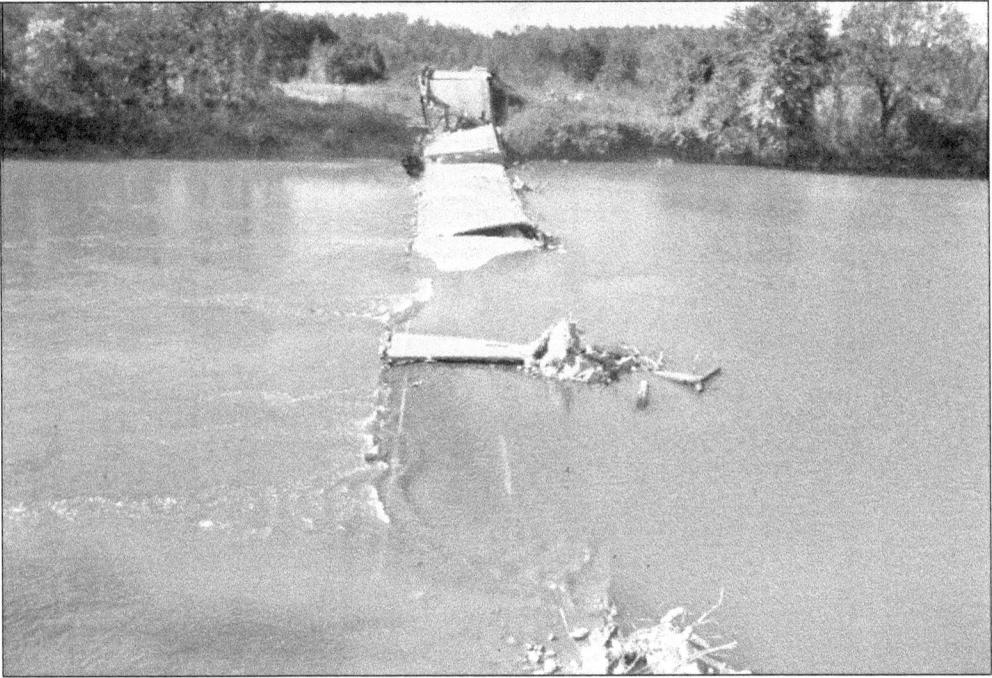

The concrete bridge that replaced the original Glass Bridge was destroyed in 1973 as part of the Corps of Engineers' plan for the reservoir created by damming the Chattahoochee at West Point. A U.S. Army team from Fort Benning used over 200 pounds of C-4 explosive to accomplish the job. Reportedly the largest demolition project the team had participated in since World War II, the event was filmed to help train military demolition crews. (Courtesy of the Troup County Archives.)

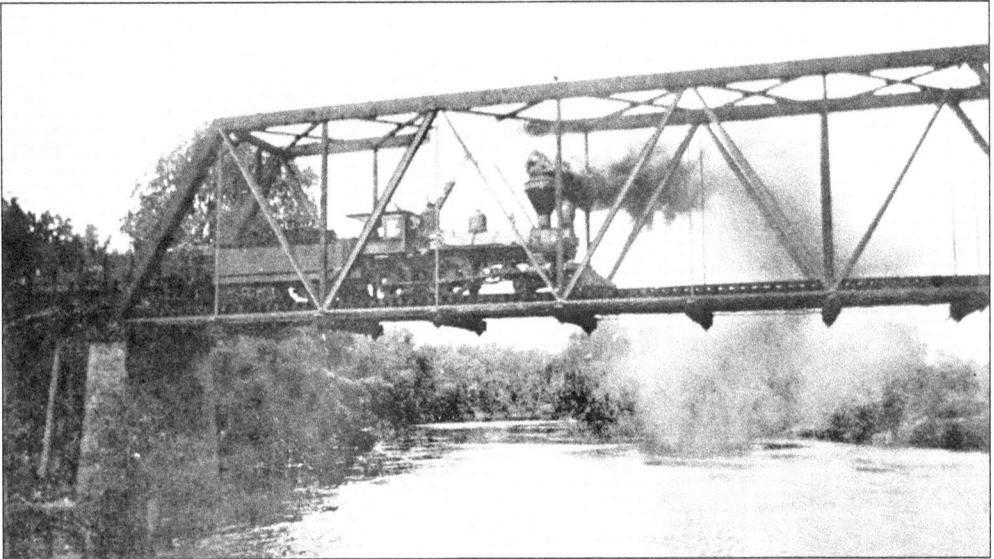

Railroads have given life to several towns throughout the Chattahoochee Valley. This image shows a train crossing a bridge over the river near Omaha, Georgia, around 1900. The town owes its existence to the Seaboard Airline Railroad's decision to run its line through the area. (Courtesy of the Georgia Department of Natural Resources.)

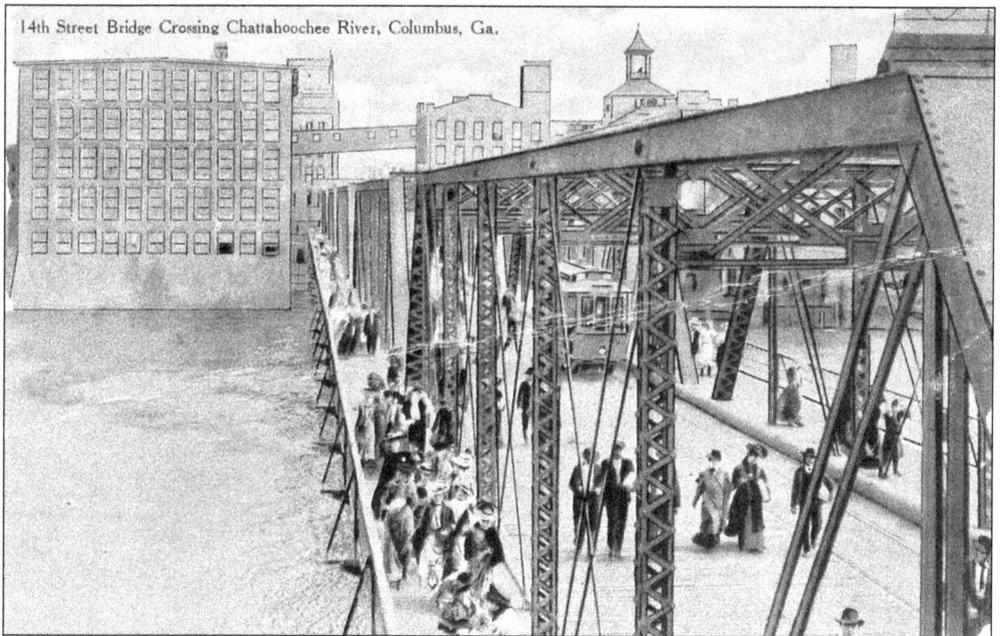

14th Street Bridge Crossing Chattahoochee River, Columbus, Ga.

This postcard depicts the Fourteenth Street Bridge, which connects Columbus, Georgia, and Phenix City, Alabama, around 1910. The original bridge at this location, built by former slave and master bridge-builder Horace King, was destroyed during a flood in 1902. (Courtesy of the Columbus Museum.)

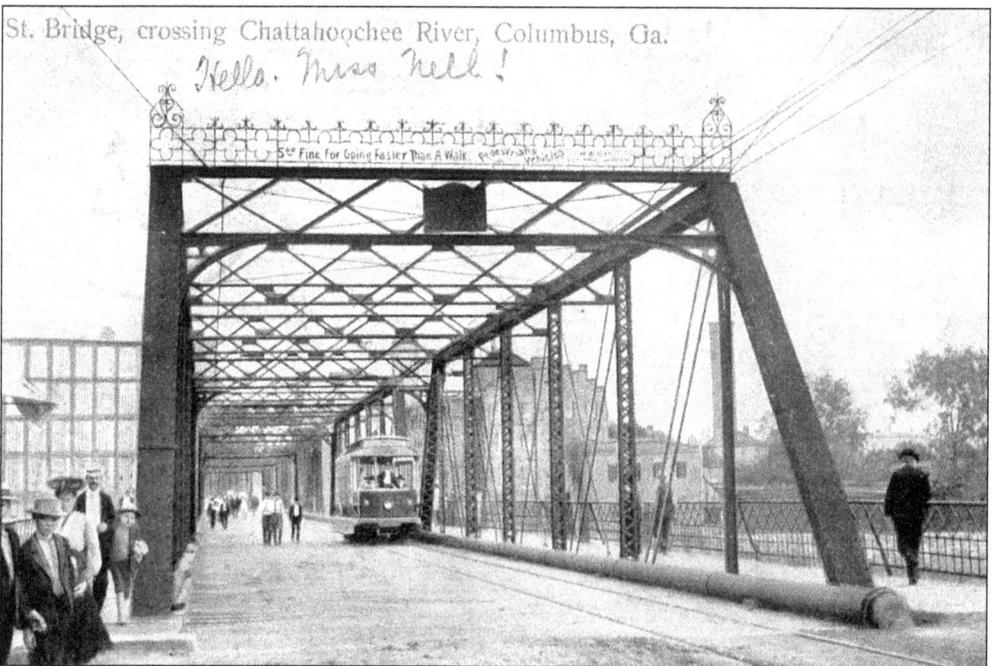

St. Bridge, crossing Chattahoochee River, Columbus, Ga.

This postcard shows another c. 1910 view of the Fourteenth Street Bridge. This bridge was replaced with another structure by the Hardaway Company in 1922. A major thoroughfare connecting Columbus and Phenix City for three quarters of a century, today it is open only to pedestrian traffic. (Courtesy of Dennis Jones.)

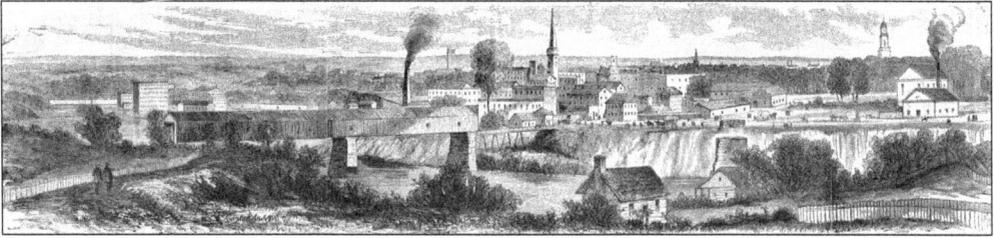

This engraving appeared in the September 10, 1868, issue of *Harper's Weekly*. The scene pictured, showing Columbus and the Dillingham Street bridge from the Alabama side of the Chattahoochee, belies the fact that nearly the entire waterfront industrial complex had been destroyed three years earlier during the Civil War. The speedy recovery of Columbus's river-powered industries was a vital part of the city's rapid recovery from the devastation of the war. (Courtesy of the Columbus Museum.)

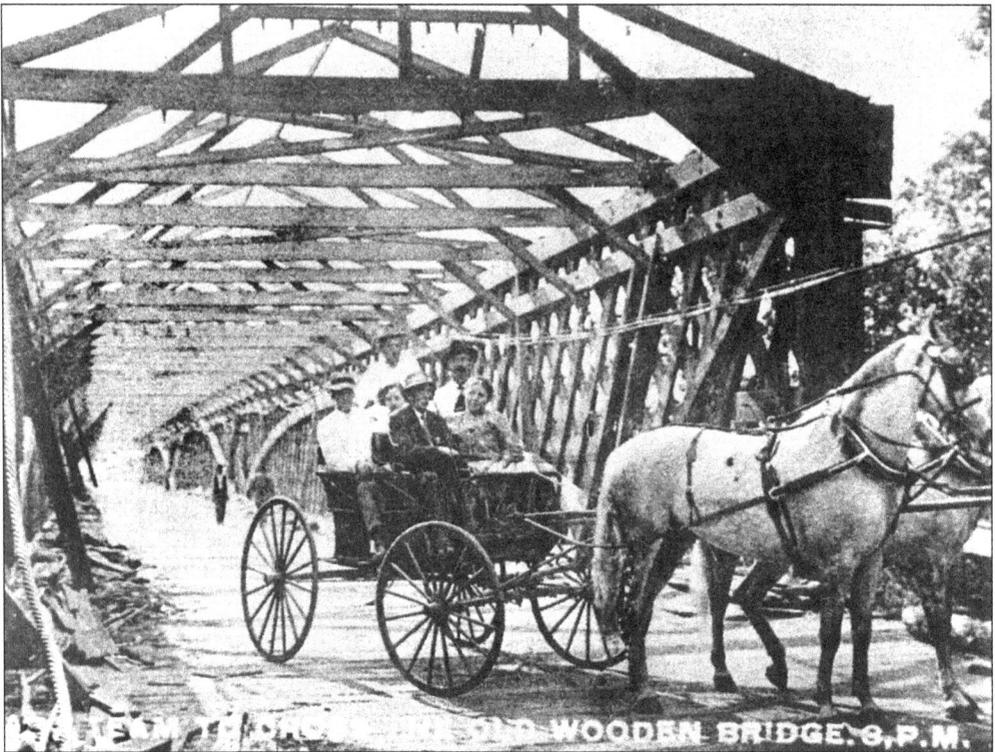

This image allegedly shows the last horse-and-carriage team to cross the wooden Dillingham Street bridge before it was replaced with a concrete structure. The image is significant because it graphically depicts the end of an era in the history of the Chattahoochee Valley. Covered bridges, horses and carriages, and even river-borne trade were quickly becoming things of the past at the time it was taken. (Courtesy of Jim Cannon.)

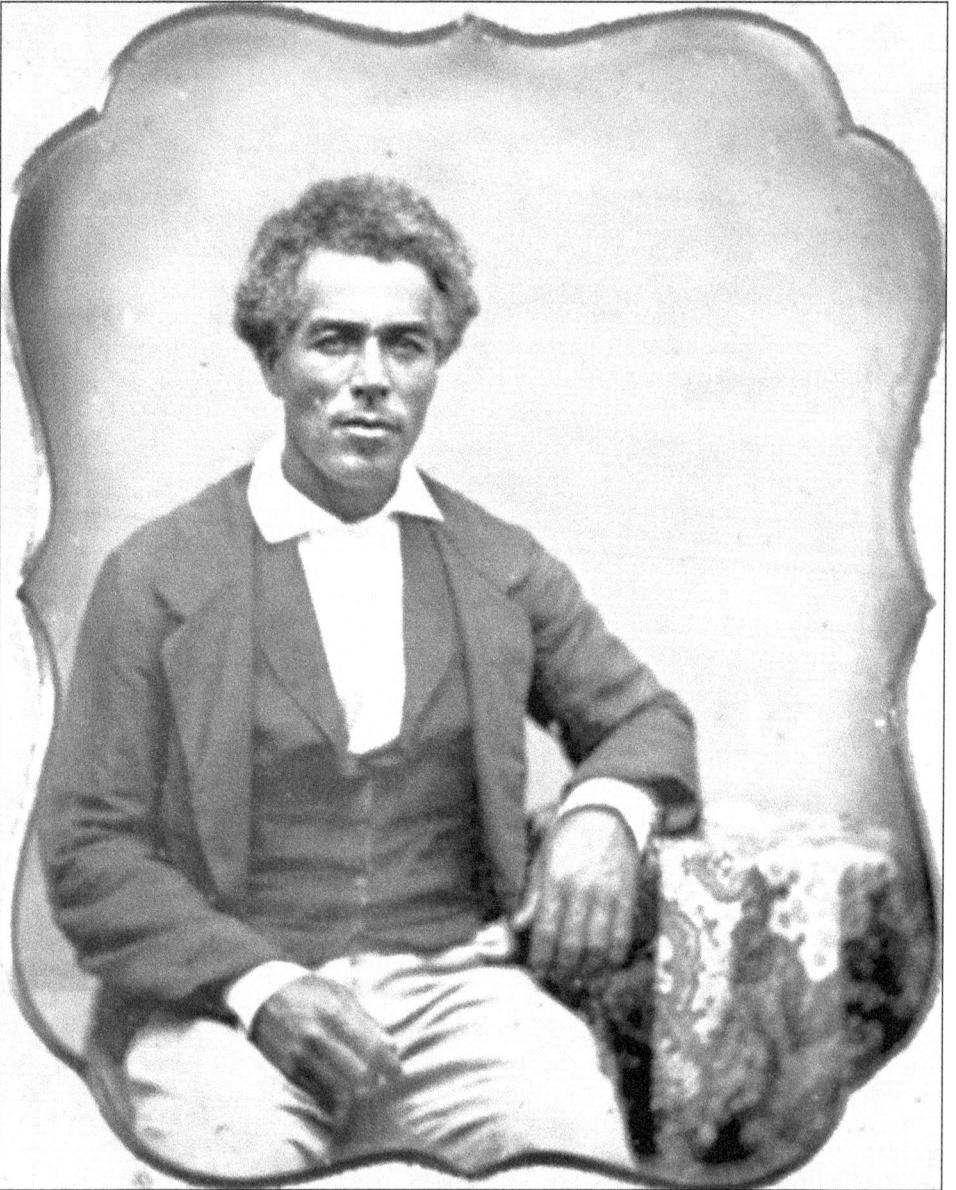

One of the individuals most closely associated with the history of the lower Chattahoochee Valley is legendary bridge-builder Horace King. A former slave who was freed in 1846, King became one of the most sought-after and respected craftsmen in the region despite having no formal professional training. He first came to the region with his owner to construct the first bridge over the Chattahoochee at Columbus in 1832. During the next 50 years, King became distinguished for his construction work in several areas of Georgia, Alabama, and Mississippi, as well as his two terms in the Alabama state legislature as a representative from Russell County. However, it is his work in constructing numerous sturdy bridges, mills, warehouses, and other structures in the lower Chattahoochee Valley for which he is most remembered. Through his sons, the King name remained prominent in a variety of construction efforts in the Chattahoochee Valley for decades after Horace King's death. Today a bridge connecting Columbus, Georgia, and Phenix City, Alabama, is named in his honor. (Courtesy of the Columbus Museum.)

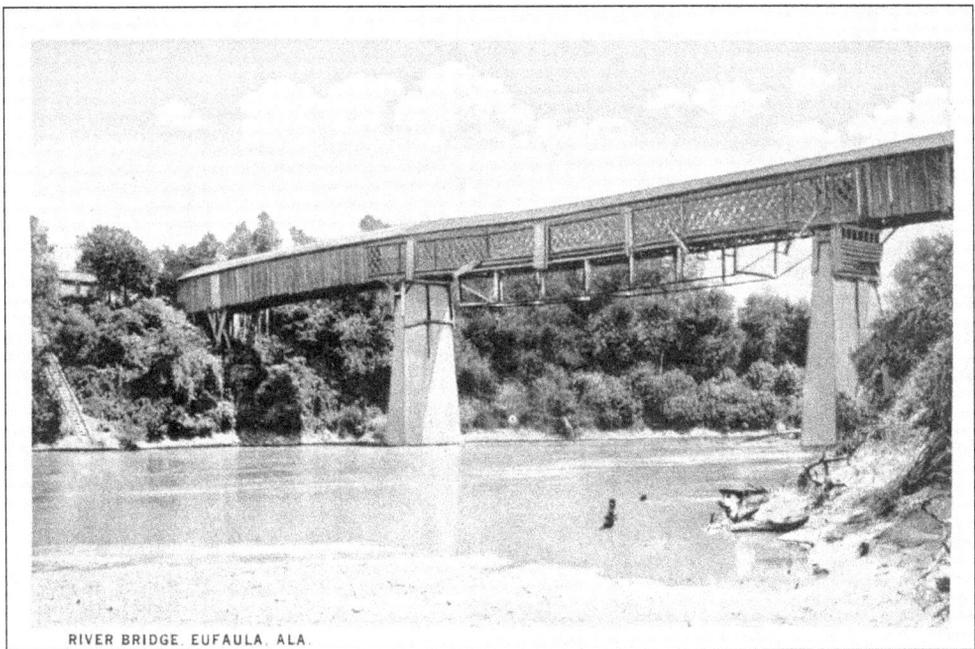

RIVER BRIDGE, EUFAULA, ALA.

Built in 1837 by a group of businessmen led by E. B. Young, this lattice-covered bridge linked Eufaula with Georgia. The bridge's designer was former slave Horace King. It survived many floods only to be eventually swept away by floodwaters. King salvaged the fallen bridge, and with the townspeople's help, it was rebuilt on the remaining piers. (Courtesy of Rob Schaffeld.)

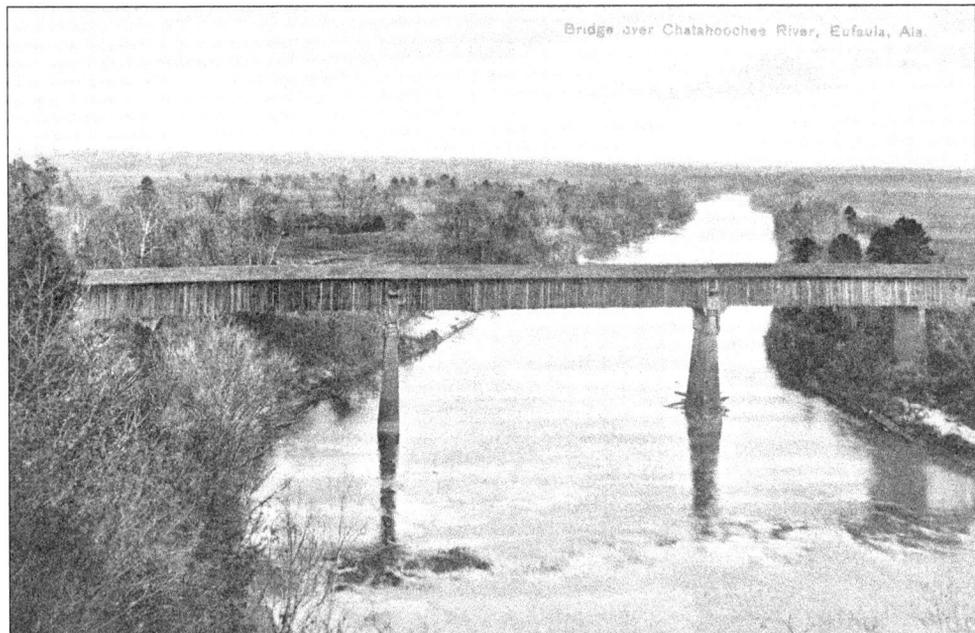

Bridge over Chatahoochee River, Eufaula, Ala.

After the original bridge was destroyed by floodwaters, Edward Young and the citizens gathered the salvaged material to rebuild the bridge. The second covered bridge was built using those materials and the original piers and approaches. (Courtesy of Rob Schaffeld.)

43

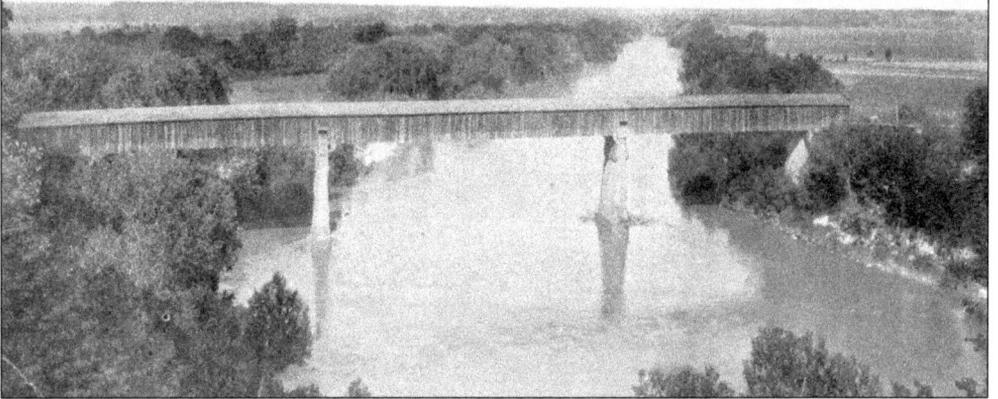

View from Bluff at Eufaula, Alabama, showing Chattahoochee River.

One of the most scenic sites in the area overlooks the covered bridge crossing the Chattahoochee River from Eufaula to Georgetown, Georgia. Steamboats traveling up- or downriver would often have to lower their stacks to go under the bridge. (Courtesy of Rob Schaffeld.)

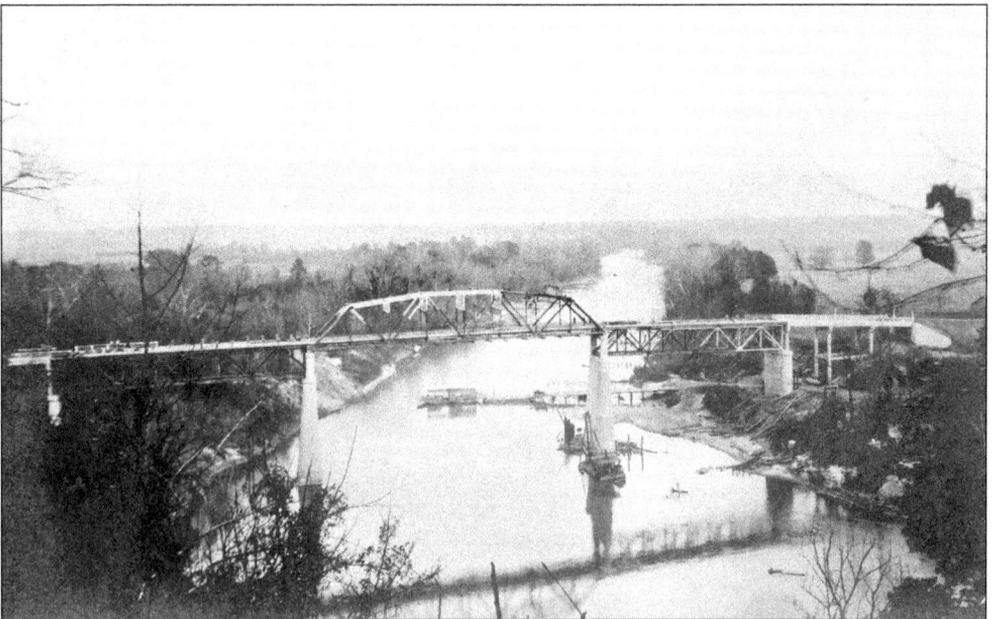

The McDowell Bridge was built to replace the covered bridge at the site, which had become unsafe by the early 1900s. This image shows the bridge under construction around 1925. (Courtesy of Rob Schaffeld.)

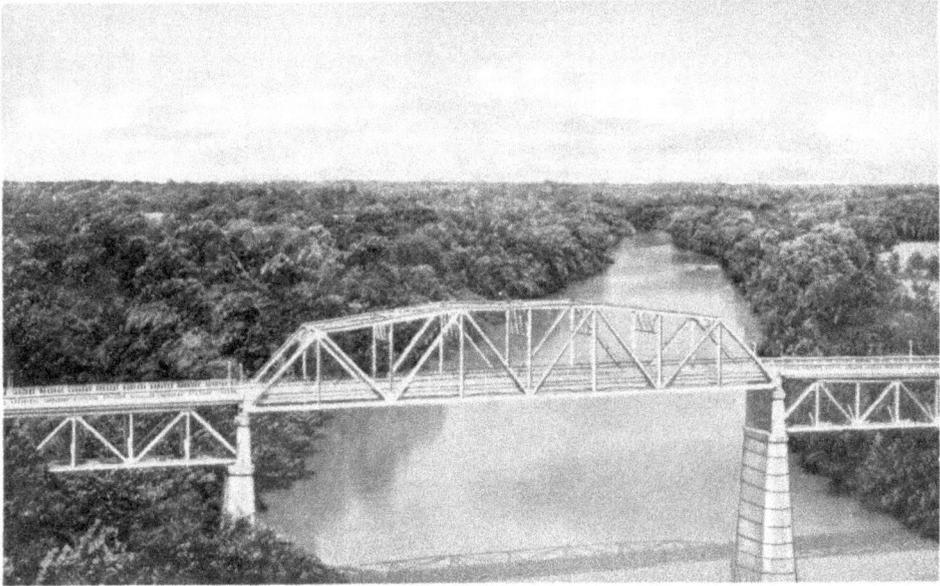

McDowell Bridge, Chattahoochee River, Eufaula, Alabama

The cantilever bridge was completed in December 1925 at a cost of $125,000. Charles S. McDowell, mayor of Eufaula, had the idea of a new steel-and-concrete bridge. After being elected to the Alabama Senate, he lobbied for its construction. (Courtesy of Rob Schaffeld.)

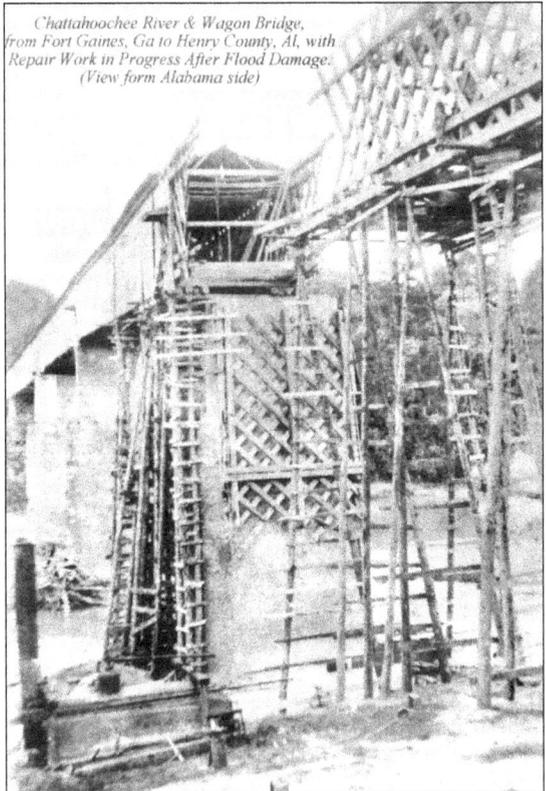

Chattahoochee River & Wagon Bridge, from Fort Gaines, Ga to Henry County, Al, with Repair Work in Progress After Flood Damage. (View form Alabama side)

Connecting Fort Gaines, Georgia, and Henry County, Alabama, this bridge was undergoing repair due to flood damage when this image was taken prior to 1925. The view is from the Alabama side of the bridge. (Courtesy of the Henry County Historical Group.)

45

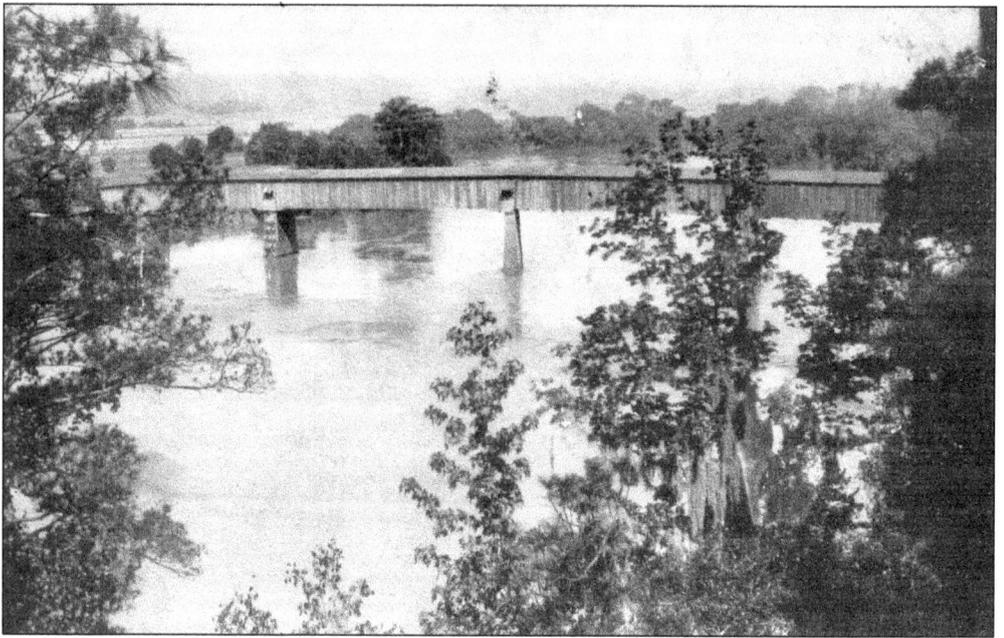

This 1905 view shows the covered bridge connecting Fort Gaines on the right with the Franklin, Alabama, flats on the left. The old Henry County town of Franklin often flooded, and the settlers who lived there abandoned the community to move to higher ground. (Courtesy of the Henry County Historical Group.)

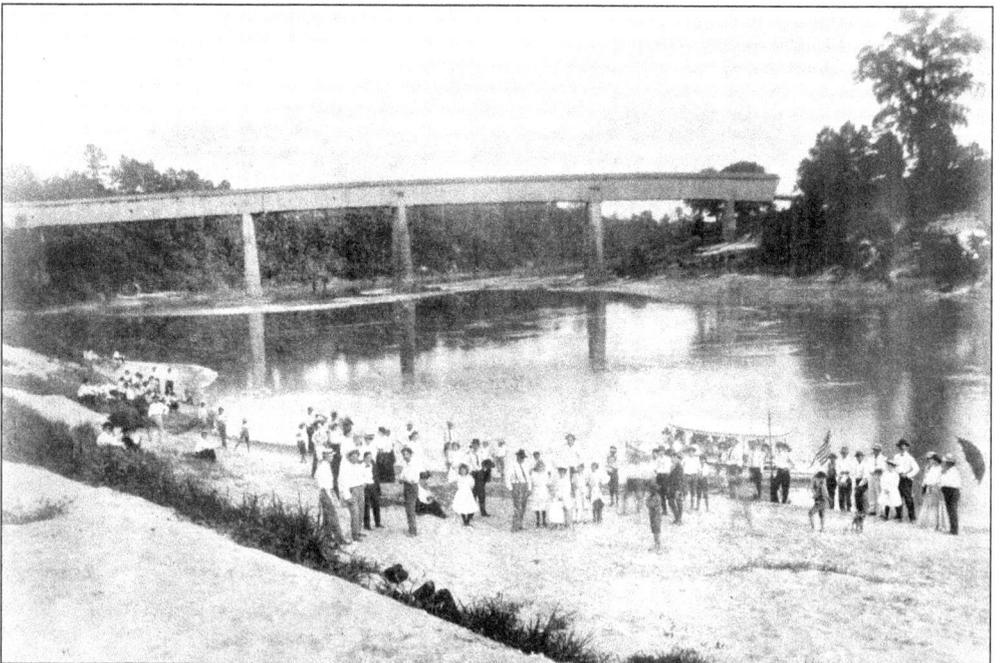

This image of the Fort Gaines covered bridge was taken in August 1908 and depicts over 75 people of varying ages enjoying an outing on the shore of the Chattahoochee River. Note the small excursion boat *Elizabeth* on the edge of the river. (Courtesy of the James E. Coleman Collection.)

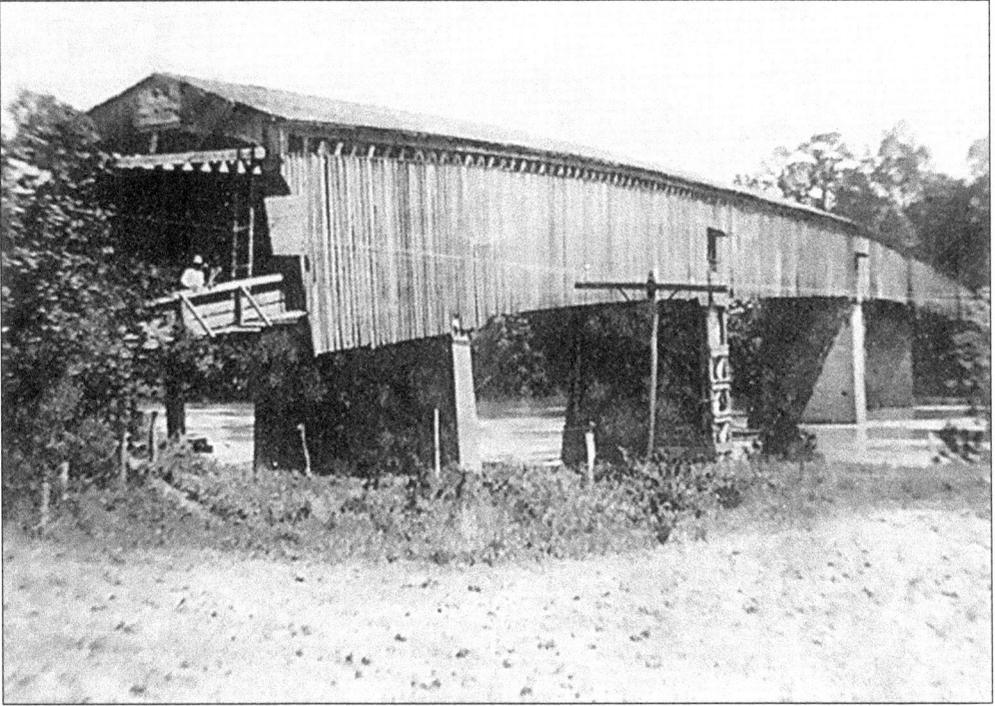

Several individuals are seen enjoying the view from the entrance to the Fort Gaines covered bridge. (Courtesy of the James E. Coleman Collection.)

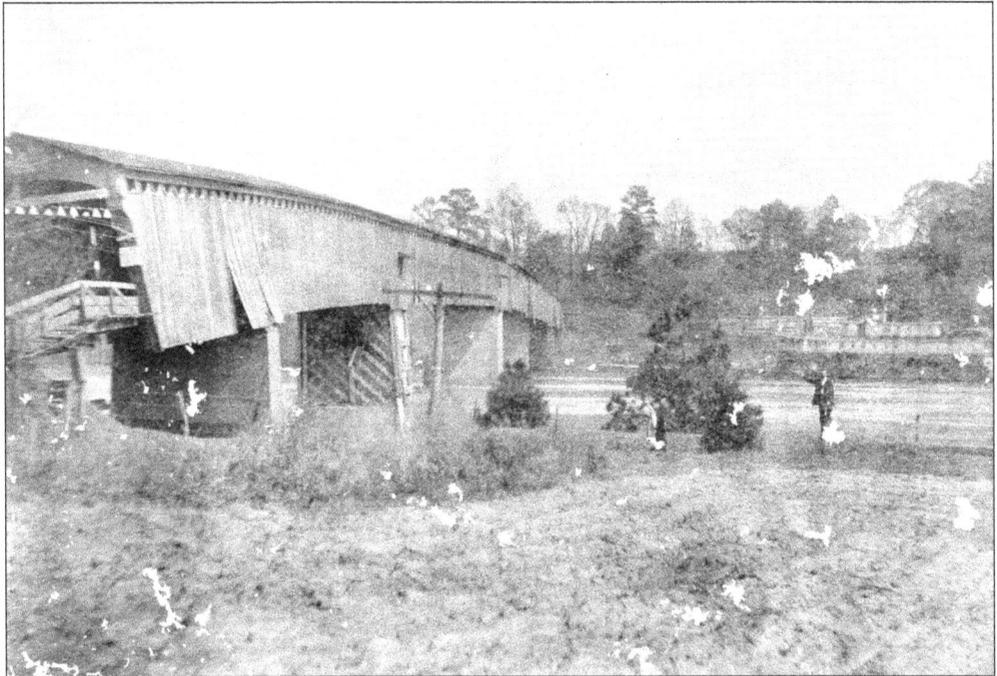

This image was taken on March 21, 1913, a few days before a portion of the bridge collapsed as a result of heavy floodwaters on the Chattahoochee River. (Courtesy of the James E. Coleman Collection.)

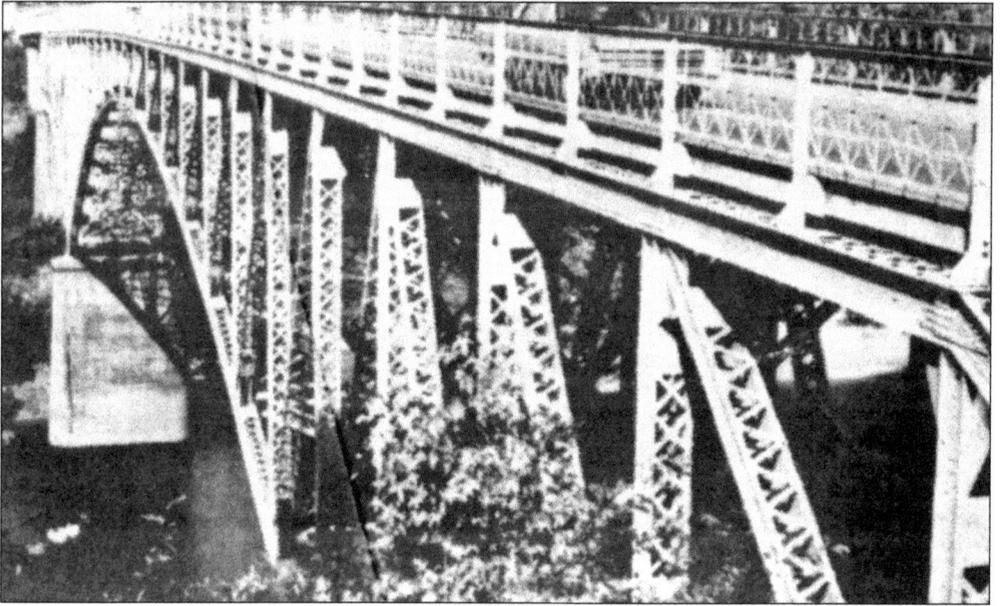

Completed in 1925, this iron bridge connecting Fort Gaines, Georgia, with Henry County, Alabama, provided passenger and commercial vehicles a safe and convenient passage across the Chattahoochee River. (Courtesy of the Henry County Historical Group.)

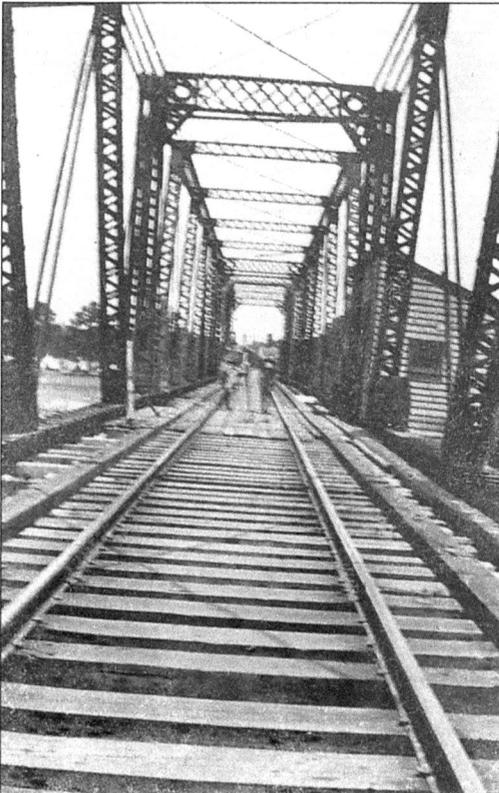

This railroad bridge on the Chattahoochee River links Georgia and Alabama at Columbia, Alabama. The drawbridge was constructed to allow steamboats to pass without having to lower their stacks in high water. (Courtesy of the L. H. Adams Collection.)

In 1918, Joe Parrish served as foreman and bridge tender for this span across the Chattahoochee River at Alaga, Alabama. Steamboats unloaded their freight into the warehouses to the left and train crews transferred the goods onto railcars. (Courtesy of the Tom Solomon Collection, Dothan Landmarks Foundation, Inc.)

The Chattahoochee Industrial Railroad, a short line in Early County, Georgia, crosses a picturesque creek just east of the Chattahoochee River. (Courtesy of Reid Smith.)

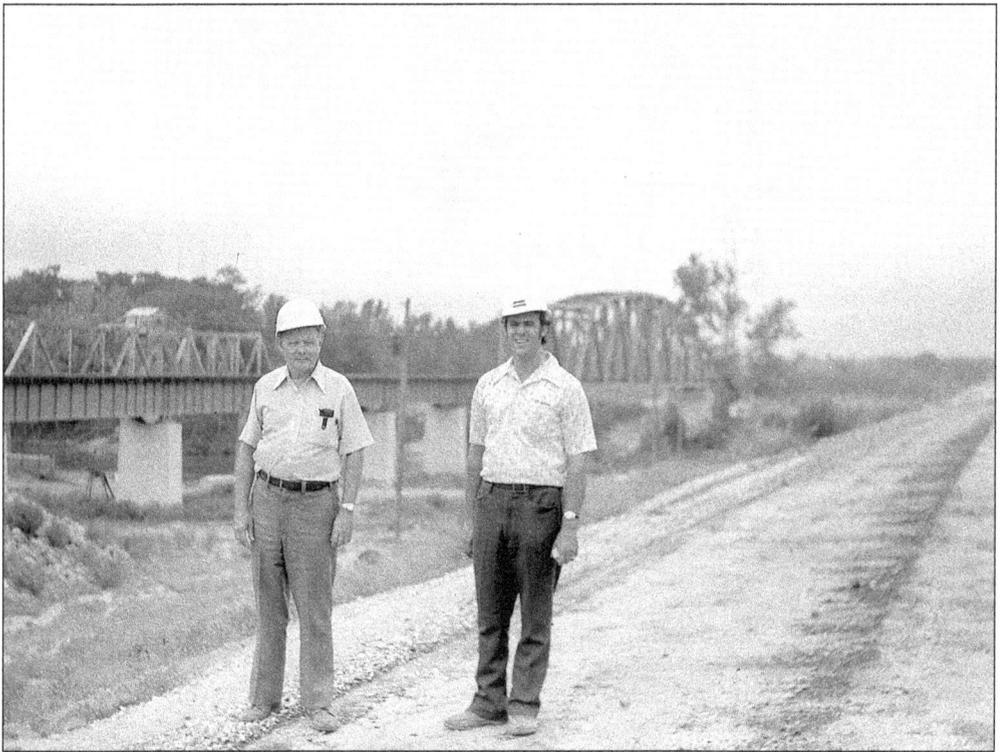

Two engineers stand on the roadbed that is the current approach to the U.S. Highway 84 bridge as it crosses the Chattahoochee River between Houston County, Alabama, and Early County, Georgia. (Courtesy of the Dothan Landmarks Foundation.)

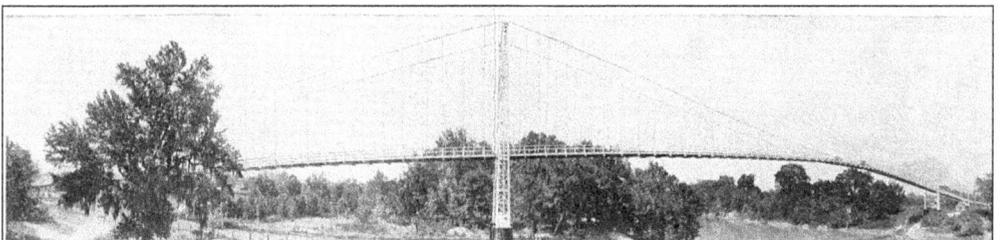

This magnificent suspension bridge recently completed over the Chattahoochee River is considered one of the finest bridge structures in the South. *The main span is 600 ft. and is 80 ft. above low water. There are two 300 ft. spans and 760 ft. of trestle making a total length of 1960 ft.* The opening of this bridge provides a convenient way for travel from points North to all coast points. It crosses the river 8 miles from Donalsonville, Ga. and is only 20 miles from Marianna, Fla. where you strike the old Spanish Trail.

Opened in August 1927, this suspension bridge was operated as a toll bridge across the Chattahoochee River eight miles southwest of Donalsonville, Georgia, linking Georgia and Florida. The 600-foot main span was situated 80 feet above low water. The bridge was 1,900 feet in length and was constructed and owned by the Austin Brothers Bridge Company of Austin, Texas. It remained in use until January 1953, at which time it was declared unsafe by the Georgia Highway Department. Tolls were collected until the bridge was purchased by the State of Georgia in 1938. (Courtesy of John Hines and the Donalsonville–Seminole County Chamber of Commerce.)

Four

RECREATION

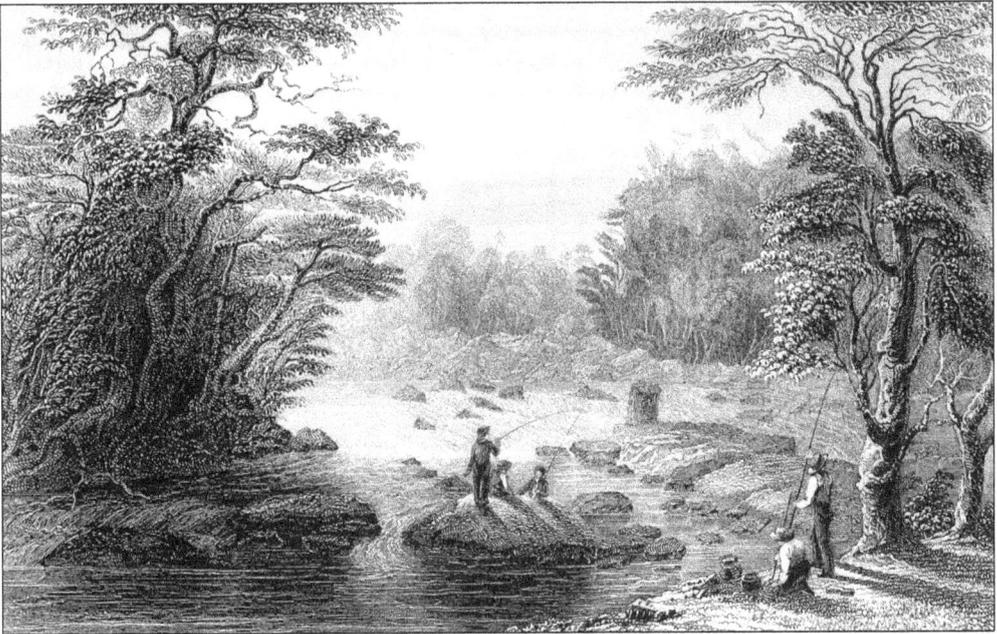

This 1840s image from T. Addison Richards's *Georgia Illustrated* shows fishermen at a spot on the river near Columbus known as Lover's Leap. The name of the location has its origins in the legend of a Native American couple from rival tribes who allegedly leaped in the river to escape attackers who were angered by their relationship. (Courtesy of the Hargrett Rare Book and Manuscript Library, University of Georgia Libraries.)

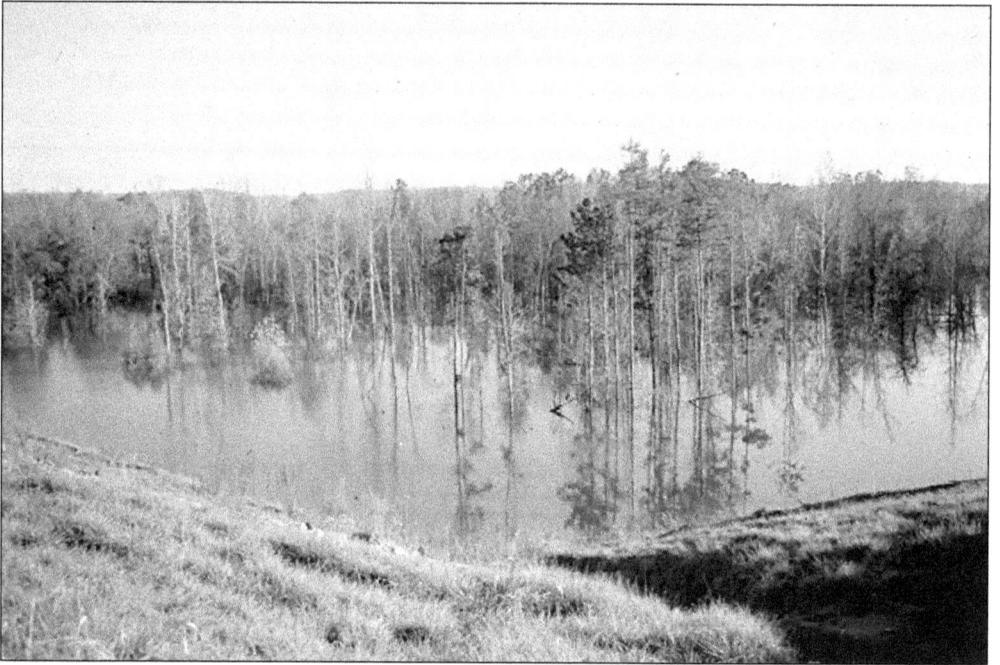

Construction of West Point Lake began in 1966 and was completed in 1975. To form the lake, thousands of acres of Georgia land were inundated by the construction of West Point Dam. This photograph, *c.* 1970, shows land near West Point being flooded as the river's level began to rise. (Courtesy of the Troup County Archives.)

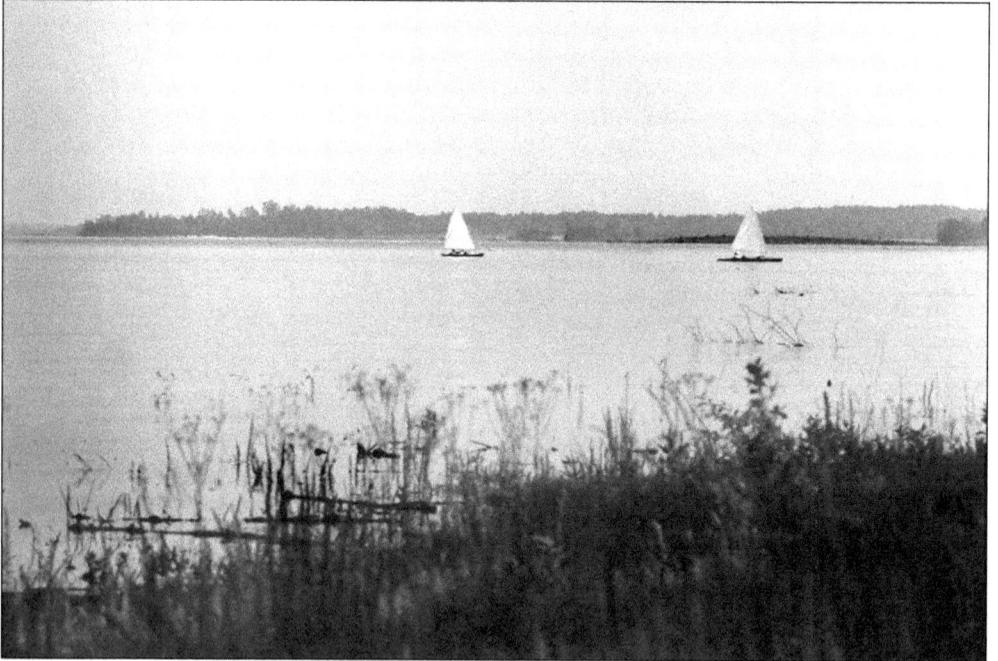

West Point Lake is one of the largest tourist attractions in the lower Chattahoochee Valley. This image shows sailboats on the lake shortly after its completion in the 1970s. (Courtesy of the Troup County Archives.)

West Point Lake is a 26,000-acre reservoir with a shoreline of over 500 miles. Encompassing a large section of the river valley north of West Point, the lake backs up the river all the way to Franklin, over 25 miles upriver. A popular spot for boating and fishing for local residents, the lake is also one of the region's main tourist attractions. (Courtesy of the Troup County Archives.)

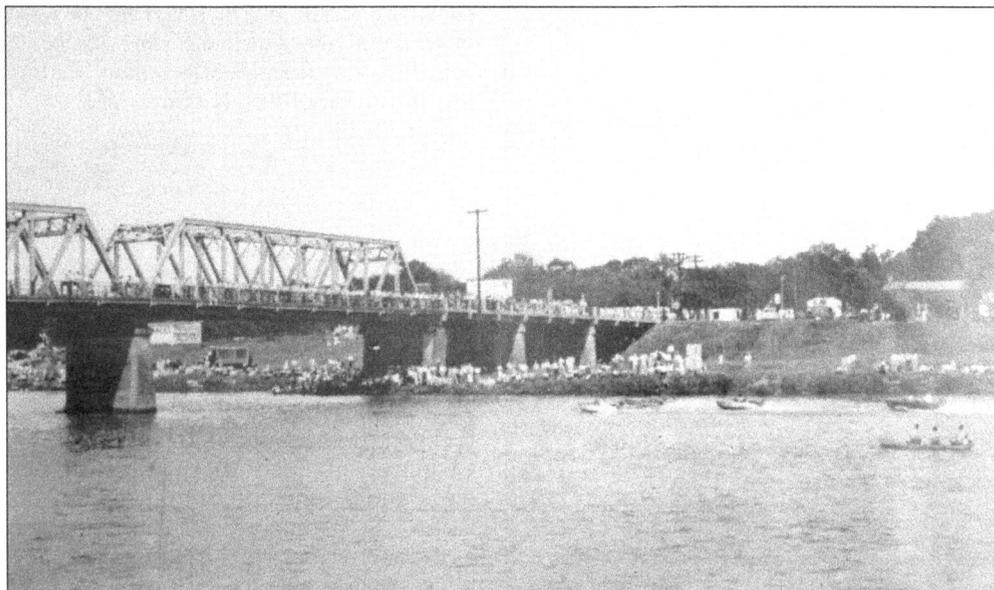

Festivals and other annual events have been popular recreational activities on the river for generations. In this image, spectators in West Point watch boat races during the 1950 Cotton Festival. (Courtesy Wayne Clark and Cobb Memorial Archives.)

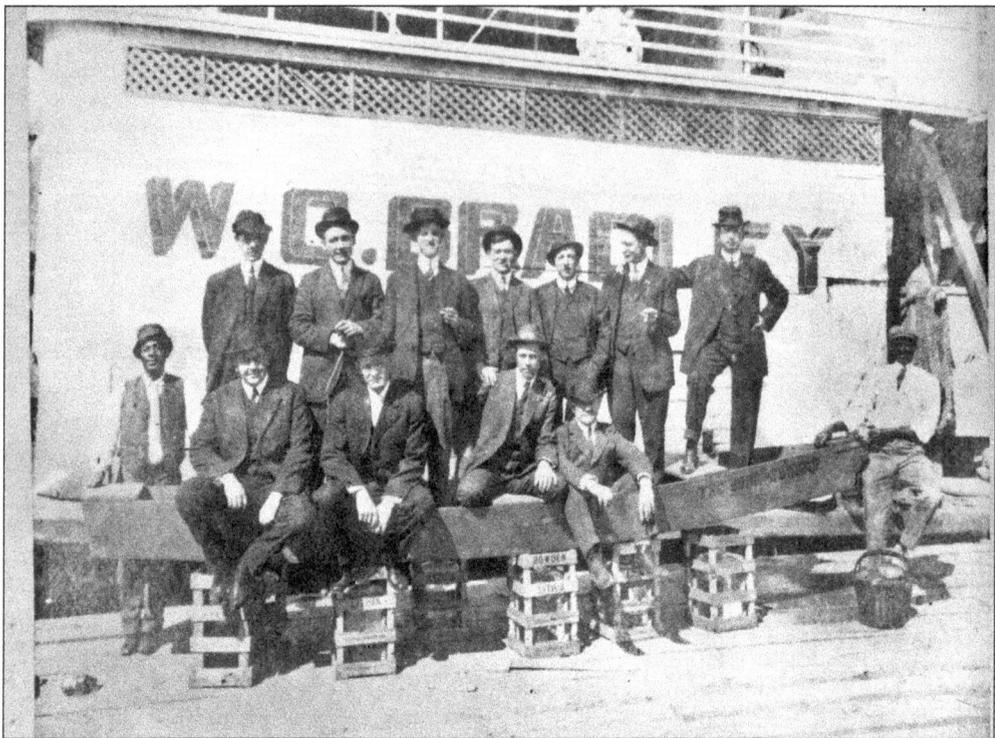

The Thronateeska Fishing Club was organized in 1913 by a group of leading Columbus businessmen as a fraternal and recreational organization. The group's clubhouse was in Iola, Florida, near the town of Wewahitchka. The name *Thronateeska* actually comes from the Creek name for the nearby Flint River. (Courtesy of F. Clason Kyle.)

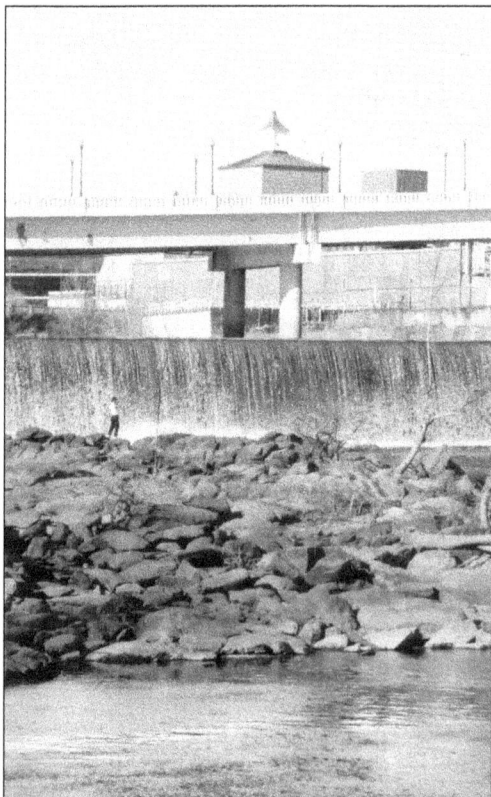

This image captures both the progress and tradition that are integral to the lower Chattahoochee River Valley. As they have for centuries, fishermen cast lines into the river at downtown Columbus. The background showcases the most recent bridge over the Chattahoochee in the Columbus area, the Thirteenth Street Bridge, and the former Muscogee Mill complex. (Courtesy of Susan Waldrop.)

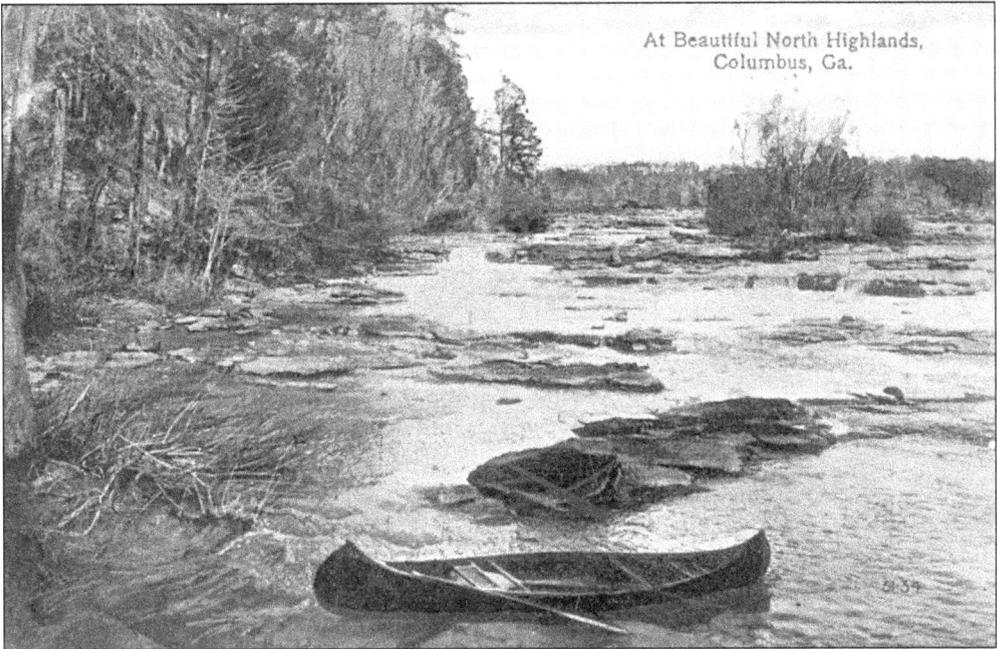

At Beautiful North Highlands,
Columbus, Ga.

The small boat in this scene alludes to the popularity of recreational activities along the river in the early 1900s. A scenic stretch of the river immediately north of downtown Columbus, the North Highlands area has been a favorite spot for leisure activities for generations of Chattahoochee Valley citizens. (Courtesy of Dennis Jones.)

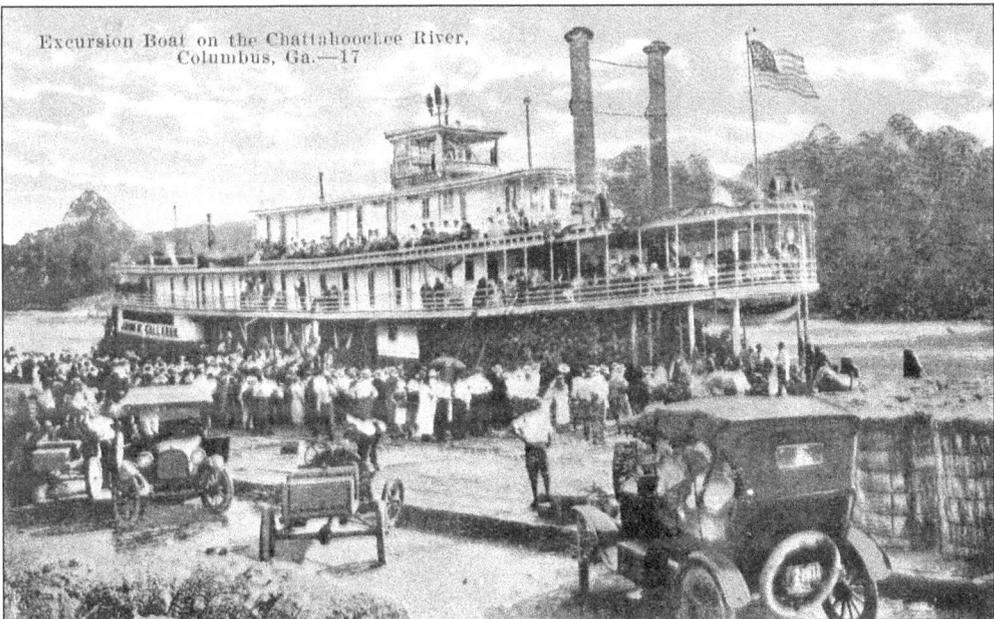

Excursion Boat on the Chattahoochee River,
Columbus, Ga.—17

This c. 1920 image shows the *John W. Callahan* in Columbus as it loads passengers for an excursion down the river. Though a popular activity throughout the lower Chattahoochee Valley during the steamboat era, trips such as the one these passengers are about to make soon became rare events. One of the last steamers to operate regularly on the river, the *Callahan* sank in 1923. (Courtesy of Dennis Jones.)

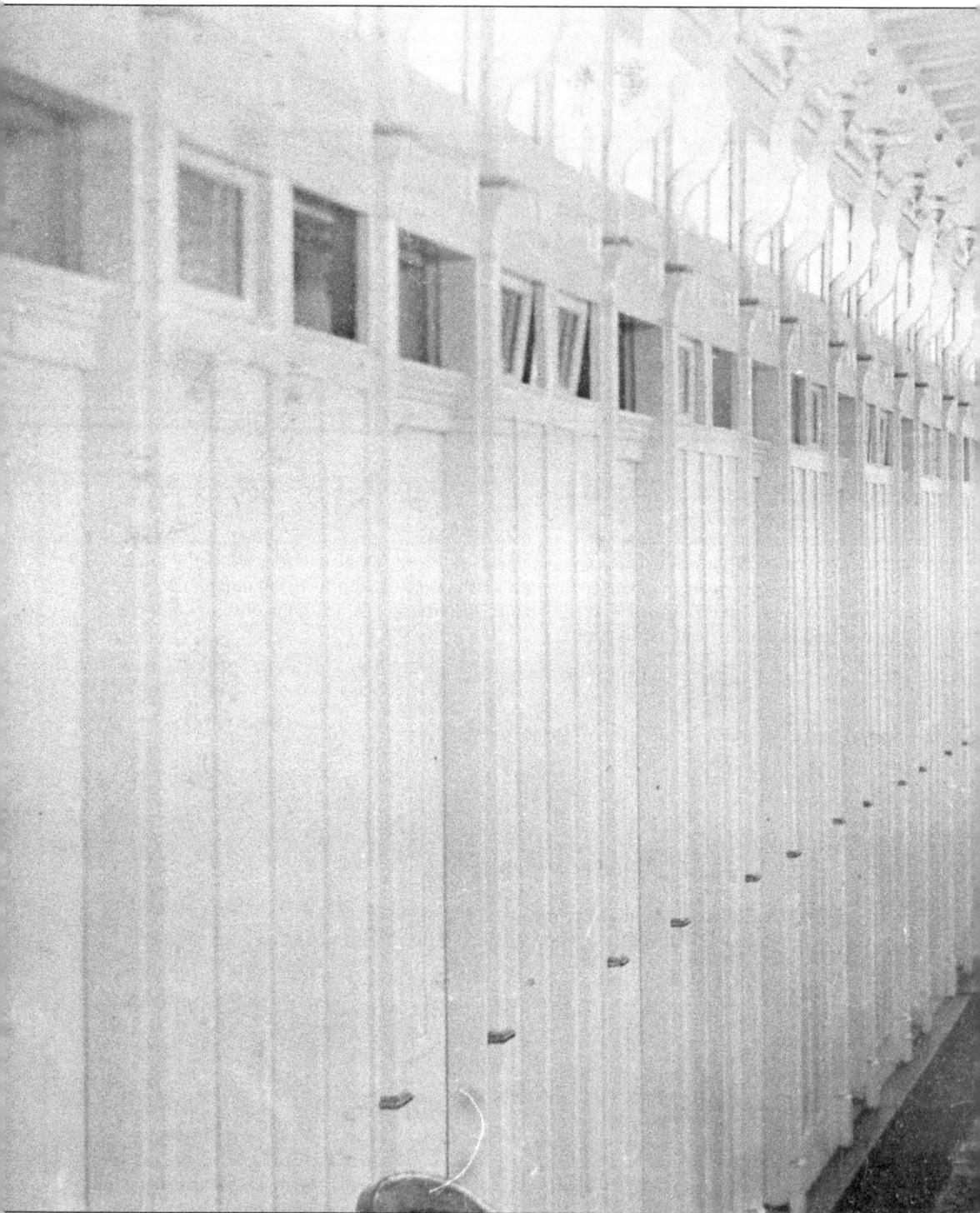

As one of the largest steamers on the Chattahoochee at the height of the era of steamboat travel, the *Pactolus* caused quite a stir when it first visited Columbus. Reportedly over 100 people stepped aboard to inspect the boat when it arrived at the city wharf at 8:00 p.m. on October 5,

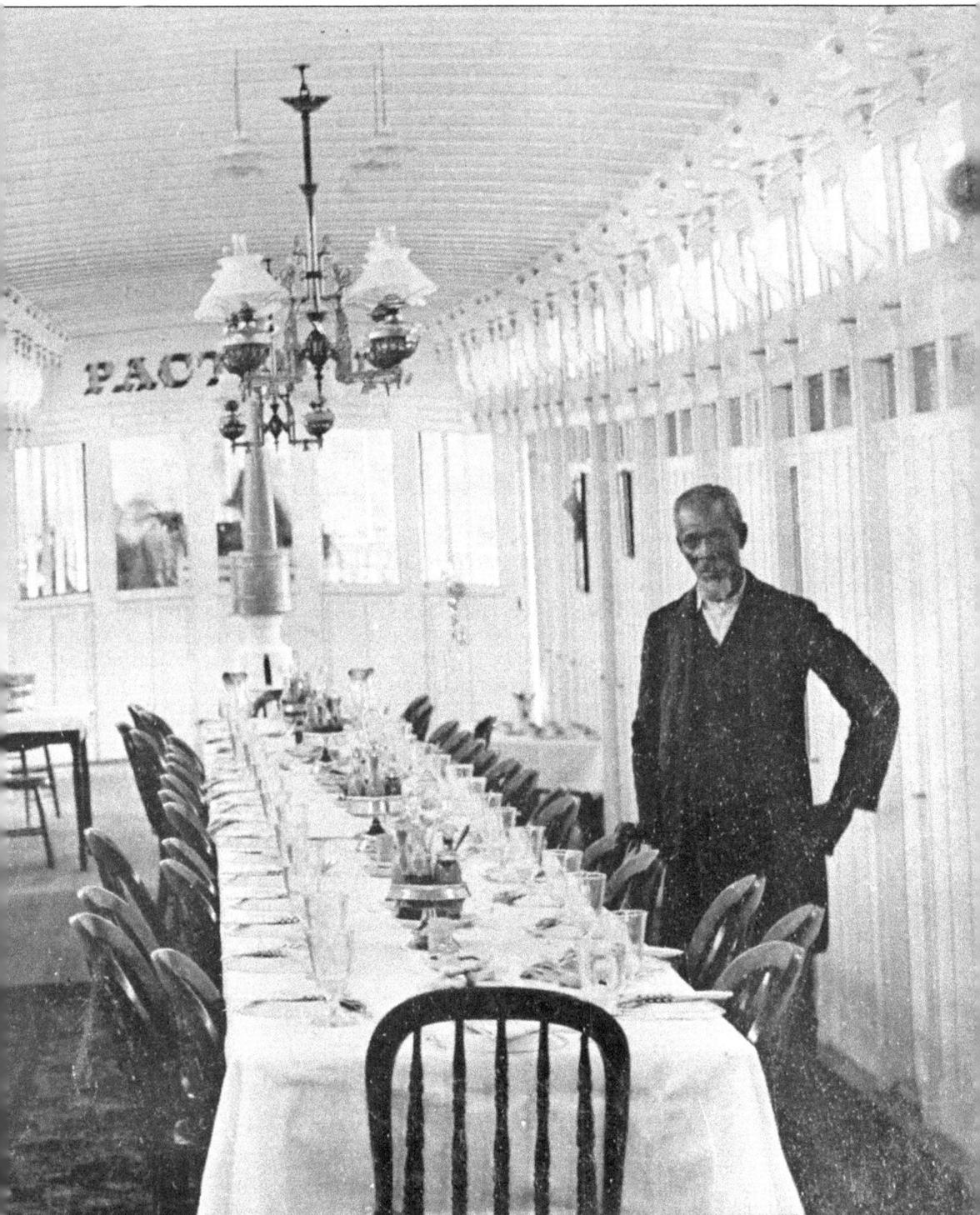

1886. Those sightseers would surely have been impressed with the boat's spacious dining room, pictured here. This exceedingly rare image is one of the few that depicts any of the interior spaces on Chattahoochee River steamboats. (Courtesy of the Georgia Archives.)

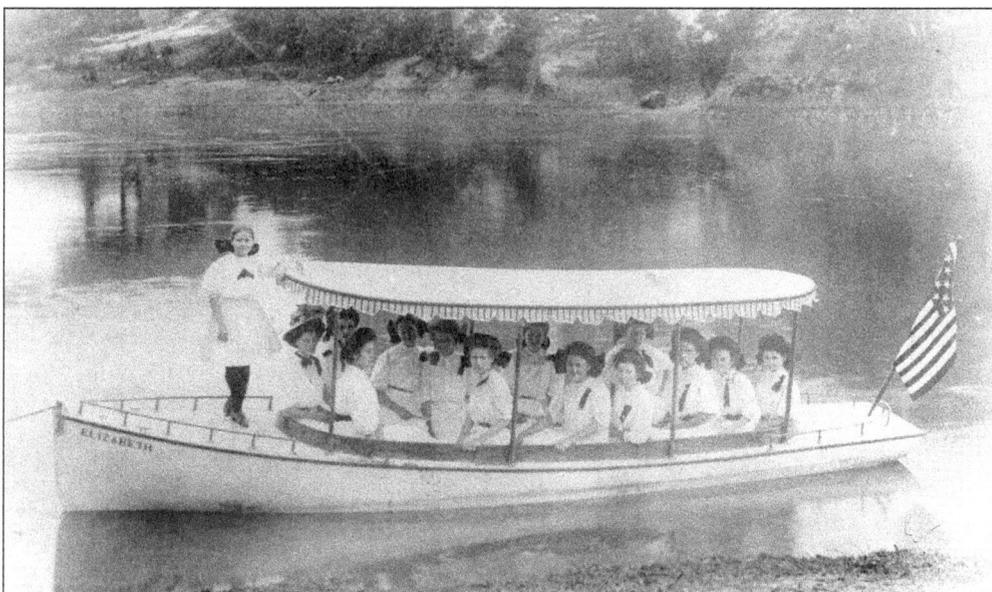

These schoolgirls and their chaperones are poised to enjoy an excursion on the tranquil waters of the Chattahoochee River in this August 1908 photograph taken near the Fort Gaines covered bridge. The *Elizabeth* was apparently a privately operated excursion boat. A 45-star American flag flutters in the breeze on the back of the vessel, as the 46-star flag had been adopted only one month previous to this event. Passengers included in this photograph are Nina Morris (Worrill), Mary Lou Killingsworth (Weston), Gena Graham (Pietro), Hellen Morris (Trulock), Sallie Hancock (Coleman), Anna Whatley (Bland), Florence Weston, Ruth Parker (Graham), and Pearl Peterson (Bosler) standing. (Courtesy of the James E. Coleman Collection.)

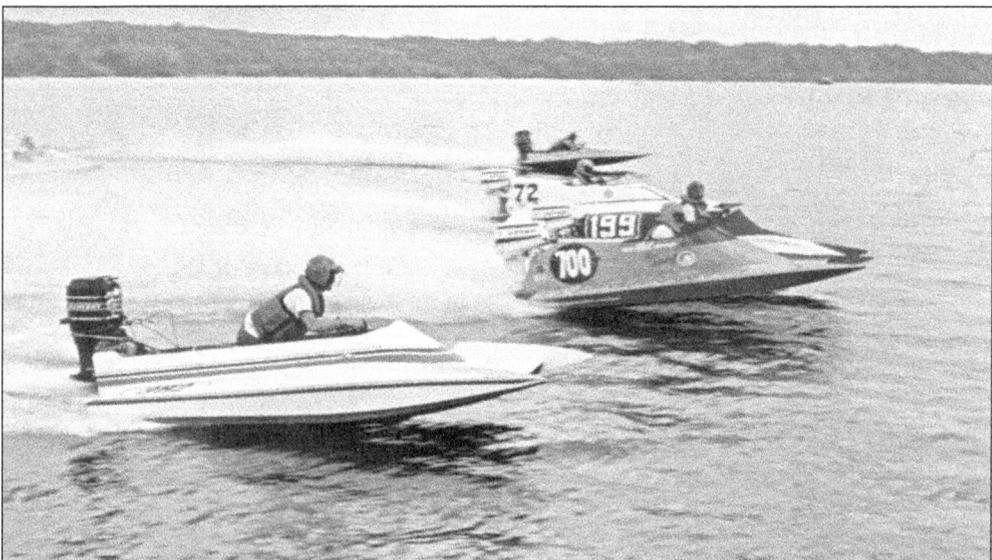

The Lake Eufaula Summer Spectacular featured American Power Boat Association (APBA)–sanctioned, outboard performance–class, closed-course, national championship boat races. Often called the Daytona 500 of powerboat racing, this event attracted approximately 200 competitors racing before more than 25,000 spectators. The boat races were held throughout the 1970s and into the early 1980s. (Courtesy of Doug Purcell.)

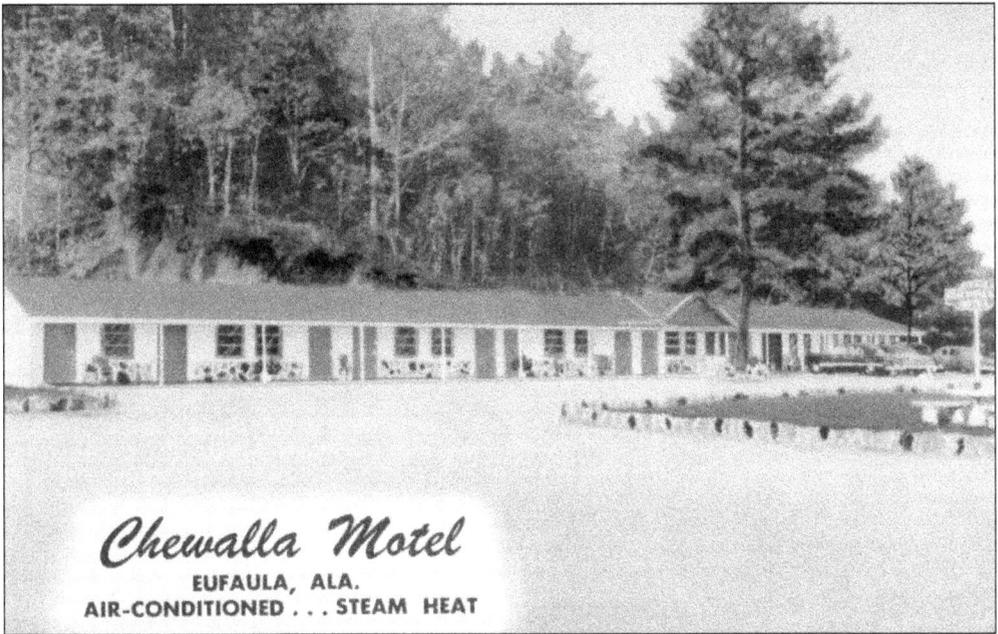

Built in 1952 by Robert Hornsby, the Chewalla Motel was Eufaula's first motel. This card advertised, "air conditioned . . . steam heat." There were 114 units. (Courtesy of Rob Schaffeld.)

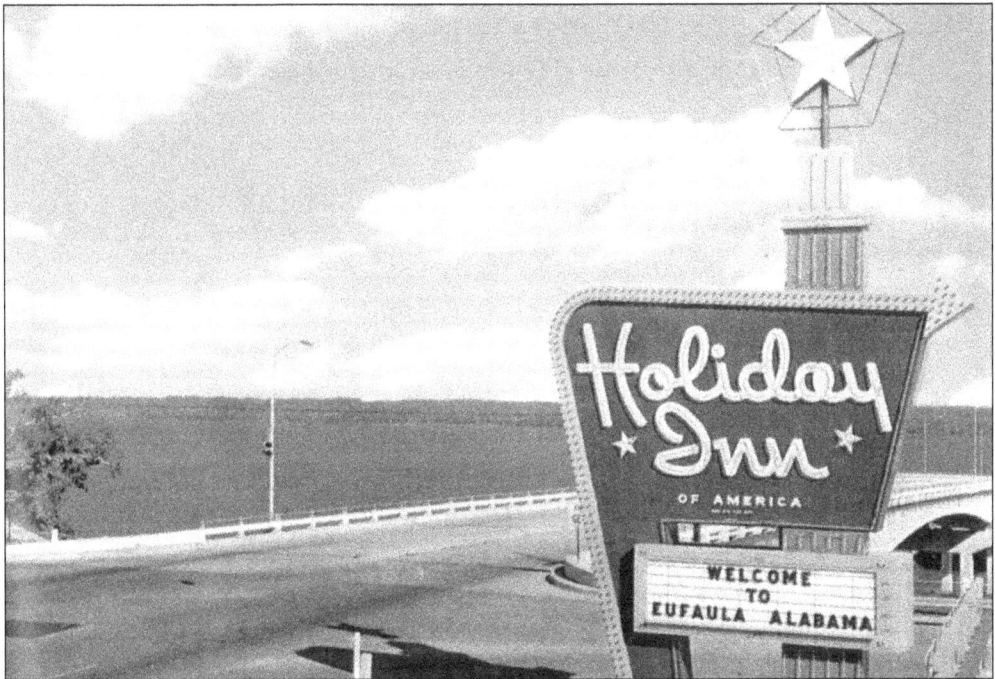

The Holiday Inn gave visitors to Eufaula a comfortable room with a view when it opened in 1962. Sitting high atop the bluff, the Holiday Inn overlooked the newly forming Lake Eufaula/Walter F. George. The motel is now closed. (Courtesy of Rob Schaffeld.)

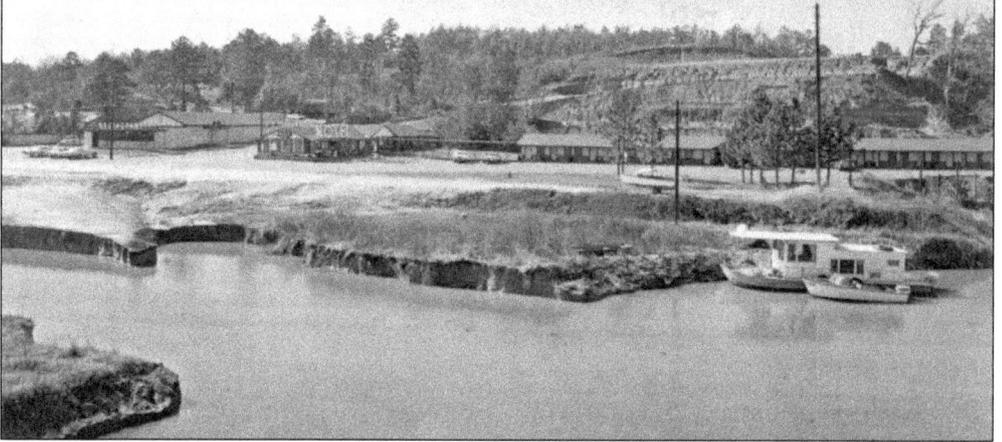

CHEWALLA MOTEL - ON LAKE EUFAULA - EUFAULA, ALABAMA

The Chewalla Motel is located directly on Chewalla Creek on Lake Eufaula. Boat travel and recreation breathed new life into Eufaula after the Chattahoochee River was impounded in the early 1960s. (Courtesy of Rob Schaffeld.)

CHEWALLA MOTEL - ON LAKE EUFAULA - EUFAULA, ALABAMA

As Eufaula grew, so did the Chewalla Motel. More units were added, and a restaurant opened next door. Known today as the Lakeside Motor Lodge, the motel still welcomes guests to Lake Eufaula/Walter F. George. (Courtesy of Rob Schaffeld.)

Five

POWER SOURCE

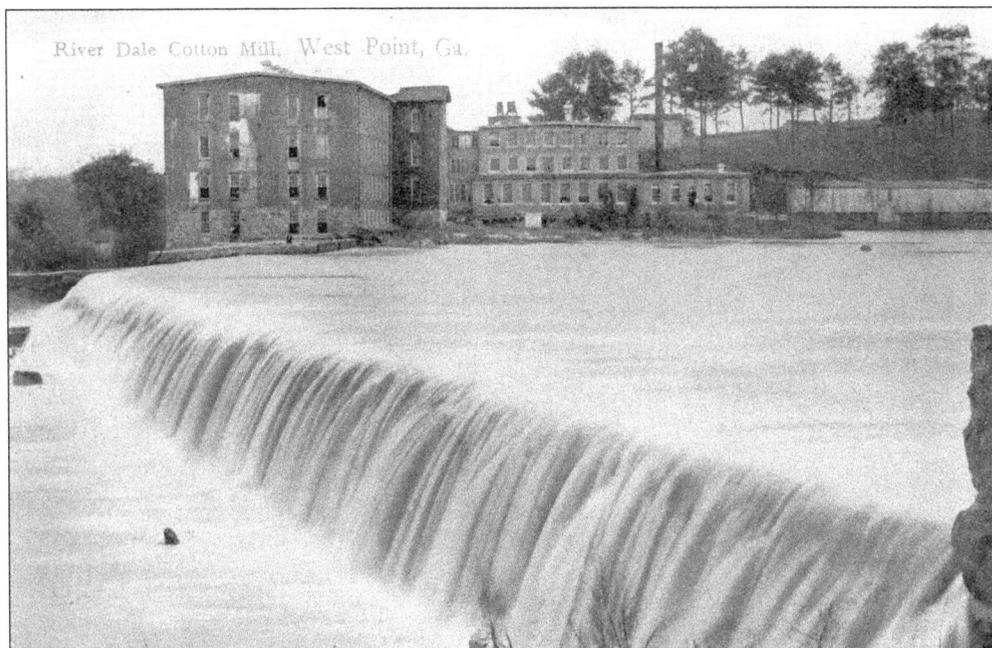

Despite the heading on this postcard, Riverdale Mill was located south of West Point in an area known locally as Riverview. Featuring pine timbers cut from local trees and brick formed from Chattahoochee River mud, the mill still stands as a monument to the industrial heritage of the region. This image shows the establishment as it appeared around 1930. (Courtesy of the Cobb Memorial Archives.)

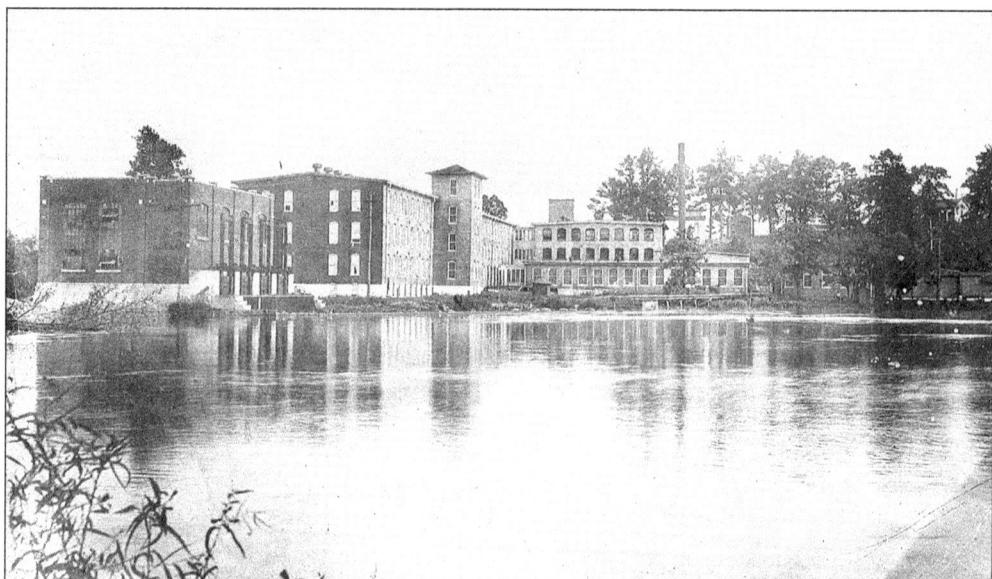

The Riverdale Mill, completed in December 1869, is unique in at least two ways. It has the distinction of being located in two states, as it was built into the bed of the Chattahoochee so that a portion of the facility lies within the western bank of the river. Perhaps just as interesting, because of the shape of the rocky bluff on which it was built, all four of the structure's floors have a ground-level entrance. (Courtesy Wayne Clark and the Cobb Memorial Archives.)

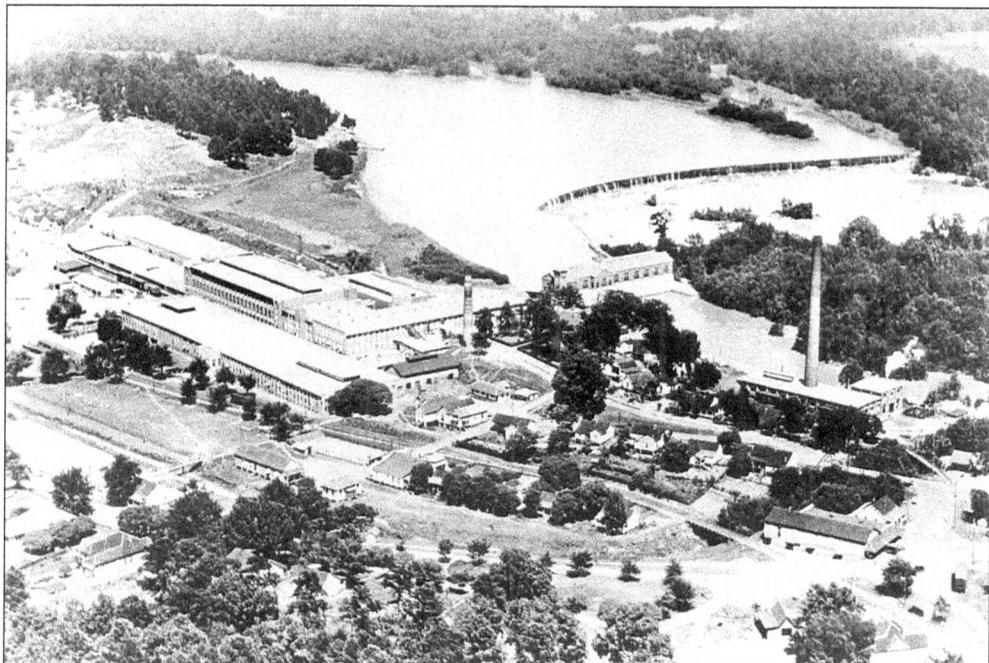

The Langdale Mill, named in honor of superintendent Thomas Lang, was built where the Chattahoochee Manufacturing Company once stood. The facility became an integral part of the long-range success of the West Point Manufacturing Company. At one time it was one of the largest textile manufacturers in the United States, including several mills in the West Point and Lanett, Alabama, area. (Courtesy of Lynn Willoughby and the Georgia Power Company.)

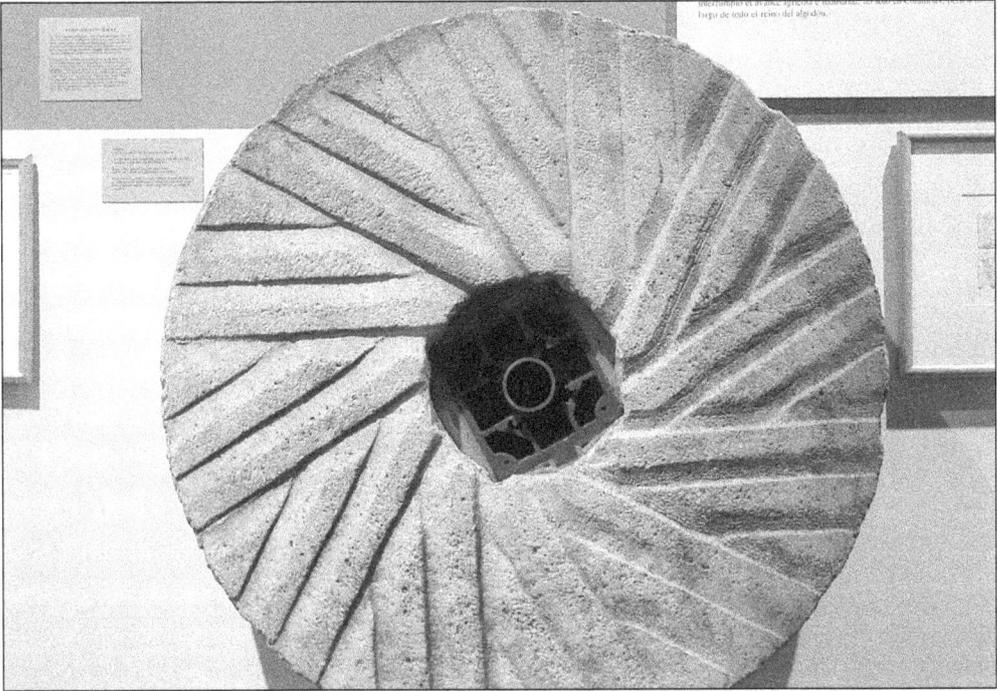

One of the longest-lived business establishments in the city of Columbus, City Mills ground wheat and corn continuously for well over 150 years. This grinding stone once used at the mill has been on loan to the Columbus Museum for a number of years, where it has been on display in the Columbus Museum's history gallery, the Chattahoochee Legacy. (Courtesy of Joe Bowers and the Columbus Museum.)

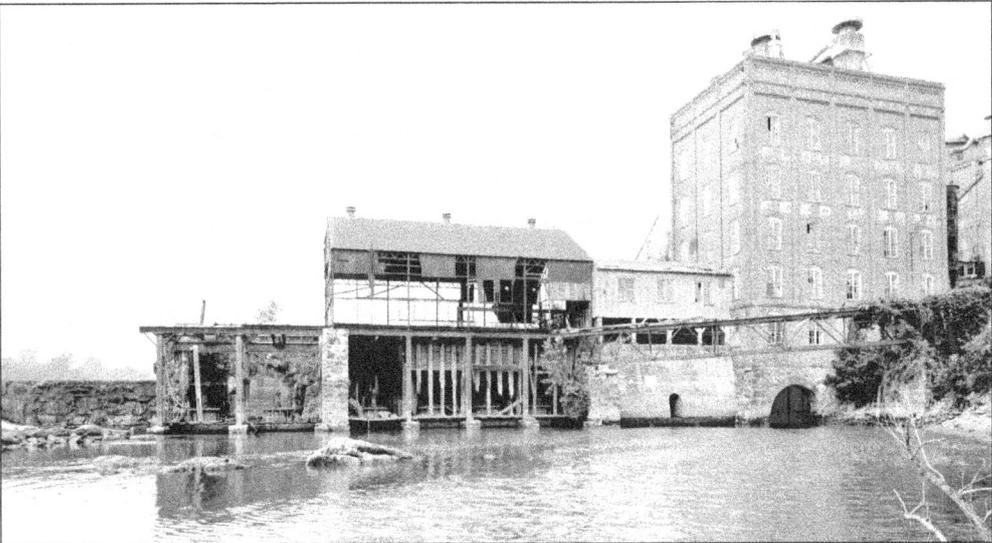

The original City Mills structures were destroyed during Union general James H. Wilson's raid on Columbus in April 1865. The majority of the buildings standing today on the City Mills site were constructed between 1890 and 1908 by George A. Pearce. Originally a mechanic at the mills, he eventually became manager and was largely responsible for the physical expansion of the company's facilities in the early 1900s. (Courtesy of the Library of Congress.)

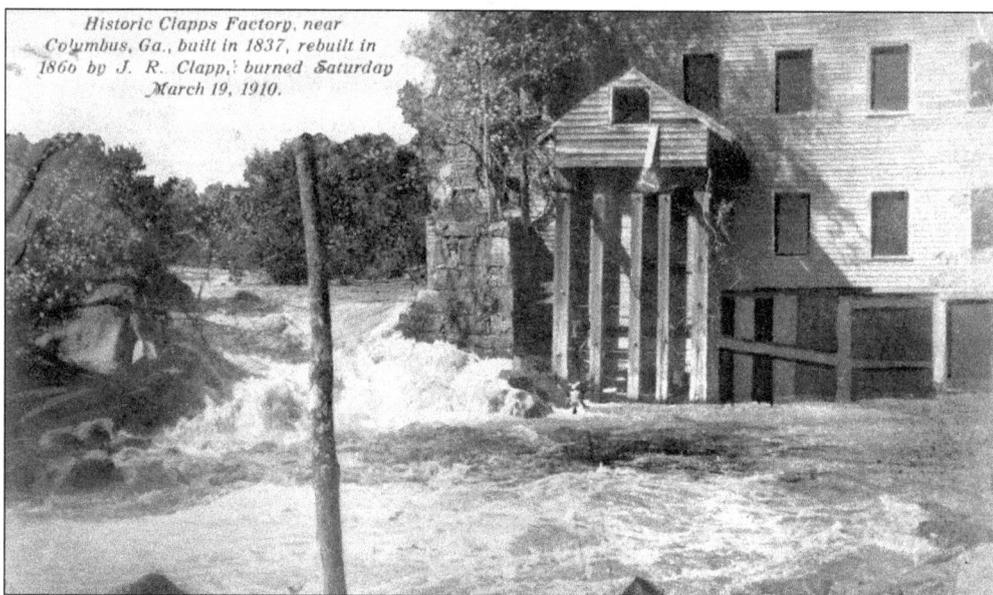

Historic Clapps Factory, near Columbus, Ga., built in 1837, rebuilt in 1860 by J. R. Clapp, burned Saturday March 19, 1910.

This postcard view of Clapp's Factory shows the structure as it appeared in the early 1900s. The building was constructed just north of Columbus at the site of one of the area's first textile manufacturing facilities, the Columbus Factory, which had been built in the 1830s. The factory closed in the 1880s and burned in 1910. (Courtesy of the Columbus Museum.)

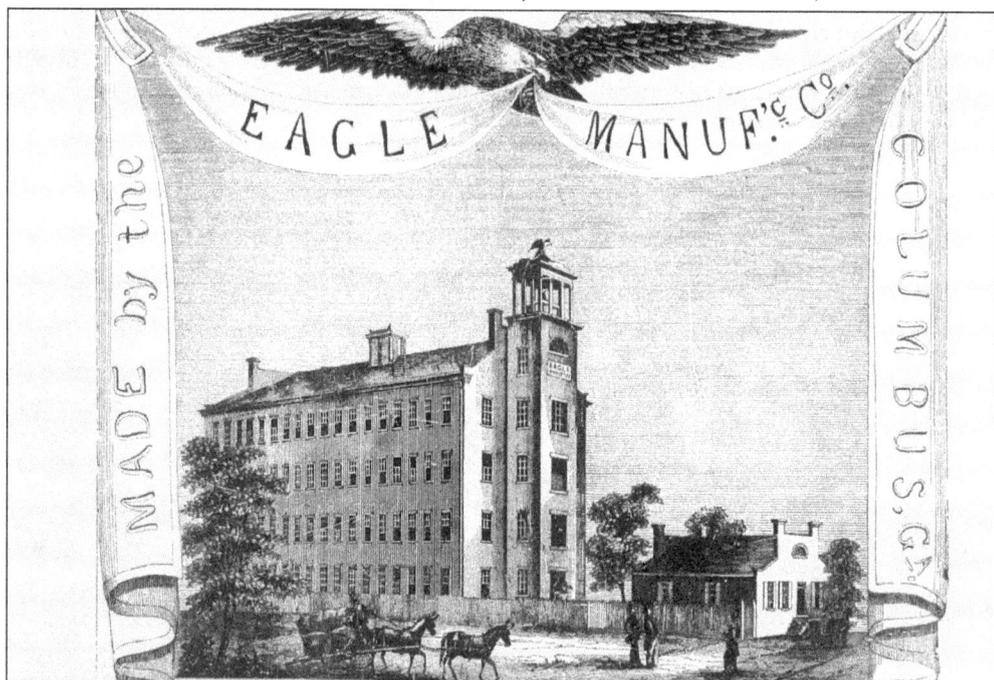

This image shows the Eagle Manufacturing Company's facilities as they appeared in the 1850s. Founded by one of Columbus' foremost businessmen, William H. Young, the company was one of the largest of its type in the South prior to the Civil War. During the conflict, it employed hundreds of workers and produced a wide variety of textiles for the Confederacy. The company's facilities were destroyed during Wilson's raid on Columbus in April 1865. (Courtesy of the Library of Congress.)

64

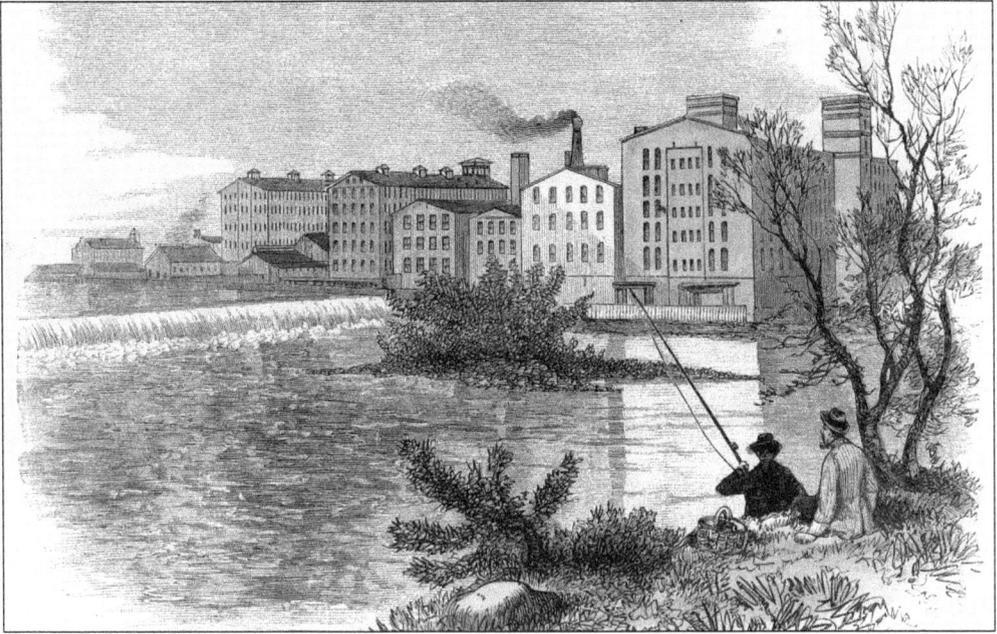

Columbus was home to one of the largest industrial complexes in the South during the Civil War, and the Eagle Mills was one of its largest facilities. It produced over 2,000 yards of gray tweed and 1,500 yards of cotton duck daily with a workforce of several hundred. After the battle for the city on April 16, 1865, Union forces burned virtually everything of military value in Columbus, including the Eagle Mills. It was soon rebuilt and back in operation, however. (Courtesy of the Columbus Museum.)

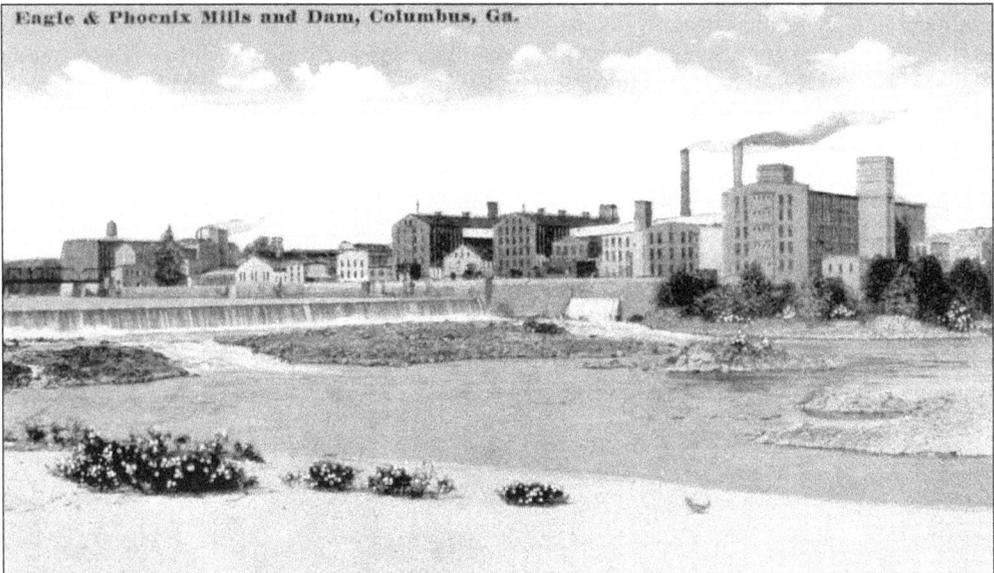

Columbus's postwar industrial recovery proved to be very rapid; some companies were back in operation as early as the fall of 1865. The Eagle Mills experienced a remarkable recovery, opening a new facility in 1866. Symbolizing its literal rise from the ashes, it was renamed the Eagle and Phenix Mills. The new name gave rise to the name of Phenix City, Alabama, where a company mill village was located. (Courtesy of the Columbus Museum.)

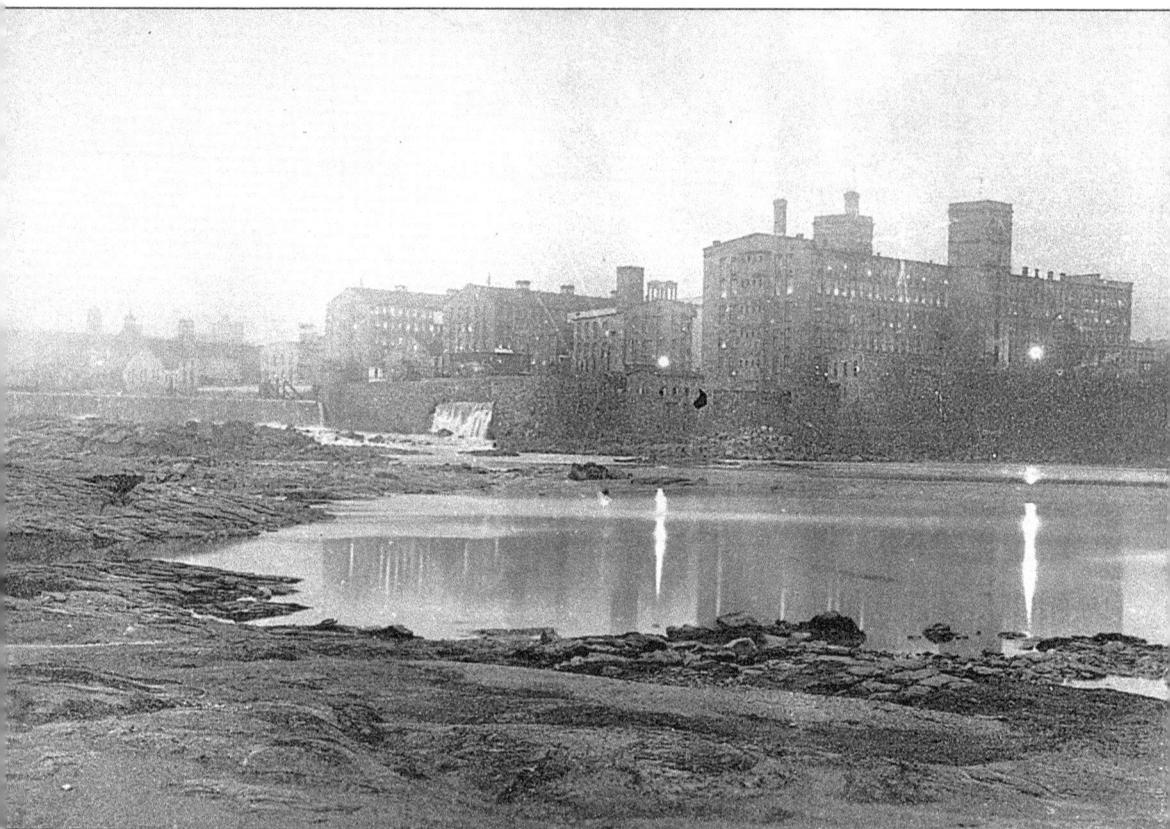

Although the Eagle and Phenix Mills had undergone a period of rapid expansion in the 1870s, as the 20th century approached, much of its machinery was worn and dated. In addition, many of its products were still marketed towards individuals making homemade clothing in relatively old-fashioned styles. Under the leadership of noted Columbus businessmen G. Gunby Jordan and W. C. Bradley, the Eagle and Phenix Mills underwent an intensive modernization campaign in the early 1900s that helped keep it competitive for decades afterward. They installed new equipment and changed much of the company's marketing strategy to increase its position within the existing marketplace. Part of this upgrading effort included the installation of electric lighting. Electric lights were installed in Mill No. 3 in 1881, making it one of the first in Columbus to be so illuminated. (Courtesy of the Library of Congress.)

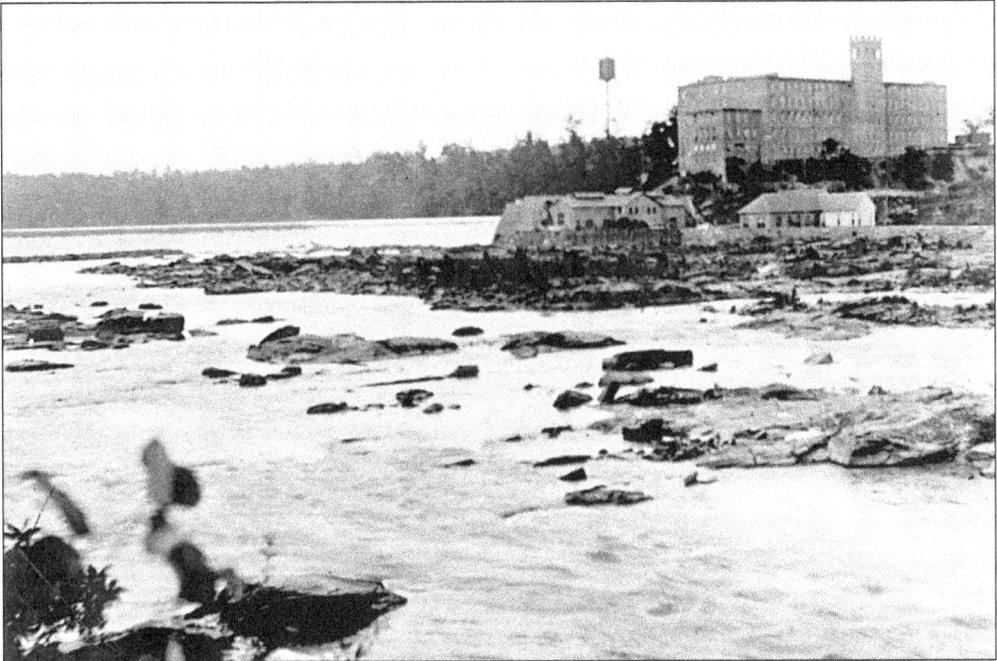

Opened in 1900 as a 20,000-spindle mill, Bibb Mills in Columbus had grown to include nearly 127,000 spindles in only 50 years. At one time reputed to be the world's largest cotton mill under one roof, the six-story facility was over 1,000 feet long and 128 feet wide. Among the products closely associated with the mill were heat-resistant tire cord, fabrics, sheeting, and bedspreads. (Courtesy of the Library of Congress.)

The Columbus Manufacturing Company traces its origins to the development of the North Highlands Dam and Bibb Mills. Organized in 1899, the company was the first and largest purchaser of power from the North Highlands development. The original mill was very similar to the Bibb facility, featuring a 300-foot-long building housing 25,000 spindles. The mill later came under the direction of the West Point Pepperell Manufacturing Company. (Courtesy of the Library of Congress.)

Built on the site of the Coweta Falls Factory, the first textile mill constructed within Columbus' city limits, the Muscogee Manufacturing Company facility has been a prominent landmark in Columbus since shortly after the Civil War. Mill No. 2, completed in 1880, features a unique bell tower recognizable in the city's skyline. In addition to its importance to the city's textile industry heritage, the mill was also the site of the first hydroelectric power production for commercial use in 1885. (Courtesy of the Library of Congress.)

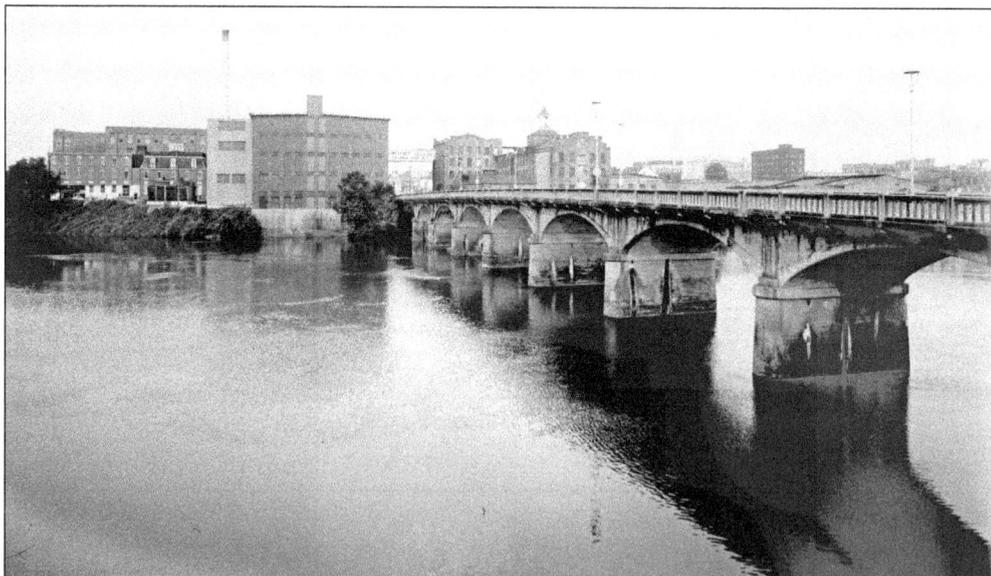

The Muscogee facility was built and operated by the Swift family for nearly a century before being bought by Fieldcrest Mills in 1963. By the mid-1970s, the plant had over 44,000 spindles and was one of the largest towel production facilities in the world. (Courtesy of the Library of Congress.)

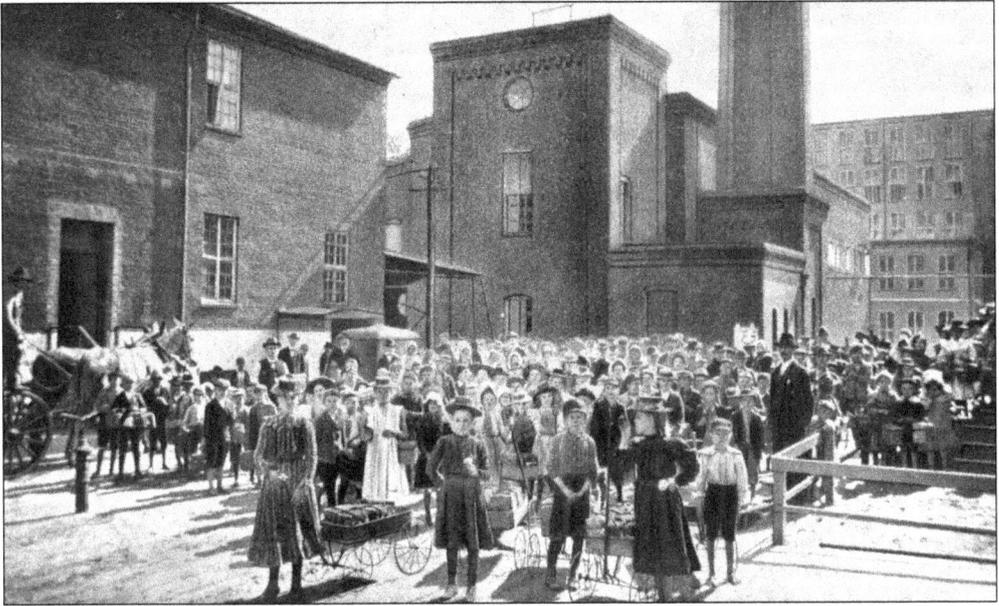

Perhaps no aspect of life in the mills was as unfortunate as the textile industry's widespread use of child labor. Prior to legislation prohibiting such practices, children were actively sought by mills to perform tasks especially suited to small, nimble hands or to perform the most menial and low-paying chores. The workers shown here are a few of the hundreds of "dinner toters" who were paid a few cents a week to carry lunches to mill workers in the late 1800s and early 1900s. (Courtesy of the Columbus Museum.)

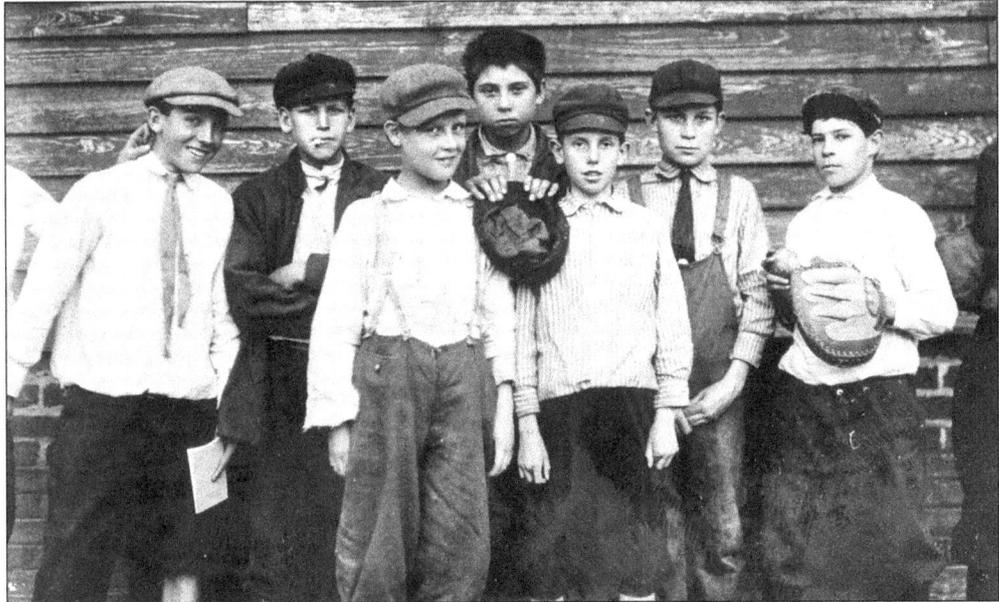

This photograph was taken by nationally recognized photographer Lewis Wickes Hine while visiting Columbus around 1913. Hine, who worked for the National Child Labor Committee, used poignant images to advocate for reform in American labor laws. According to Hine's notes, these boys, aged 10 to 15, were working in excess of 12 hours per day at a Columbus mill. (Courtesy of the Columbus Museum.)

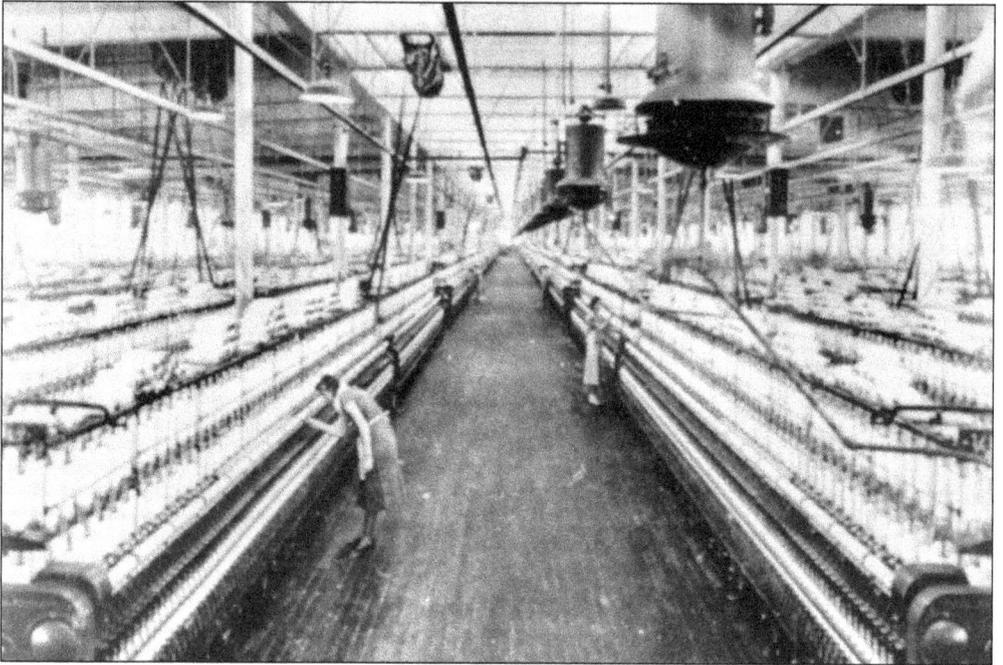

This image of the interior of Bibb Mills gives a glimpse of life inside a textile facility. Many of the rows of heavy machinery at which workers toiled created a deafening noise and shook to the point that the whole building vibrated when in operation. Especially in earlier years before many modern safety regulations, much of the work was dangerous. (Courtesy of the Library of Congress.)

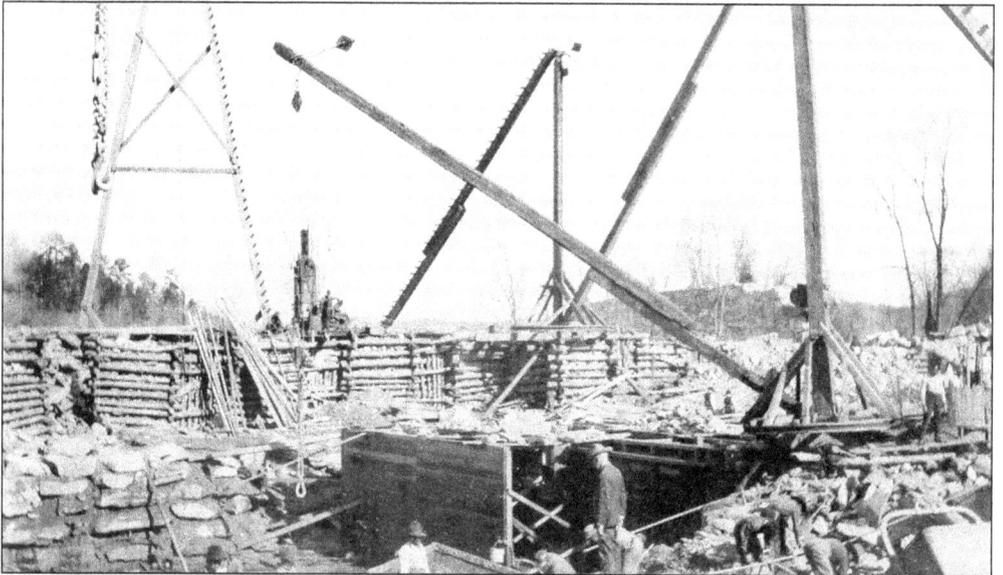

Langdale Mill's growth in the late 1800s and early 1900s quickly outpaced its original power supply systems. Around 1905, the process of converting to hydroelectric power began with the reconstruction of the original dam across the Chattahoochee River. This image captures a few of the hardy workers who participated in that difficult undertaking. (Courtesy Wayne Clark and the Cobb Memorial Archives.)

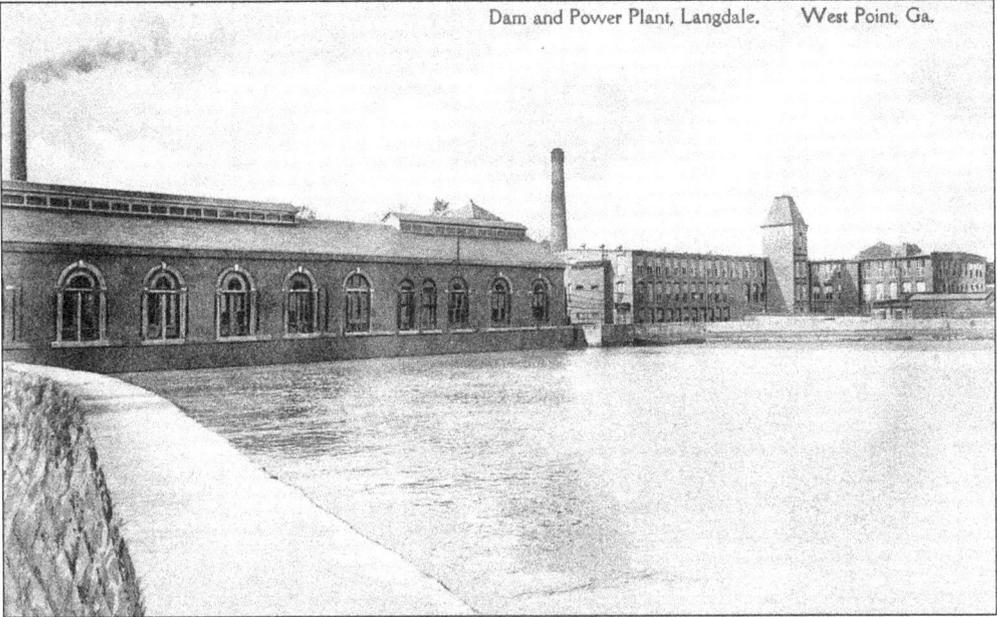

After completion in 1908, the new Langdale Dam and power plant was West Point's first modern hydroelectric facility. The complex transformed the industrial potential of the area. Eventually a cluster of electrically powered mills was established nearby in what became the communities of Fairfax and Shawmut; along with West Point and Lanett, this became collectively known as the Valley area. (Courtesy of Cobb Memorial Archives.)

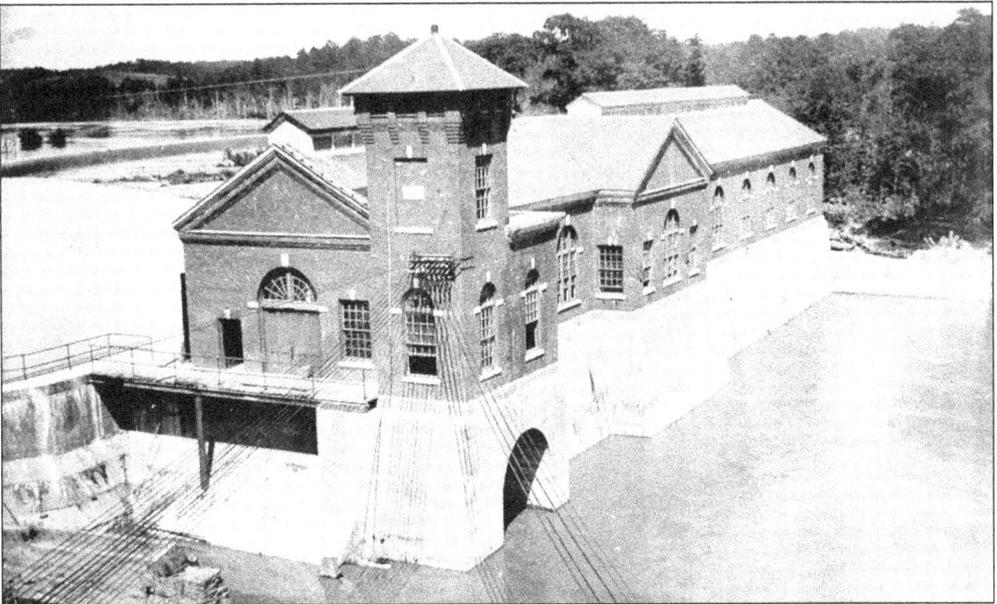

For the better part of four decades, the original dam at Langdale diverted river water to a waterwheel that powered machinery at Langdale Mill. This power was delivered through a system of rope drives to the mill. As Langdale's need for power increased during the late 1890s, it converted its machinery to steam power before eventually utilizing the dam for hydroelectric power production. (Courtesy Wayne Clark and Cobb Memorial Archives.)

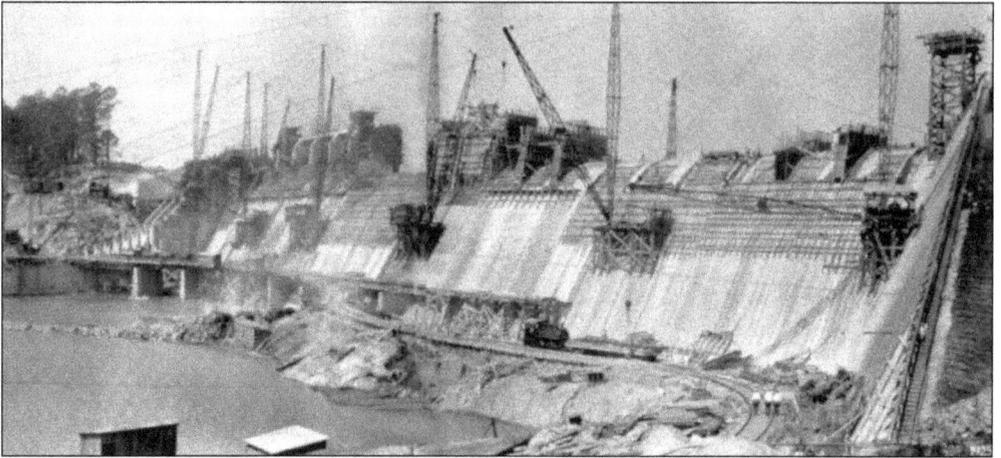

Construction of Bartlett's Ferry Dam on the Harris County, Georgia, and Lee County, Alabama, border was a monumental undertaking requiring nearly 1,500 men working several months. The workers lived rent-free in temporary dwellings located near the construction site. Besides rudimentary housing, the makeshift village included a hospital, a dining hall, and a movie theater. During the 1980s, one of the surviving crew members would recall how managers, fearing workers would not return, discouraged the men from traveling to Columbus during their time off. (Courtesy of Susan Reames and Georgia Power Company.)

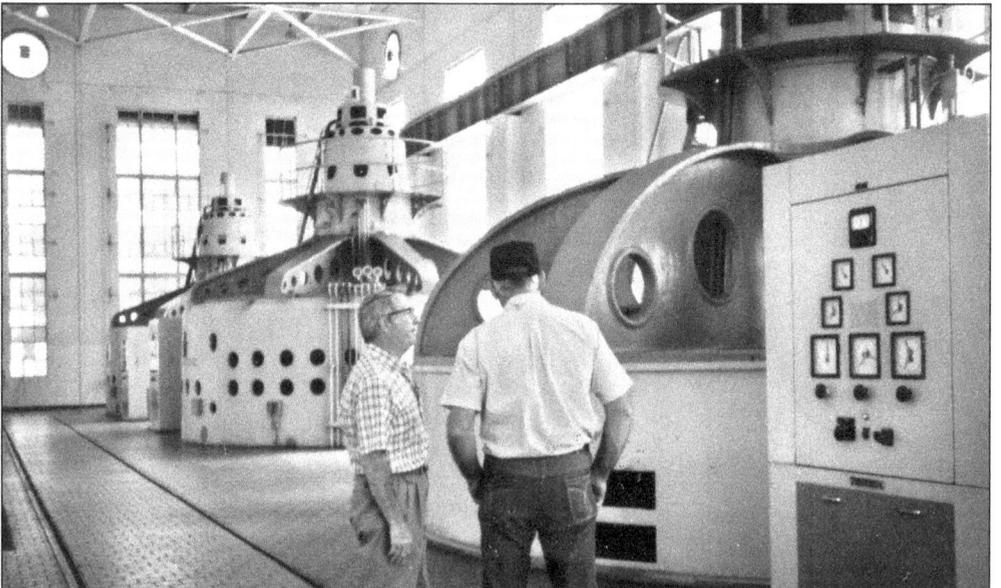

The men in the foreground of this image provide a sense of the scale of the equipment in the power plant at Bartlett's Ferry Dam. The dam originally contained two generators, with a third added in 1928 and a fourth in 1951. A final upgrade occurred in the 1980s. (Courtesy of Susan Reames.)

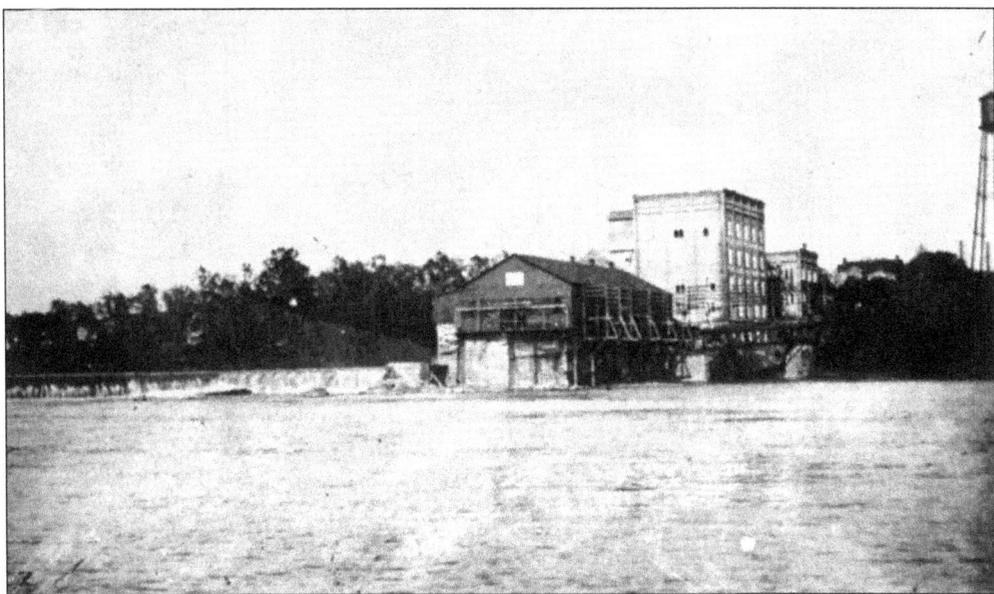

The Columbus Railroad Company power station was located adjacent to the City Mills complex. The first hydroelectric generating plant in Columbus, the facility once provided the bulk of electricity used in the town. Though the turbines were state of the art at the time they were installed in the 1890s, power generation at the station was notoriously unreliable. It was so inconsistent that, at times, it caused disruptions in the electric streetcar schedule. (Courtesy of the Library of Congress.)

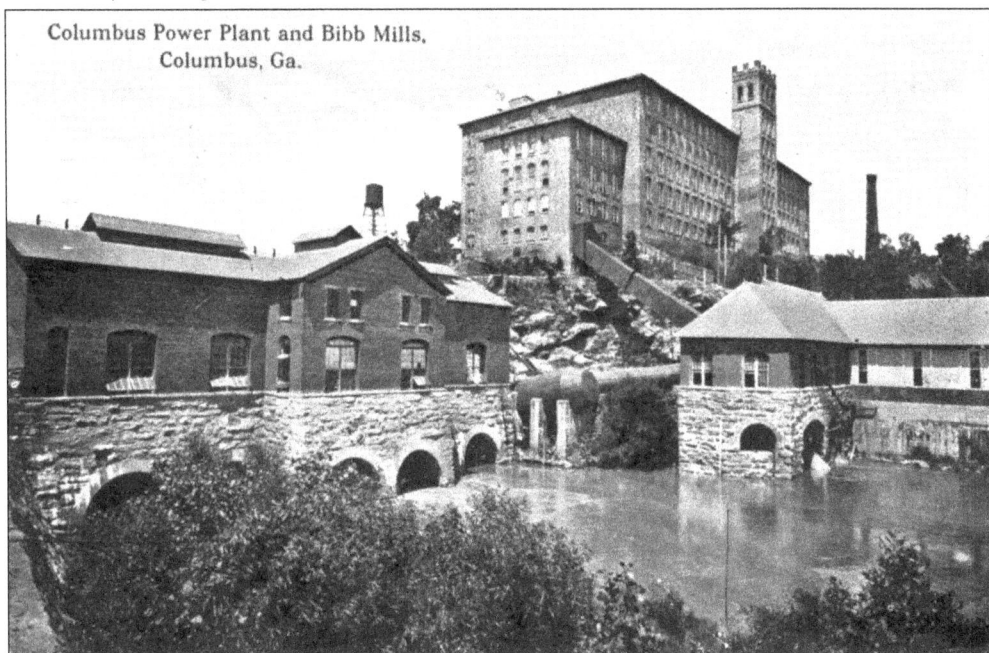

Columbus Power Plant and Bibb Mills,
Columbus, Ga.

This card, c. 1900, shows the recently constructed Bibb Mill facility and the powerhouse for the North Highlands Dam. These structures were at the forefront of a new era of water-powered industrial endeavors that took shape in Columbus in the early 1900s. (Courtesy of the Columbus Museum.)

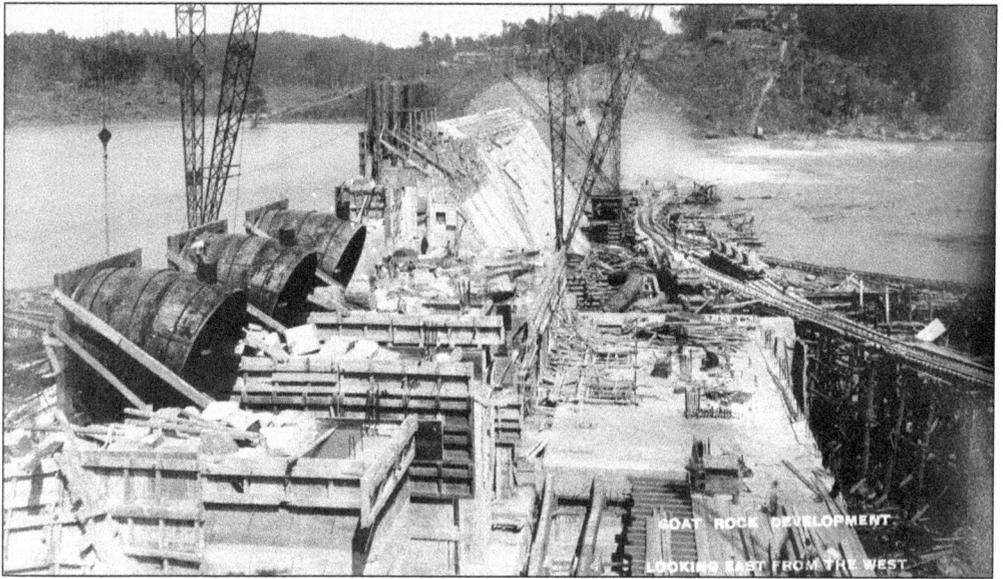

Envisioning both increased demand for hydroelectric power in the lower Chattahoochee River Valley beyond Columbus and competition to the monopoly held by the Columbus Power Company, contractor Benjamin Hardaway and other businessmen in 1909 organized the Chattahoochee Power Company. Within a year, however, an agreement was reached between the two companies whereby Columbus Power would build the Goat Rock Dam north of Columbus with Hardaway as the contractor. (Courtesy of the Georgia Archives.)

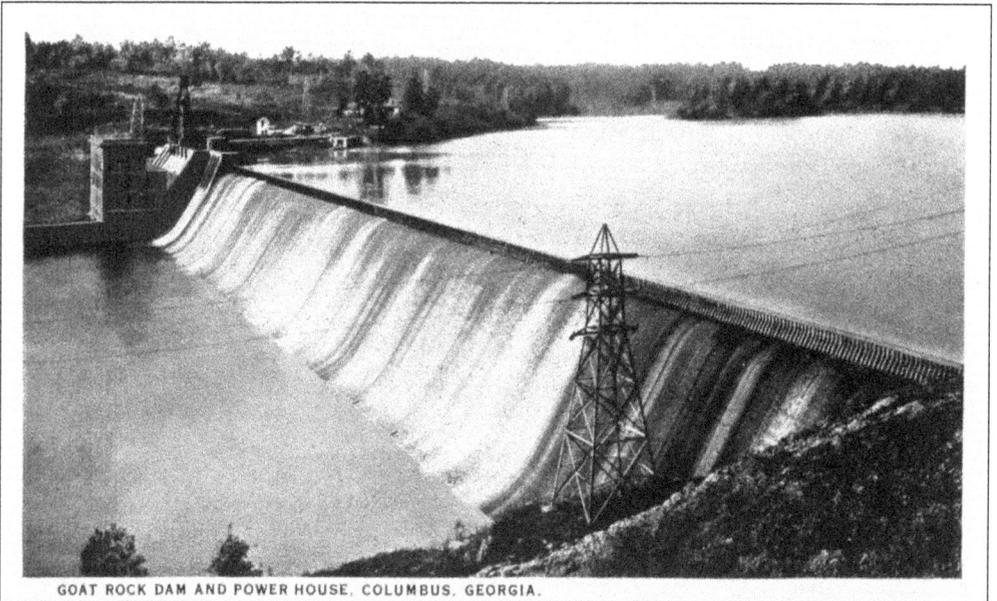

GOAT ROCK DAM AND POWER HOUSE, COLUMBUS, GEORGIA.

Completed by the Hardaway Construction Company in 1912, the Goat Rock Dam began a new era in power generation along the Chattahoochee River. Previously only areas located directly on the river could benefit from hydroelectric power production. Goat Rock, located a few miles north of Columbus, facilitated long-distance transmission of the electricity it produced, spurring industrial growth in regional towns where large-scale water-powered industry was not possible. (Courtesy of the Columbus Museum.)

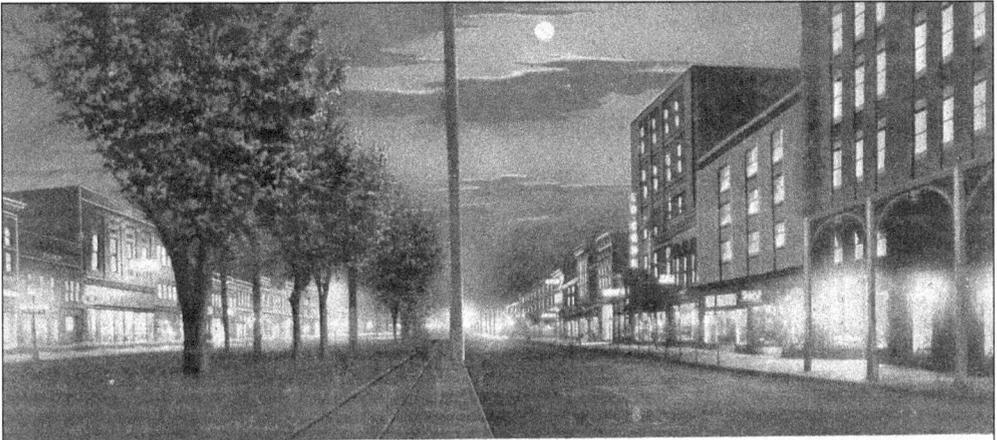

COLUMBUS, GEORGIA, "THE ELECTRIC CITY OF THE SOUTH."
Population, City and Suburbs 40,000 A Delightful and Healthy Climate.
All modern improvements—Schools, Churches, Paved Streets, Sewers, Water Works, Gas, Electricity,
Street Railway. An Ideal Tourist Resort, Social Clubs, Golf Links, Trap Shooting,
Fine Base Ball Grounds, Boating, Fishing, Transportation: Eight Lines of Railroad,
and Line of Steamers To The Gulf. Fine Location for Manufacturing Industries of all kinds,
Labor conditions exellent, Hydro Electric Power developed and being developed 90,000 H. P.

Hydroelectric power, first used in Columbus in 1882, quickly became profitable as mill powerhouses, then dams, began to generate electricity. By the 1920s, dams on the Chattahoochee were selling electricity to thousands of citizens far from the river's banks, and Columbus was as recognized for its role in power generation as its other long-standing manufacturing capabilities. (Courtesy of Dennis Jones.)

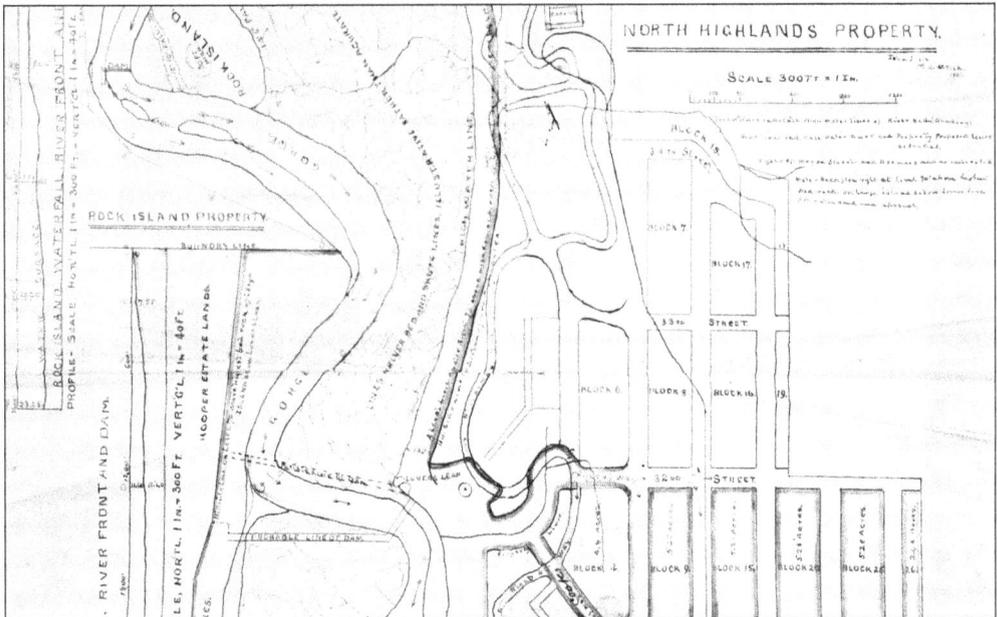

Long before the first large-scale construction at the site, the North Highlands area was recognized as ideally suited for water-powered industry. The river rushes through the Highlands, located north of downtown Columbus, in a steep rock-lined channel. Due to its difficult terrain and limitations in hydroelectric power transmission, the river's power at this site was not harnessed by developers until the construction of the North Highlands Dam. (Courtesy of the Library of Congress.)

The North Highlands Dam was the largest structure of its kind in the South when it was built by the Hardaway Company in 1900. The dam originally provided water for two hydroelectric powerhouses—one that powered machinery at Bibb Mills via a rope drive and another that sold the electricity it produced. (Courtesy of the Library of Congress.)

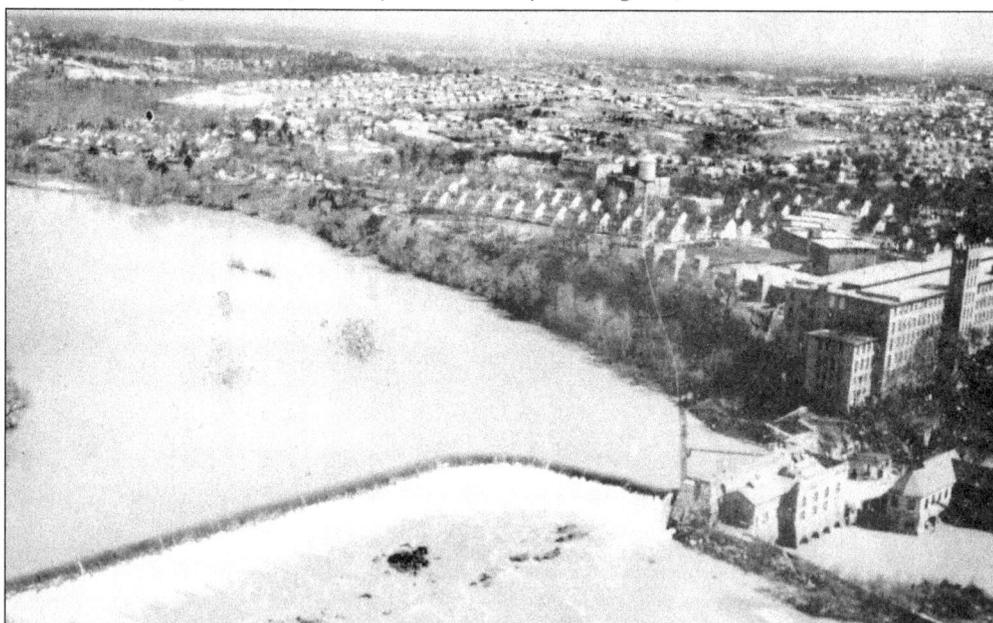

Since the flood of December 1901, which caused significant damage to the structure, the North Highlands Dam has undergone few major structural improvements. The two original powerhouses designed as part of the facility continued to supply electricity for Columbus consumers until 1963, when they were replaced with a more modern hydroelectric plant. (Courtesy of the Library of Congress.)

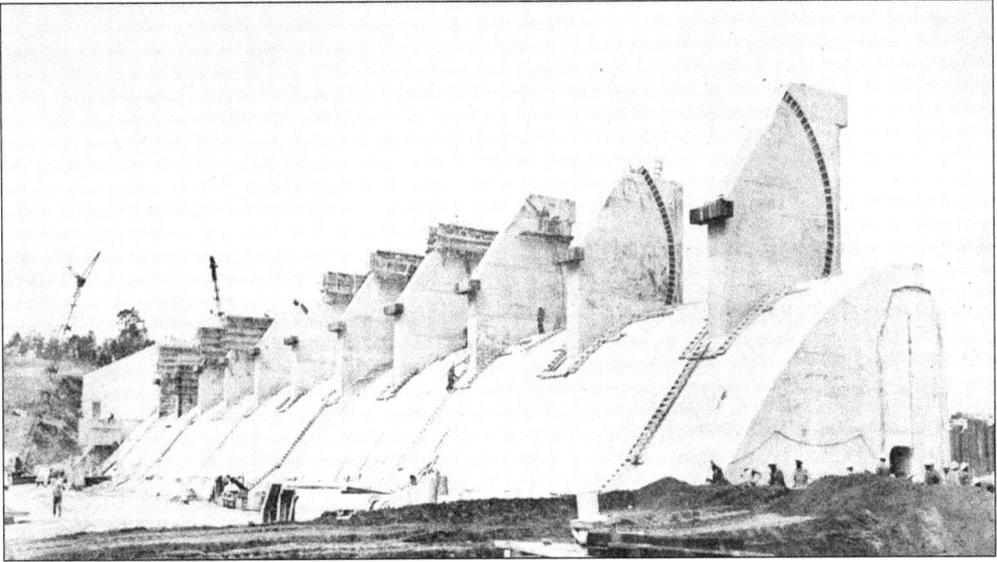

The engineers who built Oliver Dam included provisions for the future addition of locks on the Alabama side of the structure that would enable navigation. The idea of facilitating navigation on the river as far north as Atlanta was popular in some circles as early as the 1920s. At present, however, the northern limit to Gulf access on the river is still Columbus. (Courtesy of the Library of Congress.)

Alabama governor George Wallace was one of the principal speakers at the dedication ceremony for the Walter F. George Lock and Dam on June 14, 1963. The dam formed Lake Eufaula/Walter F. George, which has 640 miles of shoreline and covers 45,180 acres of land. Total length of the dam is 13,585 feet with a maximum height of 132 feet. The massive navigational lock measures 82 feet wide by 450 feet tall and was designed for moving river barges carrying fertilizer and fuel. (Courtesy of the Dothan Landmarks Foundation.)

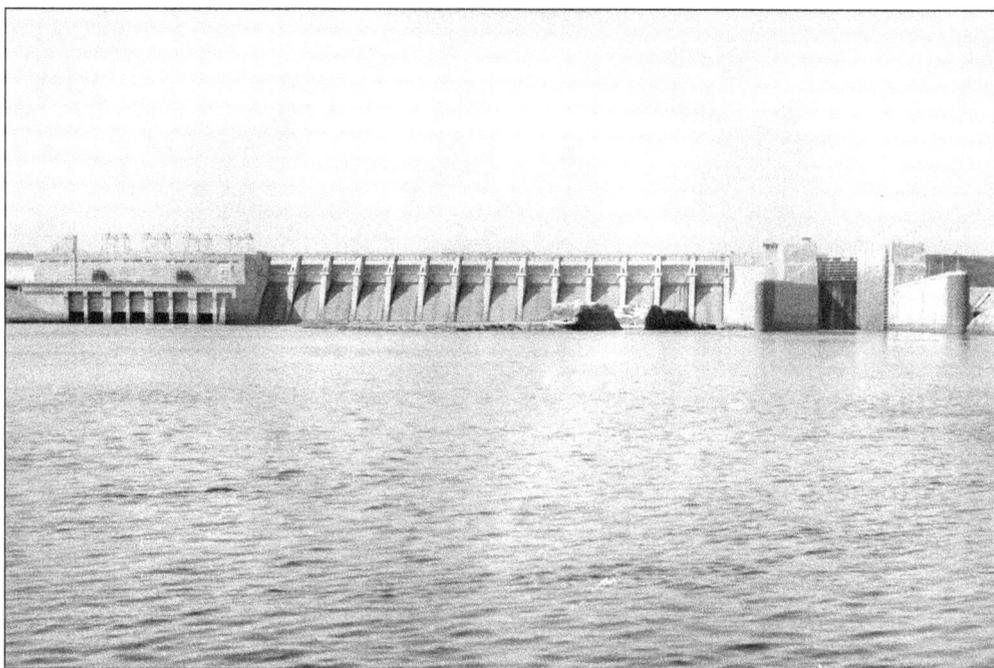

Operational since 1963, the dam extends 13,585 feet between Clay County, Georgia, and Henry County, Alabama. It slowly drops or lifts boats and barges 88 feet between the lake level and the riverbed below the dam. (Courtesy of the James E. Coleman Collection.)

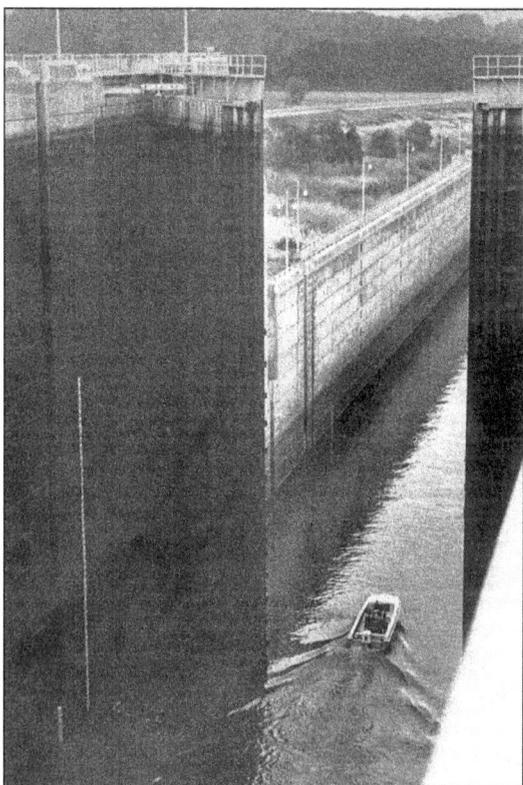

A boat exits the Walter F. George Lock at Fort Gaines, Georgia. At 88 feet, the lock lift is the second highest east of the Mississippi River. (Courtesy of the Henry County Historical Group.)

Six

FLOODS AND DISASTERS

In this photograph, Bob McAllister and son John Turner are shown viewing the swollen waters of the Chattahoochee River during the flood of March 1913. (Courtesy of the James E. Coleman Collection.)

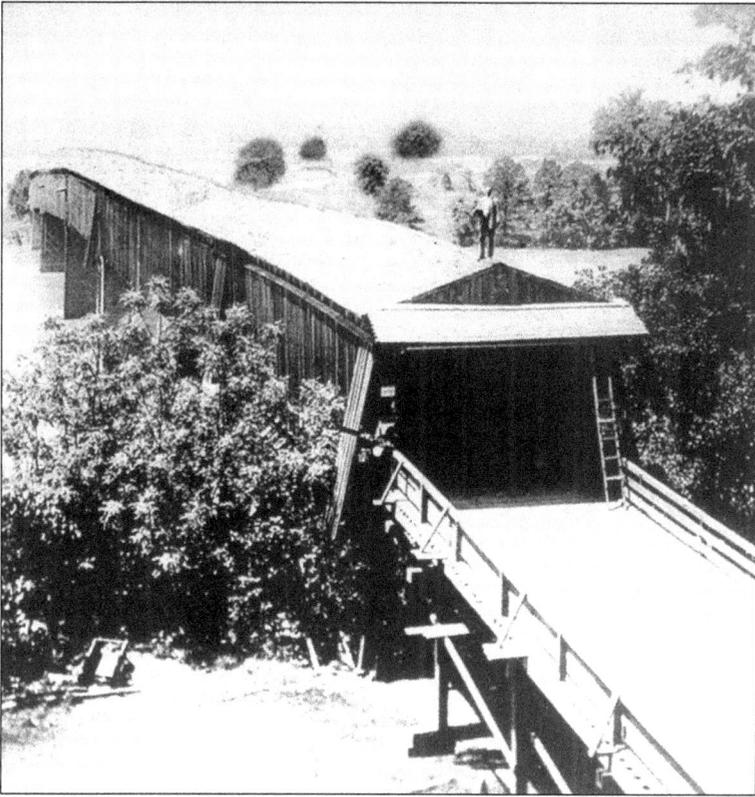

The old Fort Gaines covered bridge weathers another flood as seen in this image looking west to the Franklin Flats in the background. Note the man standing on the roof above the ladder propped up at the entrance to the bridge. (Courtesy of the Henry County Historical Group.)

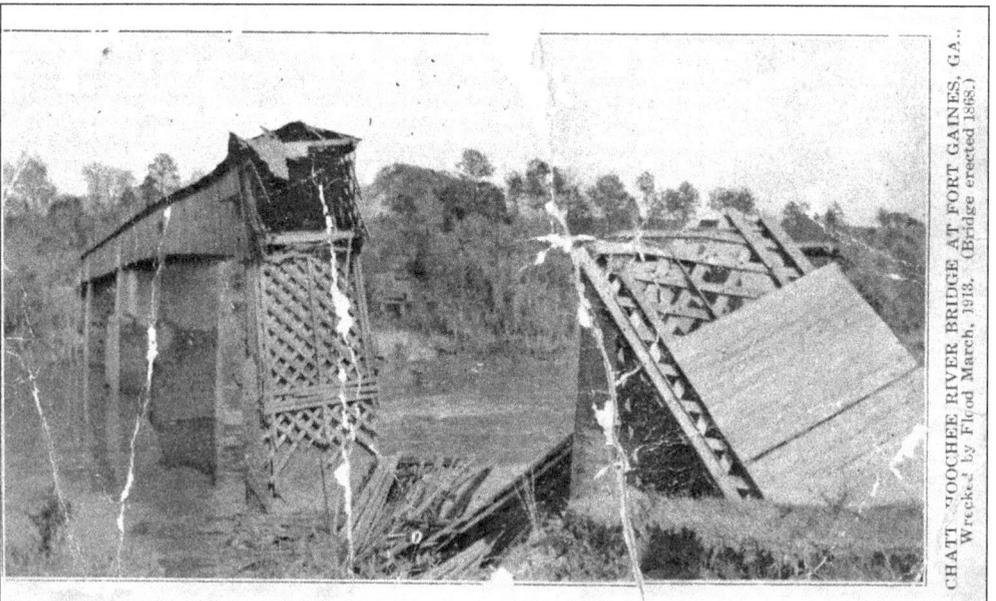

CHATT COOCHEE RIVER BRIDGE AT FORT GAINES, GA.. Wrecked by Flood March, 1913. (Bridge erected 1868.)

Flood damage to the Fort Gaines covered bridge is clearly evident in this image. A span of the bridge was washed away by the flood of 1913. The bridge was originally constructed around 1868. (Courtesy of the James E. Coleman Collection.)

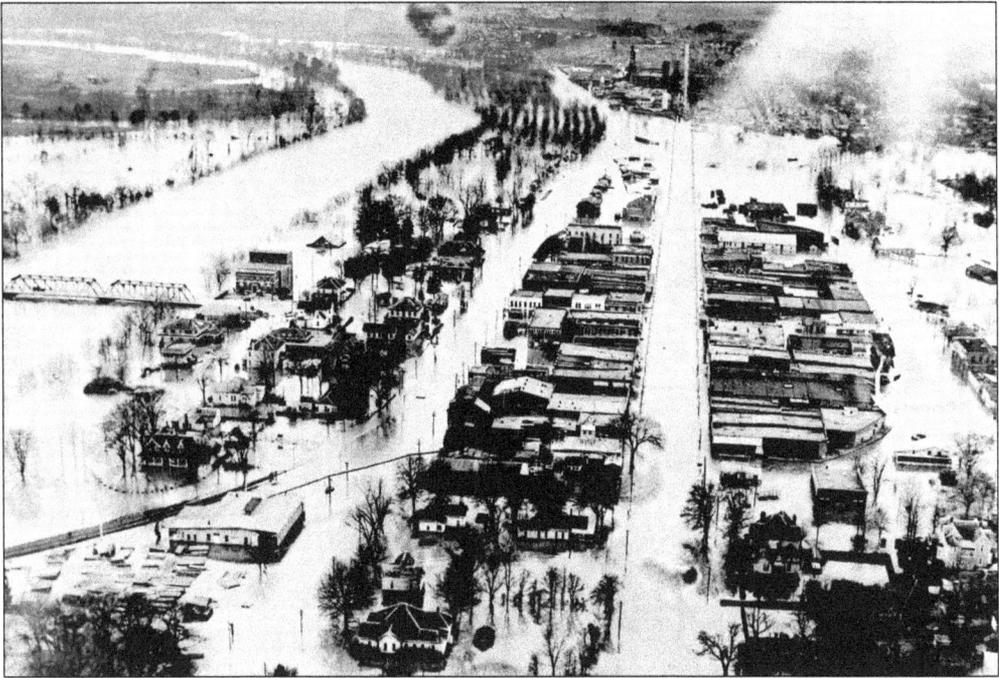

The 1919 flood caught many people throughout the lower Chattahoochee Valley by surprise, leaving an untold number trapped in or on top of buildings. The survival stories from the West Point area were especially poignant, where newspapers carried accounts of people surviving for days on rooftops and by clinging to telephone poles. (Courtesy of the Troup County Archives.)

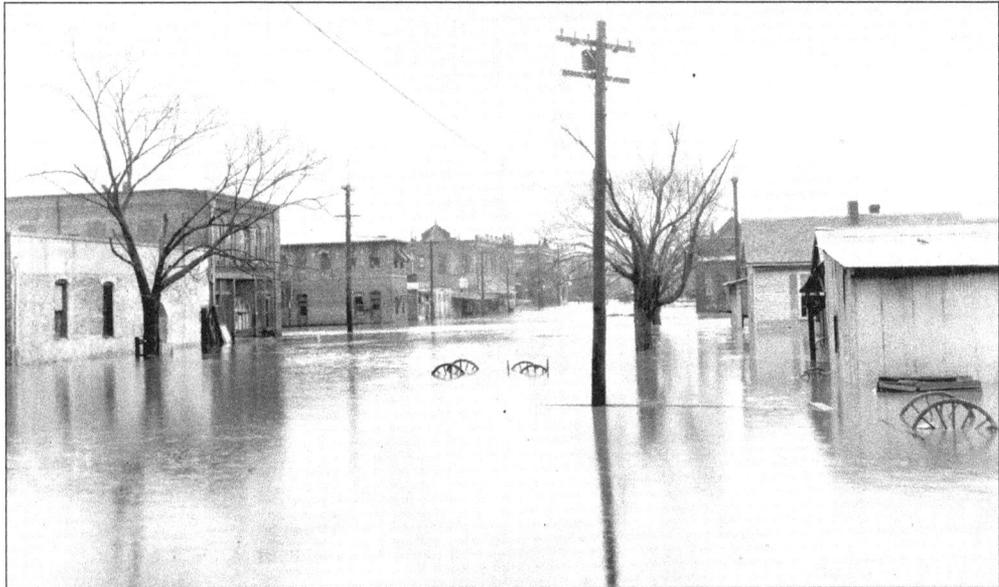

The destruction caused by the flood of 1919 sparked a statewide relief effort aimed at helping recovery efforts in the hard-hit town of West Point. Though aid came from several communities in Georgia and Alabama, the city of Atlanta became the primary fund-raiser in the effort. The city government, city ministers, and doctors and nurses, as well as the *Atlanta Journal*, all contributed to the relief effort. (Courtesy of the Troup County Archives.)

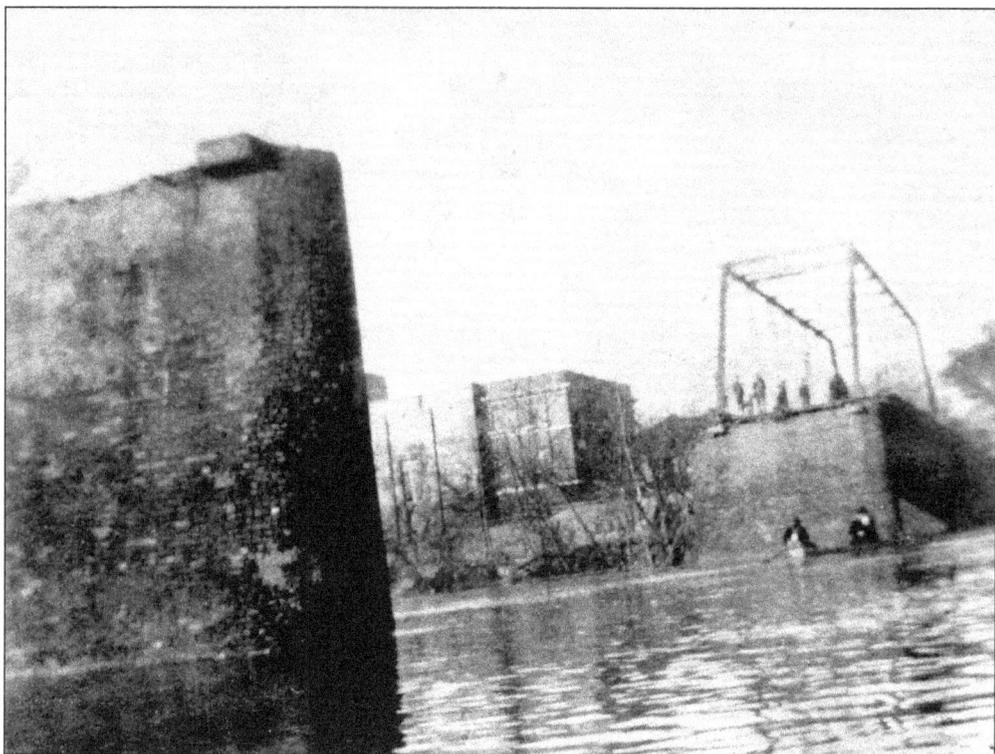

The iron bridge over the Chattahoochee River at West Point was one of the many structures damaged or destroyed in the flood of December 1919. This rare image shows local citizens examining the remains of the structure after its main span was swept away by the deluge. (Courtesy of the Troup County Archives.)

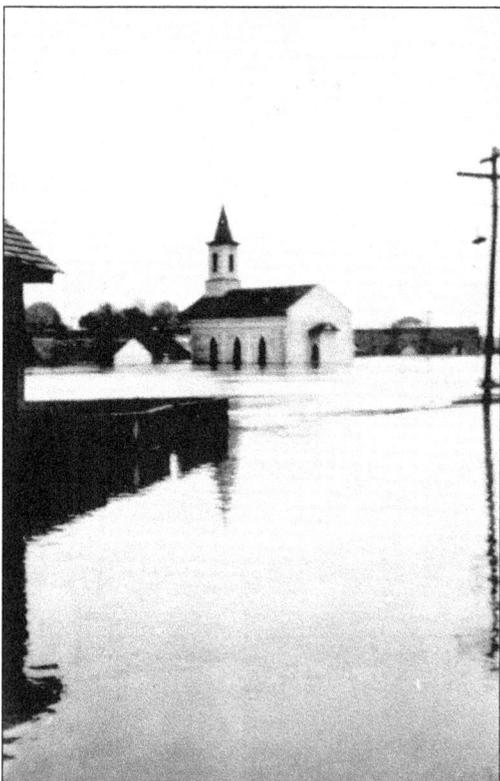

Built in 1852 with slave labor, the Presbyterian Church in Lanett had already survived both the Civil War and the flood of 1886 when one of the worst floods on record hit the lower Chattahoochee Valley in 1919. The church is shown here surrounded by high water from the 1919 flood. Coincidentally, the church was destroyed the next year by a tornado. (Courtesy of the Troup County Archives.)

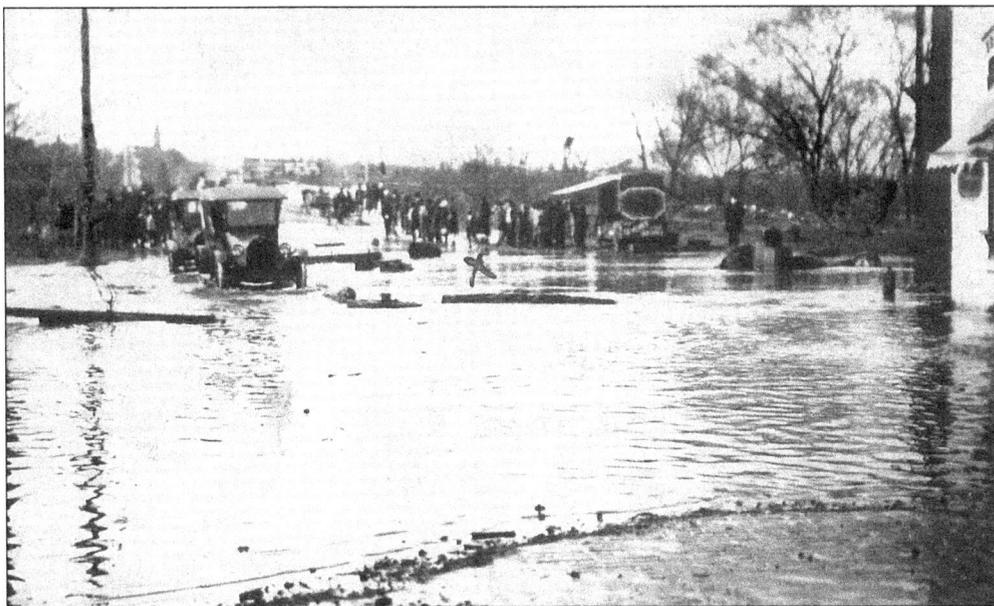

The lower Chattahoochee floods of 1919 and 1922 became known in the Columbus area as the first and second "Pershing Floods" because they occurred during Gen. John "Black Jack" Pershing's visits to Fort Benning. The events led the general to quip that Fort Benning might make as good a navy post as an army one. (Courtesy of Dennis Jones.)

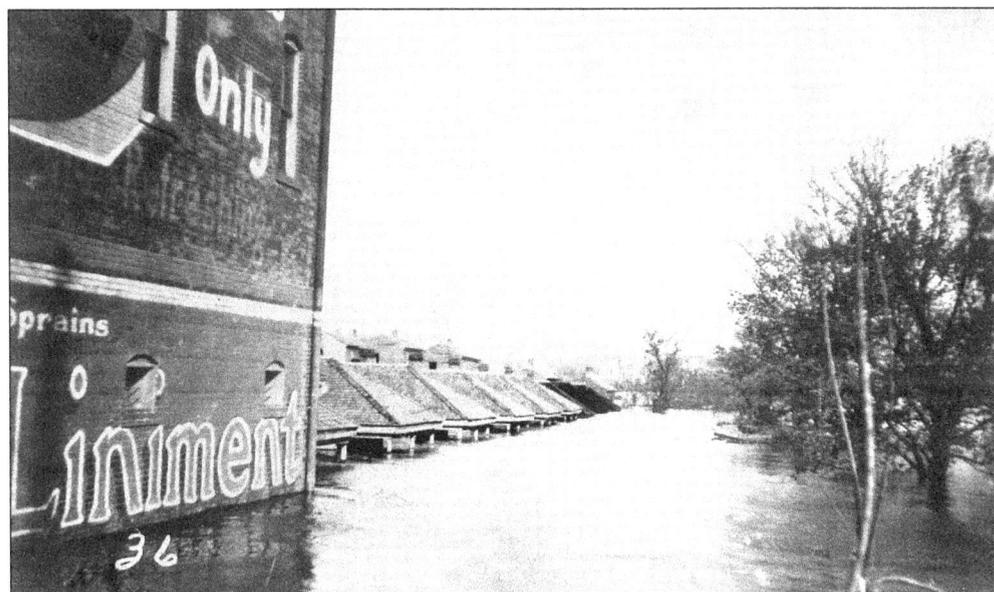

Taken from the Alabama, or Girard, side of the Dillingham Street Bridge, this image graphically shows the extent of the devastating lower Chattahoochee River flooding of 1919. Though closely connected physically and historically, the communities of Girard and Phenix City were not officially merged under one government until 1923. (Courtesy of Dennis Jones.)

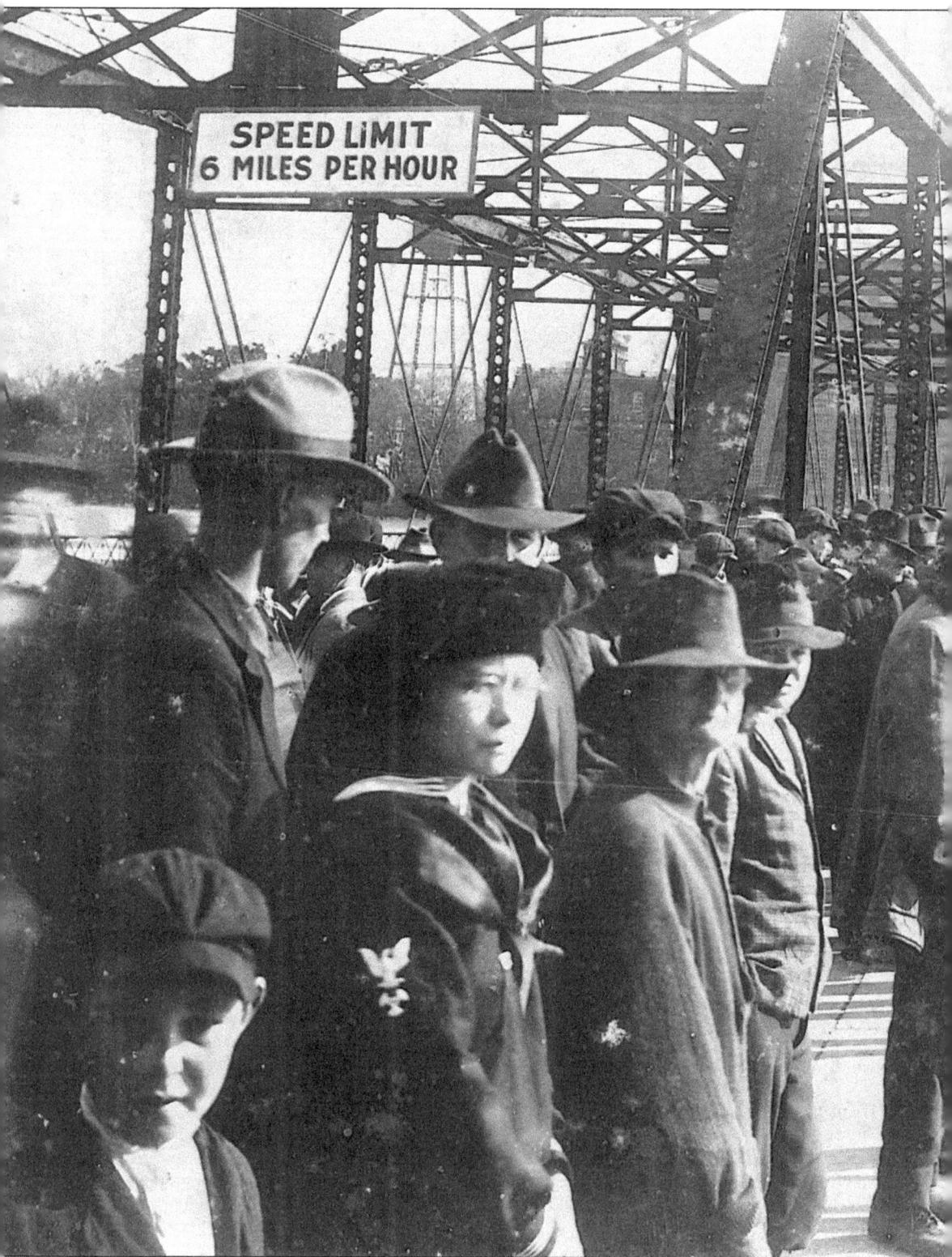

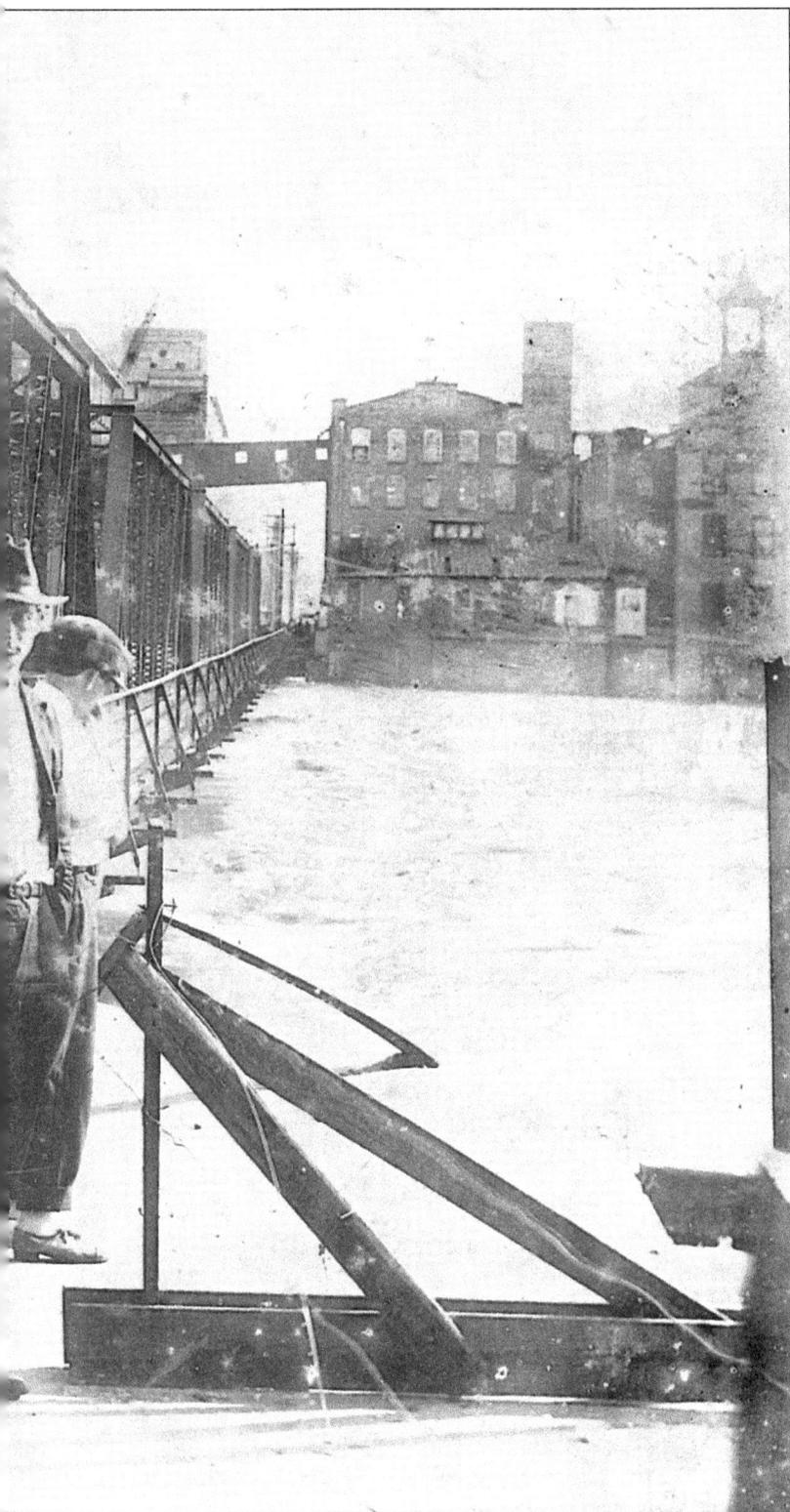

Chattahoochee River floods have always been major events and historical milestones for those living along the river. In this image, a group of spectators representing an interesting cross-section of portions of the populations of Columbus and Phenix City at the time has gathered at the Fourteenth Street Bridge to witness the power of the 1919 flood firsthand. The photograph was taken from the Alabama side of the river, as a Columbus mill can be seen in the background. Because of the height of the bluffs on which Columbus and Phenix City are located, Chattahoochee River floods have rarely hit those cities as hard as periods of high water upstream in the West Point, Georgia, area. As the speed limit posted on the bridge confirms, life truly operated at a slower pace back then. (Courtesy of Jim Cannon.)

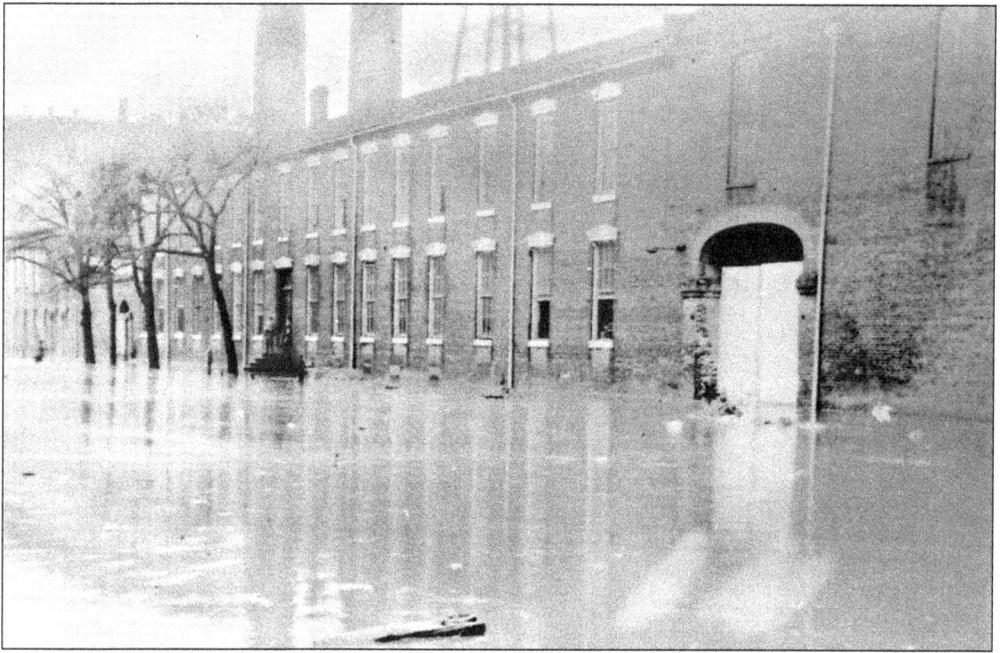

In an effort to save the vast amounts of cotton stored in their facilities, riverfront mills in Columbus hired dozens of temporary workers to haul bales of the fiber to higher floors. This image shows the extent of the flooding at the Eagle and Phenix Mills complex on Front Avenue in Columbus, one of the hardest-hit areas in town. (Courtesy of Jim Cannon.)

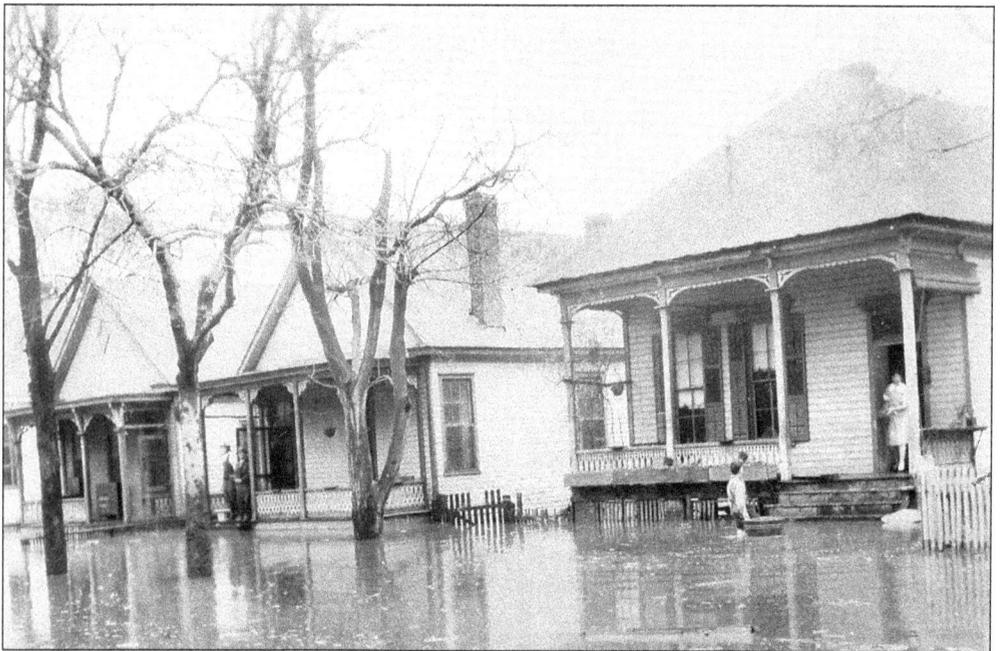

Floodwaters rose so swiftly that some citizens in Columbus and Phenix City were stranded, such as those in this photograph of homes near the Dillingham Street Bridge in Phenix City, and some had to be rescued from rooftops. The local Red Cross gave aid to hundreds of citizens displaced by the rise of the Chattahoochee. (Courtesy of Jim Cannon.)

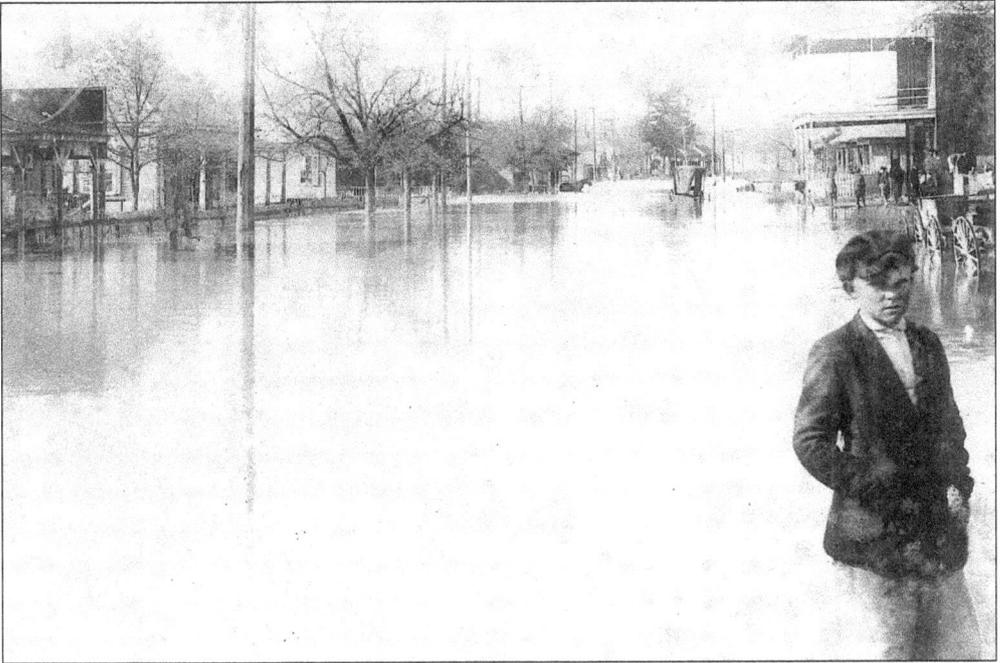

The 1929 flood inundated large areas of the lower Chattahoochee River Valley for an extended period of time. Rather than one large rise in the river with a single crest, it was actually a prolonged period of high water that crested four times in 24 days. Practically all communication between Columbus and Fort Benning was lost. In an effort to keep railroad bridges from washing away, some bridges had railroad cars loaded with coal placed on them as a means of weighing them down. (Courtesy of Jim Cannon.)

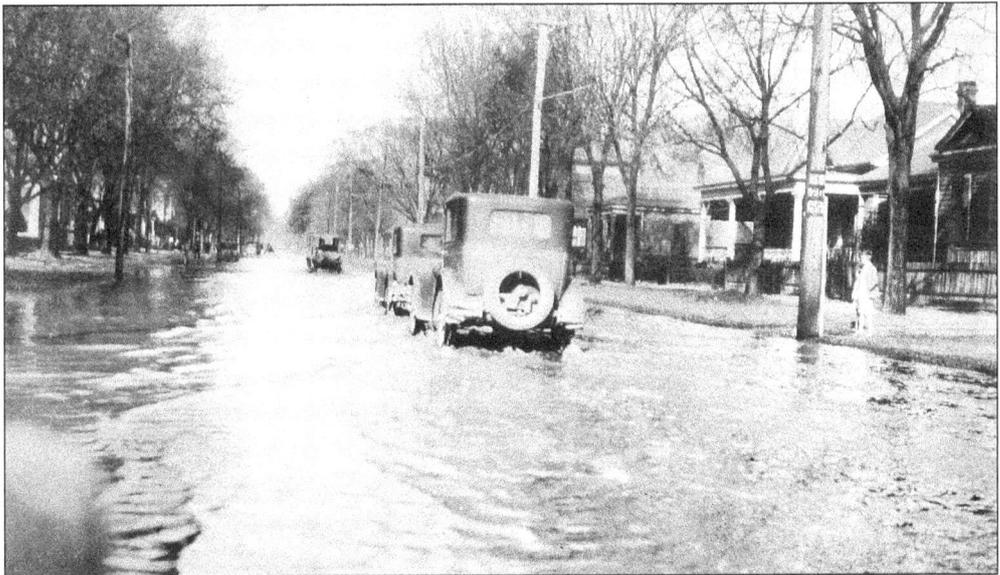

Known locally as the second "Hoover Flood" because it occurred while Pres. Herbert Hoover was in office, the flood of March 1929 is the highest on record in the Columbus area. At its height, the Chattahoochee reached an incredible level of 53.3 feet in Columbus, inundating areas of downtown that had never previously been flooded by the river. (Courtesy of Dennis Jones.)

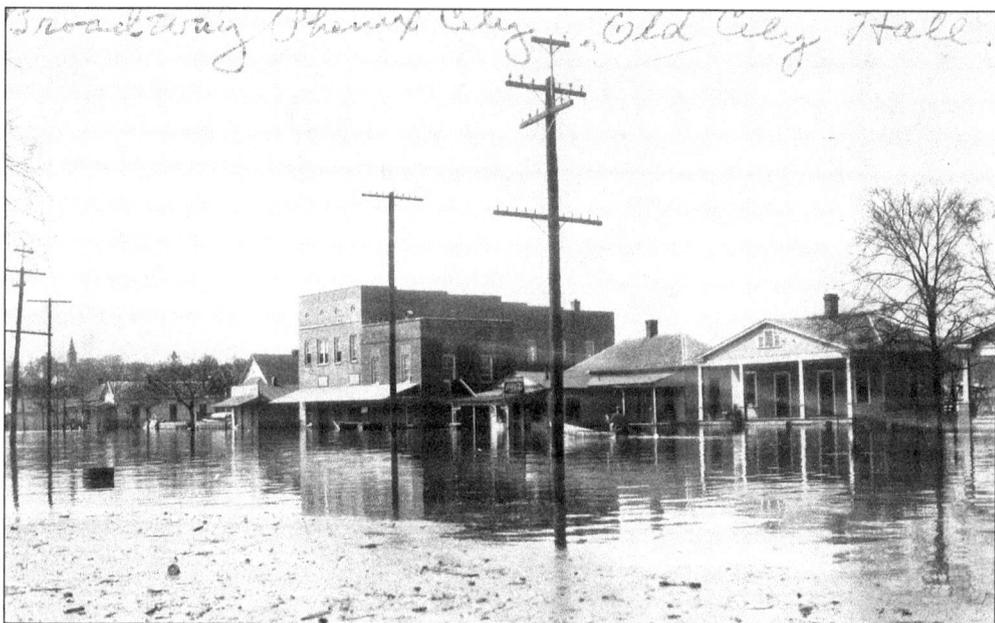

The 1929 flood inundated downtown Phenix City to an extent never seen before or since. Broad Street, one of the main thoroughfares of the city, was impassable for days. (Courtesy of Dennis Jones.)

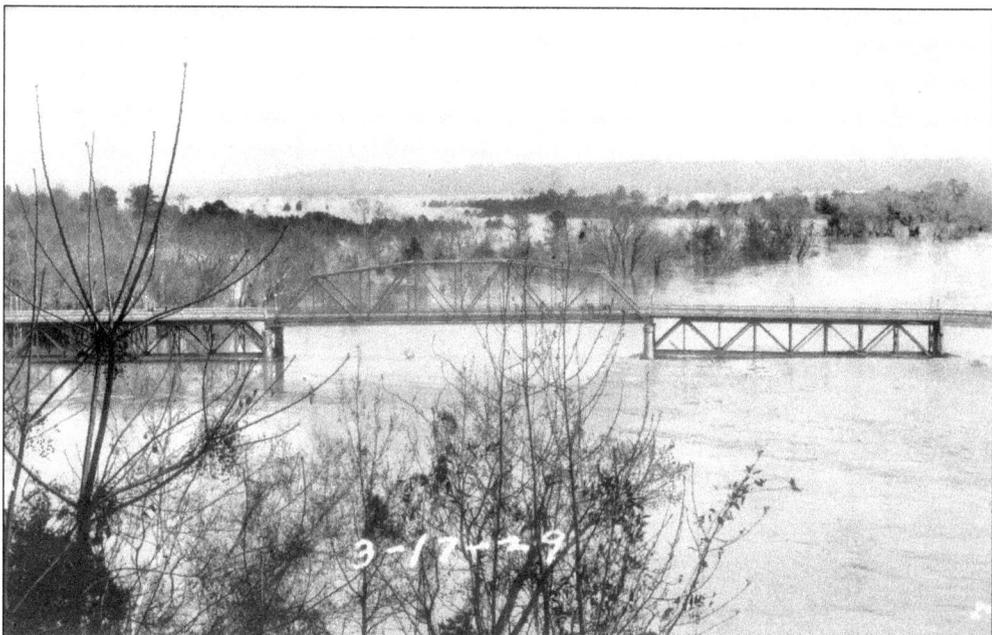

The flood of 1929 covered the Georgia Flats. Memories of this flood may have been a factor in convincing residents along the Chattahoochee that a dam was needed for flood control. (Courtesy of Mary Thomas.)

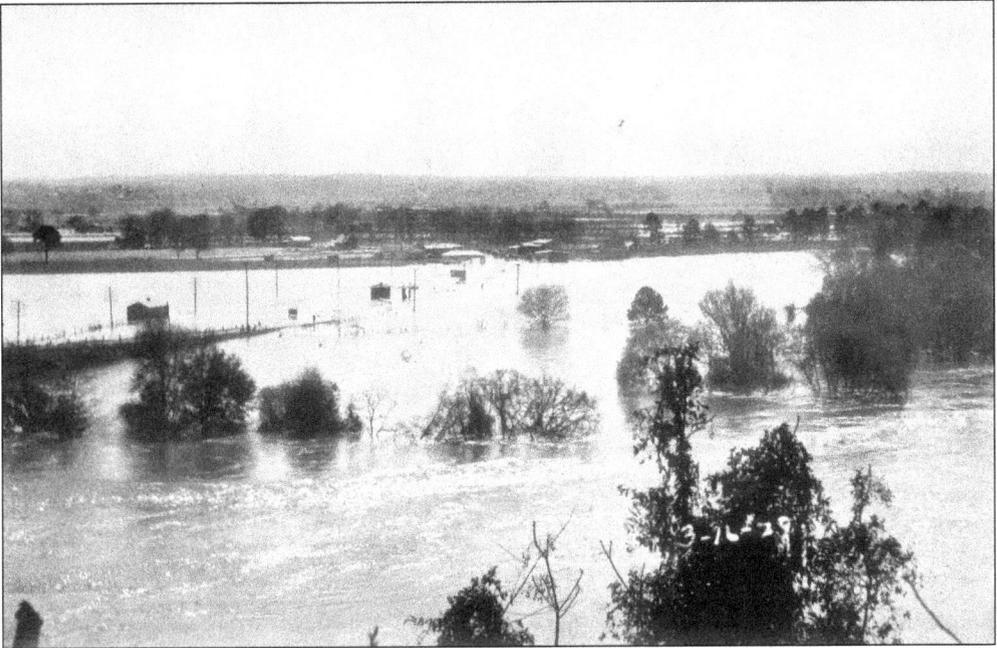

This scene is of the 1929 flood of the Chattahoochee River looking from Georgia westward towards Eufaula. (Courtesy of Rob Schaffeld.)

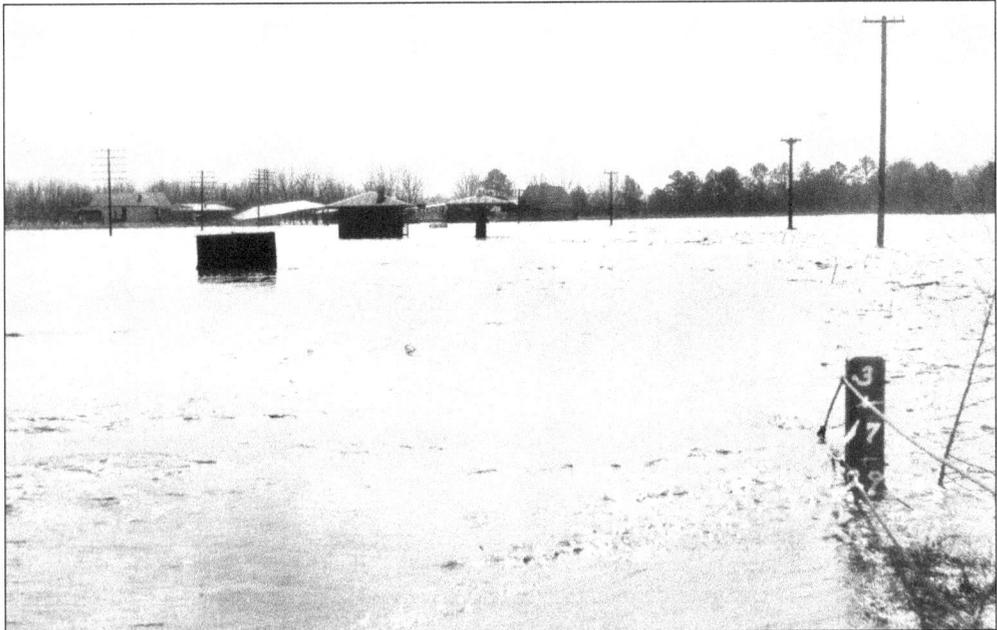

March 1929 floodwaters caused the Chattahoochee River to rise to 63.9 feet in Eutaula, its highest point in history. The spreading waters covered the fields on the Alabama side of the bridge from St. Francis Bend nearly to the roadway leading to Eufaula. (Courtesy of Rob Schaffeld.)

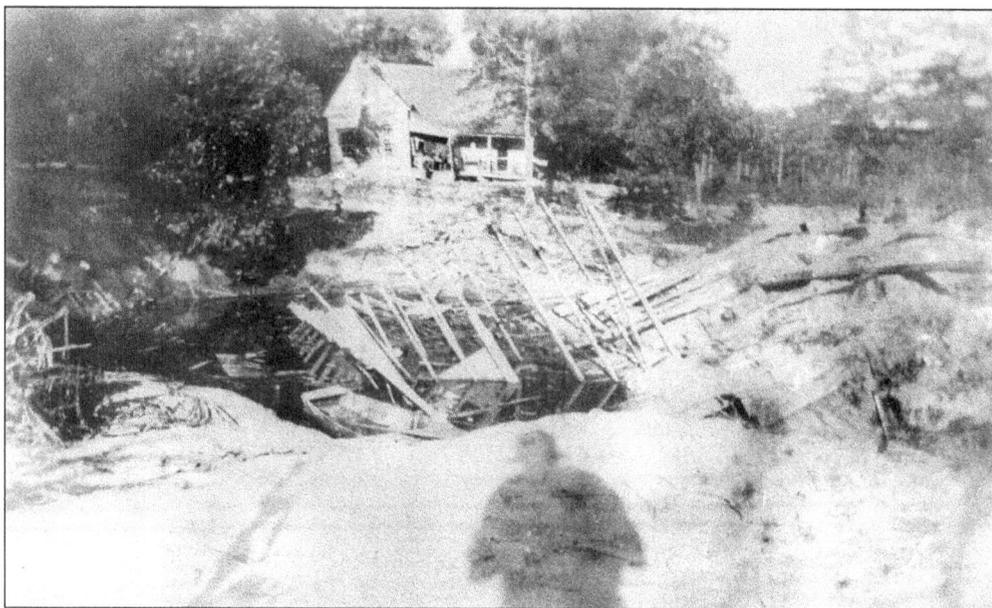

Residential sections in low areas of Columbia near the Chattahoochee River were destroyed during the flood of 1929. (Courtesy of the L. H. Adams Collection.)

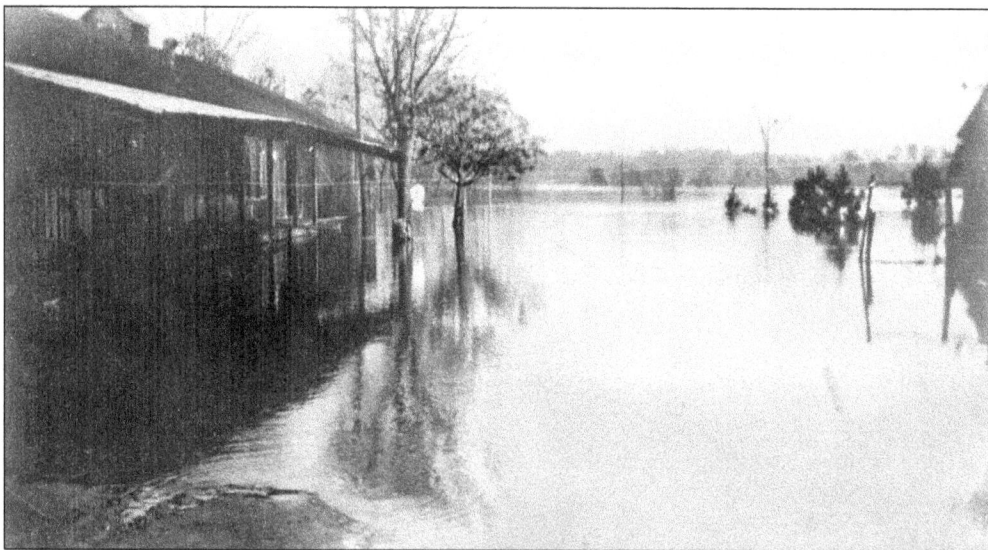

Periodically during heavy and prolonged rains, the Chattahoochee River overflowed its banks and flooded the lowlands surrounding Columbia, except on the north. Fortunately Columbia's business and residential sections sit atop a plateau and are spared the devastation of the seasonal floods. At its highest point, the 1929 flood, shown here near the railroad depot with the Chattahoochee River in the distance, devastated all structures in the lower area of the town near the river. (Courtesy of the L. H. Adams Collection.)

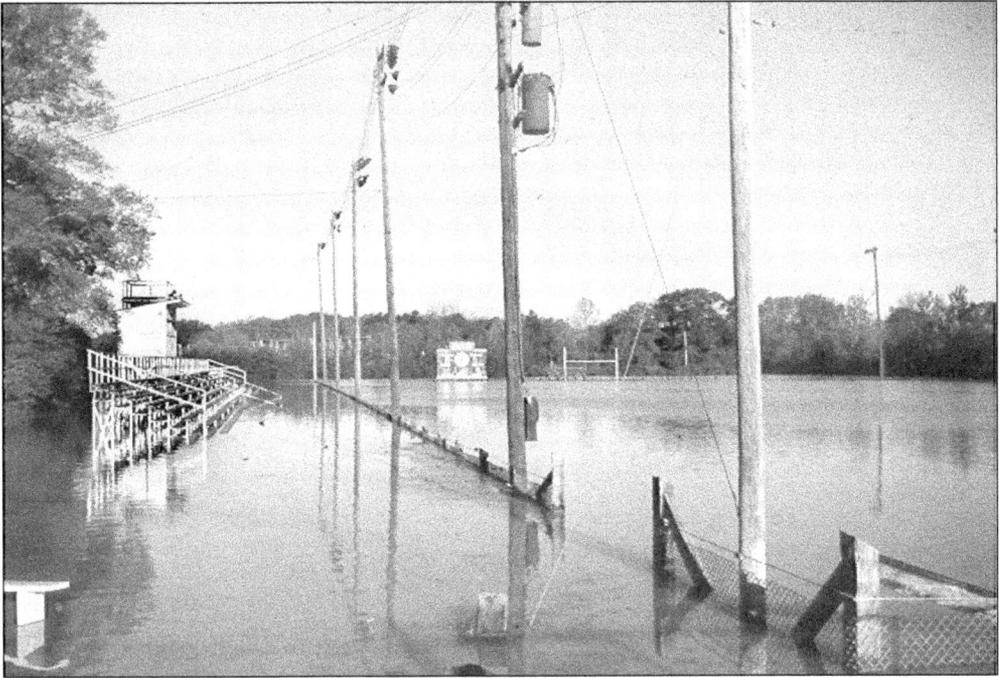

Because of its location on a relatively low bank of the Chattahoochee, West Point High School's River Bowl Stadium was a frequent victim of flooding. This photograph, believed to be taken during a flood in the 1950s, shows one of the times the facility was inundated. (Courtesy of the Troup County Archives.)

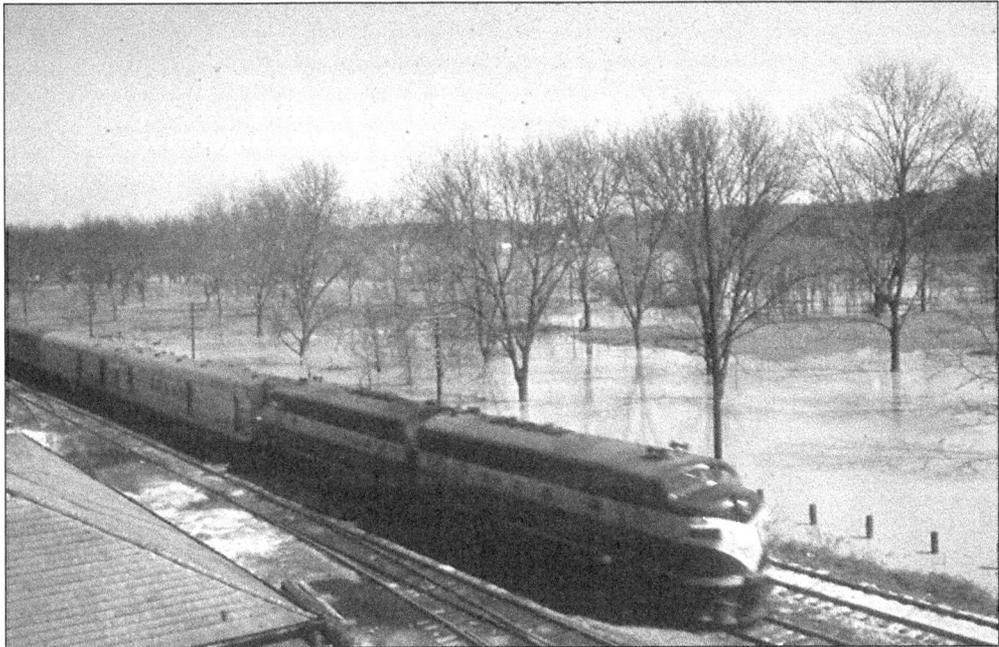

All forms of transportation near the Chattahoochee in the West Point area are affected when the river rises. This image, taken during flooding in the 1960s, shows a train as it makes its way through the town. (Courtesy of the Troup County Archives.)

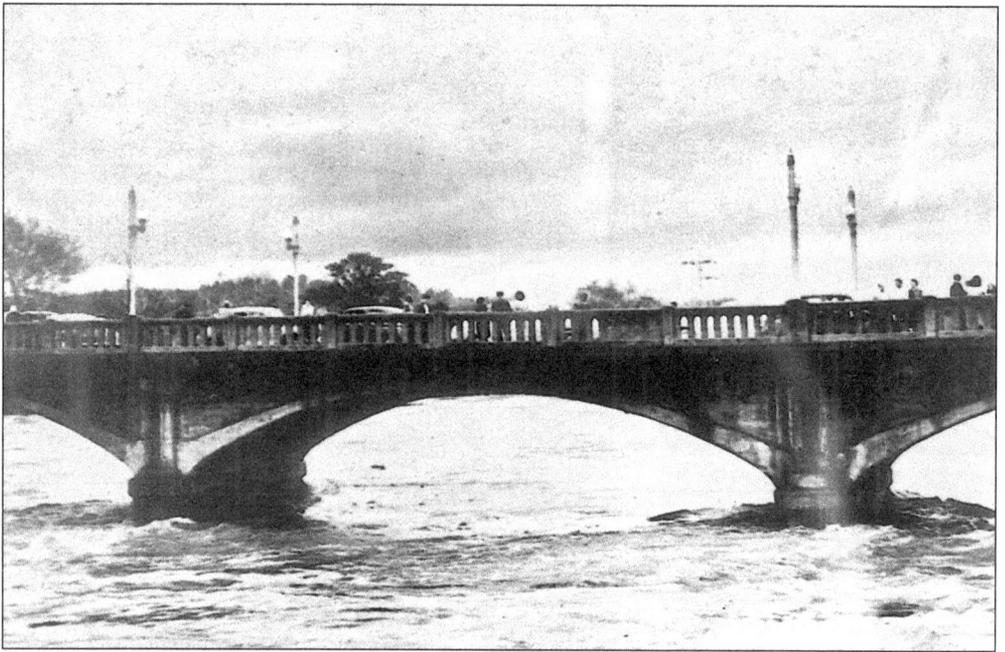

Perhaps no other occurrence better illustrates the power of the river than a major flood. This image shows a small crowd gathering on the Dillingham Street Bridge in 1953 to witness a flood. As can be seen in other images of the bridge elsewhere in this book, the normal level of the river is dramatically lower than it is at the time this photograph was taken. (Courtesy of Jim Cannon.)

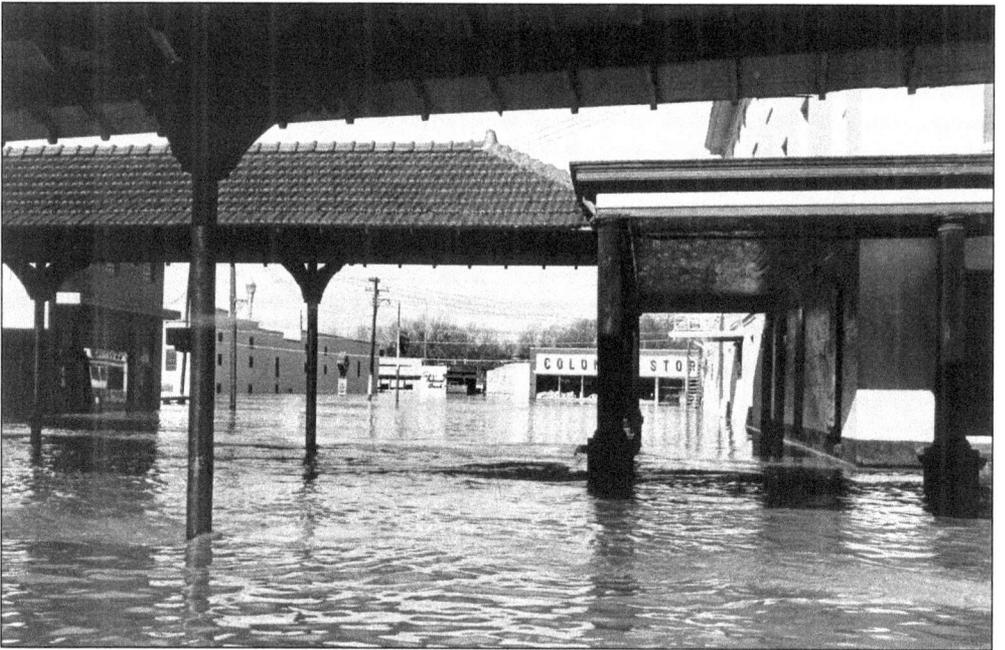

The flood of 1961 crested in West Point at 24.7 feet, marking the highest the river had risen in that area since 1929. The low-lying downtown area was hit particularly hard, as in some portions of the heart of the city water stood as much as five feet deep. (Courtesy of the Cobb Memorial Archives.)

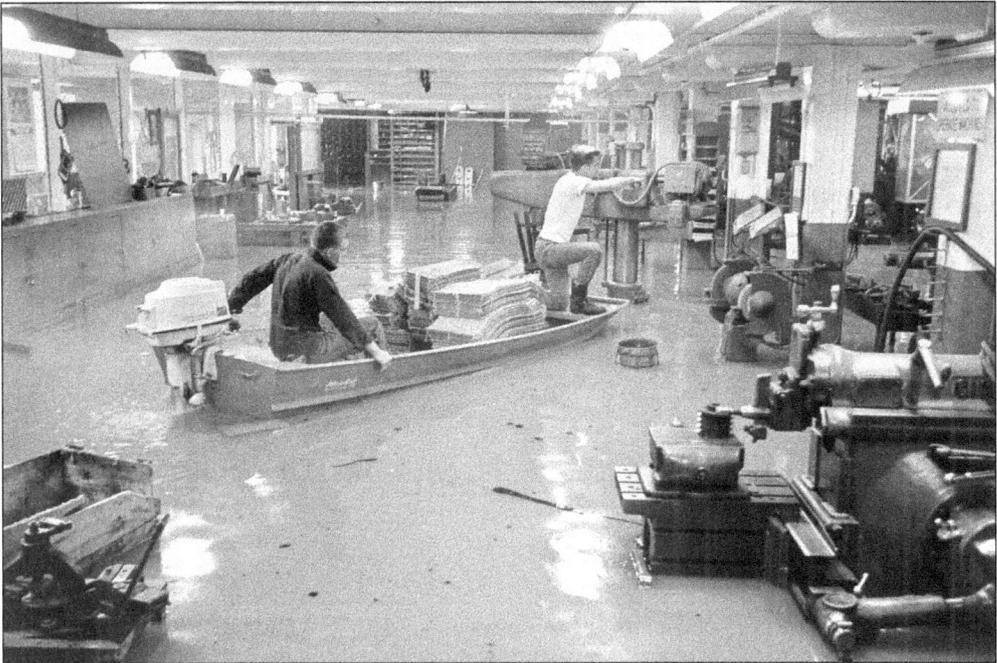

The 1961 flood halted work at Lanett and Riverdale Mills and several other businesses for over two days. This photograph of employees inside the machine shop at Riverdale was one of several that documented the event in the *Westpointer*, a publication for employees of West Point Manufacturing Company and its subsidiary companies. (Courtesy of Cobb Memorial Archives.)

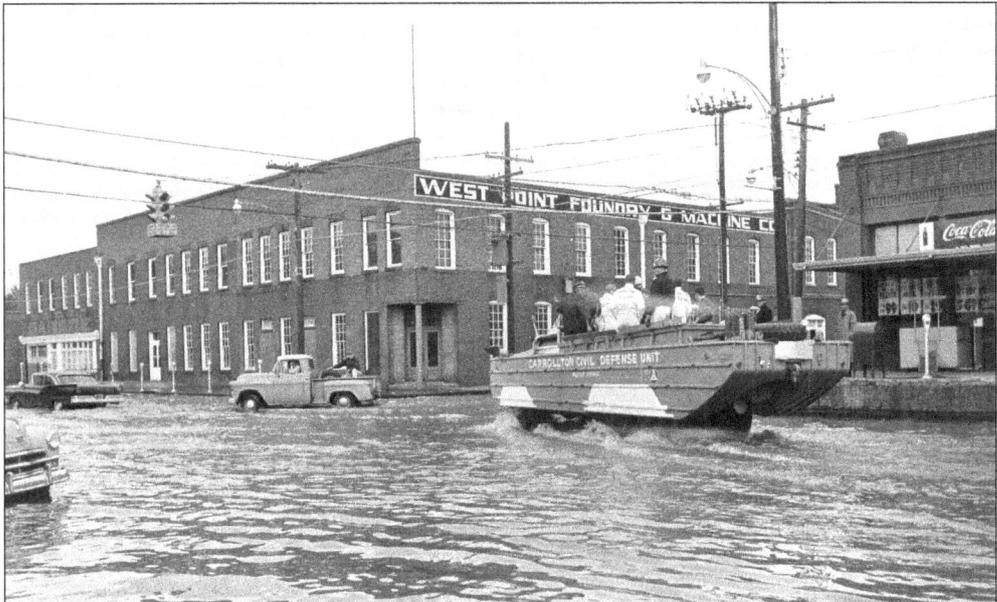

The West Point area was devastated by the flood of 1961, which marked the 40th time since 1900 the river reached flood stage in the community. When advocates of the proposed dam at West Point, which had been discussed for decades, seized the opportunity to make their case to the federal government, Congress was receptive. In the 1962 Flood Control Act, it authorized the construction of West Point Dam. (Courtesy of the Cobb Memorial Archives.)

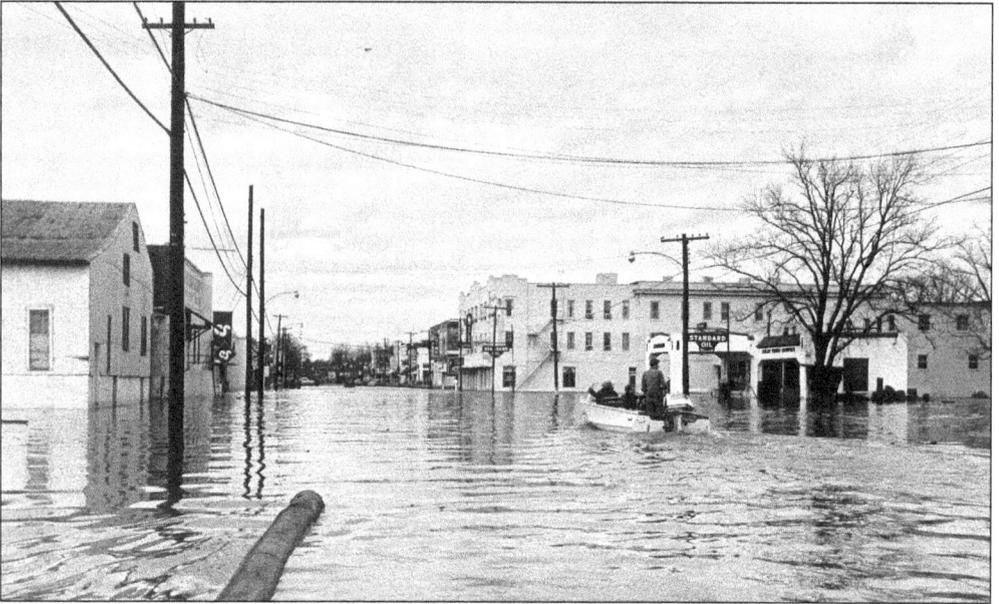

Though the great majority of damage to businesses in downtown West Point was directly caused by high water, at least some of the destruction was due to sightseers. According to newspaper reports, when locals donned wet suits and water-skied down Third Avenue, the wake from the boats broke glass storefronts. (Courtesy of the Cobb Memorial Archives.)

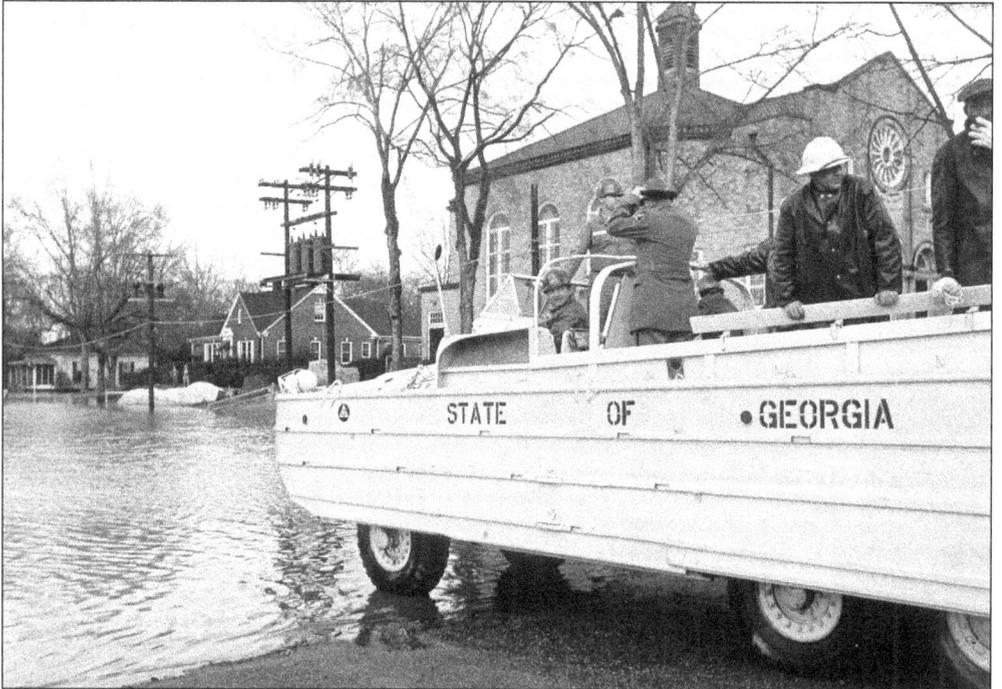

A variety of law enforcement officials were brought into the West Point area to assist in the relief effort, including reservists from the navy's utility helicopter squadron and civil defense units. Due to the extreme circumstances, police were forced to patrol flooded streets in boats. (Courtesy of the Cobb Memorial Archives.)

Built in 1874 in Columbus, the *George W. Wylly* served nine years on the Chattahoochee before meeting with a tragic end. As she approached Fort Gaines at 10:30 p.m. on the night of April 11, 1883, the boat hit one of the piers supporting the bridge and sank in less than three minutes. Thirteen people were drowned in the unfortunate incident. (Courtesy of Ed Mueller.)

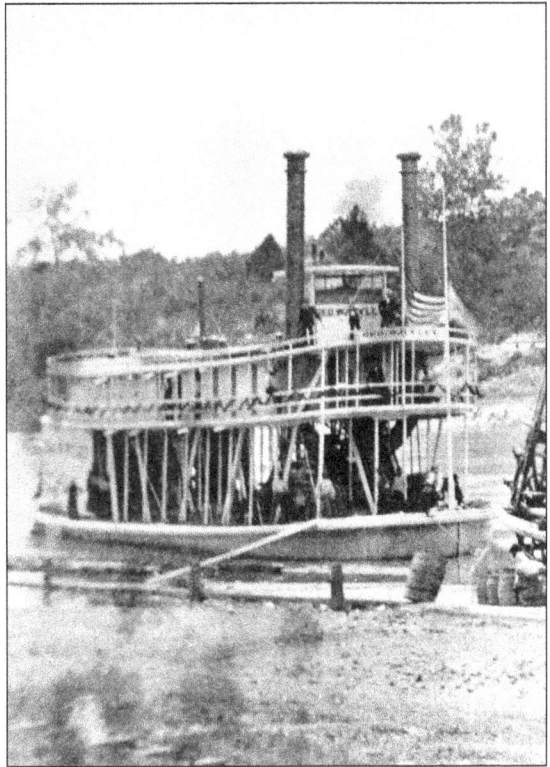

These items were recovered from the wreck of steamboat *C. D. Owens*, which caught fire at the Columbus wharf on March 22, 1899, and was destroyed. The fire quickly spread from the steamer and engulfed two other vessels, the *Bay City* and the *Flint*, and all three were cut loose to prevent further disaster and allowed to drift downstream ablaze. Fortunately no lives were lost. (Courtesy of the Columbus Museum.)

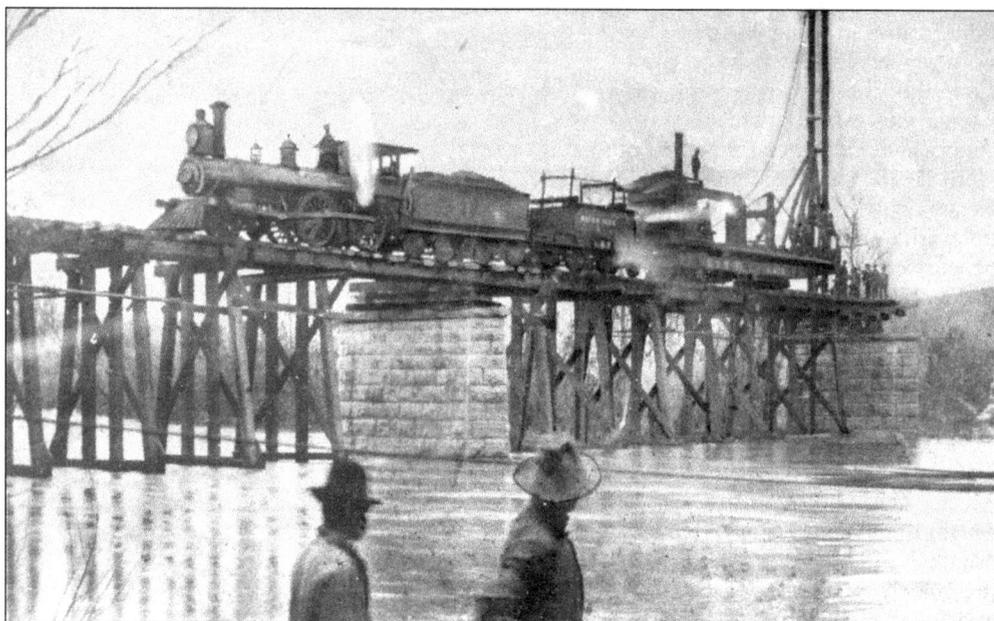

On February 20, 1905, the railroad drawbridge across the river at Columbia was opened to allow the *Queen City* to pass. Central Railroad Passenger Train No. 13, traveling from Georgia into Alabama, ran the signal and began crossing the open drawbridge. The engine and its tender, breaking its coupling with the three coaches, plunged through the still-open drawbridge into the Chattahoochee. The baggage and mail car hung over the bridge. Engineer Elijah Pate, fireman C. B. Bates, and visiting engineer John Dobbins (all of Albany, Georgia) drowned. In this photograph, two men look on as a pile driver pulls the wrecked engine and tender from the river. (Courtesy of the L. H. Adams Collection.)

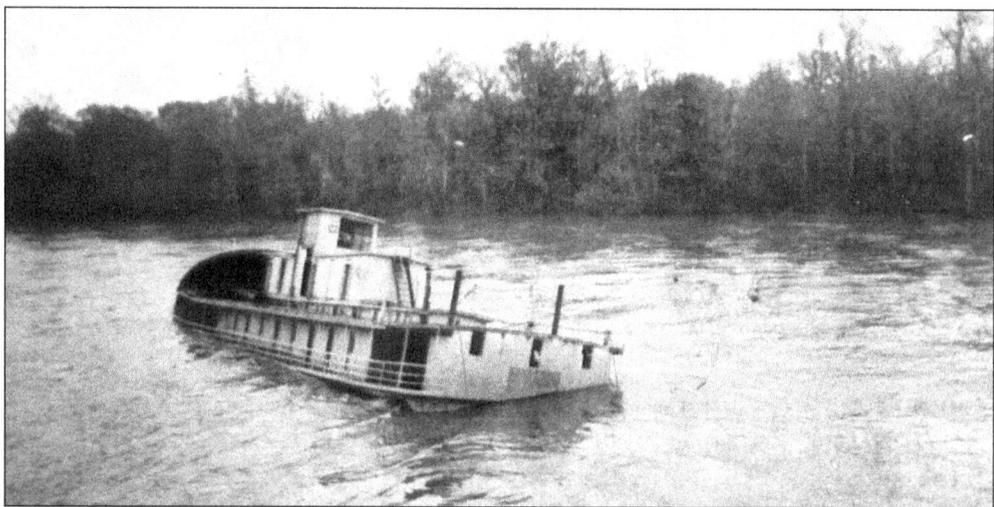

From its earliest days, steamboating on the Chattahoochee was a dangerous enterprise. The river was relatively shallow for most of the year, especially in its upper navigable reaches, and filled with dangerous hull-puncturing snags only the most experienced pilots could recognize. The inherent dangers of operating high-pressure steam-powered engines and the flammable cotton cargo only added to the danger. This wreck, though a much more modern one, is evidence that travel on the river was dangerous regardless of the era. (Courtesy of F. Clason Kyle.)

Seven

MILITARY LEGACY

Fort Apalachicola was constructed by the Spanish using Apalache Indian slaves from Florida in 1689 on the western bank of the Chattahoochee River. The fort, located near a friendly Hitchiti Indian village in present-day Russell County, was intended to serve as a barrier to encroachment into Spanish territory by English traders from the east. The difficulty of sustaining such a remote outpost, combined with the fact that area Native Americans continued to carry on trade with the English, convinced the Spanish to abandon the fort in 1691. This image showing a plan of the fort can be found in the Archives of the Indies in Seville, Spain. (Courtesy of Thomas Foster, Ph.D.)

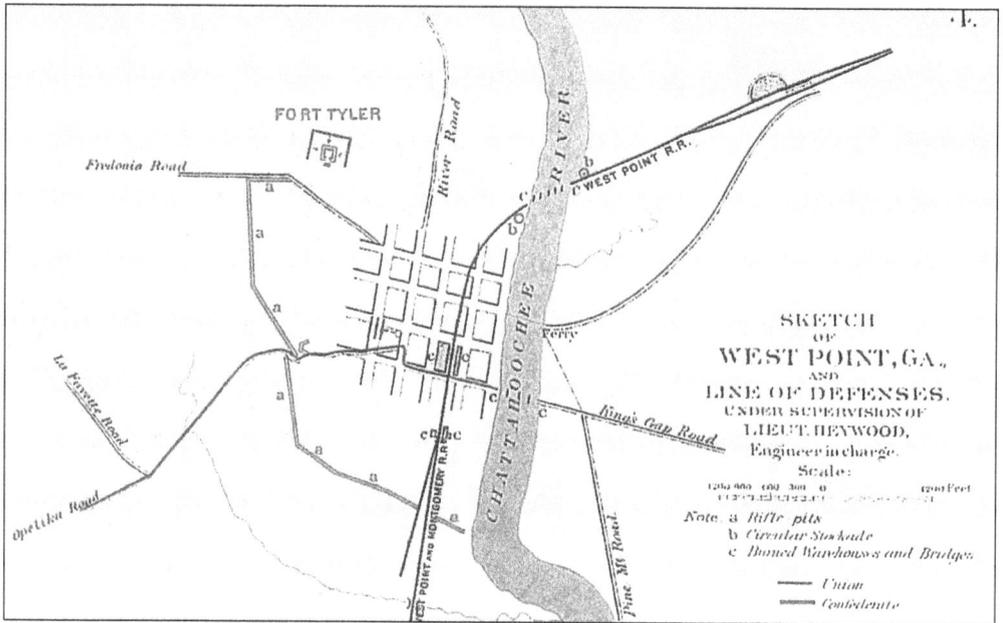

As he approached the Chattahoochee during his raid into Alabama and Georgia in the spring of 1865, Union general James H. Wilson divided his forces to secure the crossings of the river at West Point and Columbus. Col. Oscar H. LaGrange's command reached West Point on the morning of April 16, 1865. By the end of the day, LaGrange had captured the bridge and forced the surrender of the town's only point of defense, Fort Tyler. This map showing the fort originally appeared in the *Official Records of the Union and Confederate Armies.* (Courtesy of the Columbus Museum.)

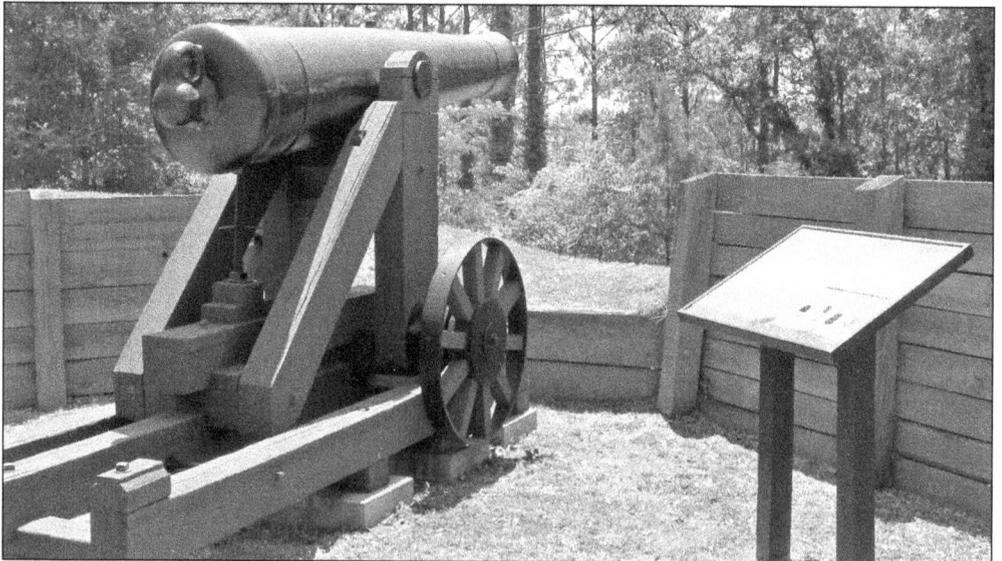

Some of the fiercest fighting of the Civil War in the lower Chattahoochee Valley took place at Fort Tyler, named in honor of Brig. Gen. Robert C. Tyler. Built in the fall of 1862 to protect the vital rail center of West Point, Georgia, the small dirt fort contained an interior of only about 35 square yards. With three cannons and an estimated 250 men, the fort's garrison withstood assaults by Union forces of over 10 times their number for several hours on Easter Sunday, April 16, 1865. This reconstruction of the fort stands on the site today. (Courtesy of the Columbus Museum.)

The Confederate ironclad gunboat CSS *Jackson* (also known as the CSS *Muscogee*) was built in Columbus by the Confederate Naval Ironworks. Begun in 1862 and launched in 1864, the ship was not fully completed when Union forces raided Columbus in April 1865. Though burned to the waterline by Union troops, the remnants of the massive warship were salvaged in the 1950s and are today on display at the Port Columbus National Civil War Naval Museum. This photograph is believed to be one of only two known images of Confederate ironclads in service. (Courtesy of the Port Columbus National Civil War Naval Museum.)

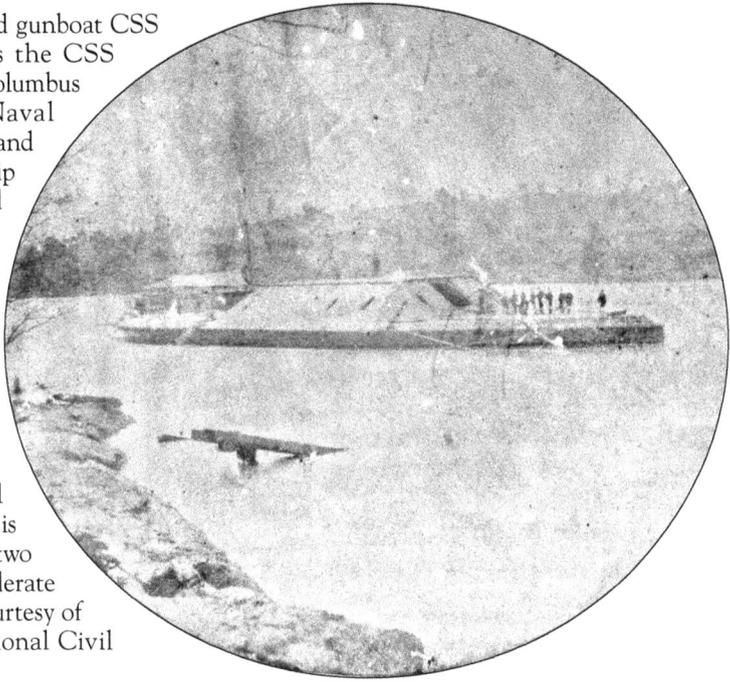

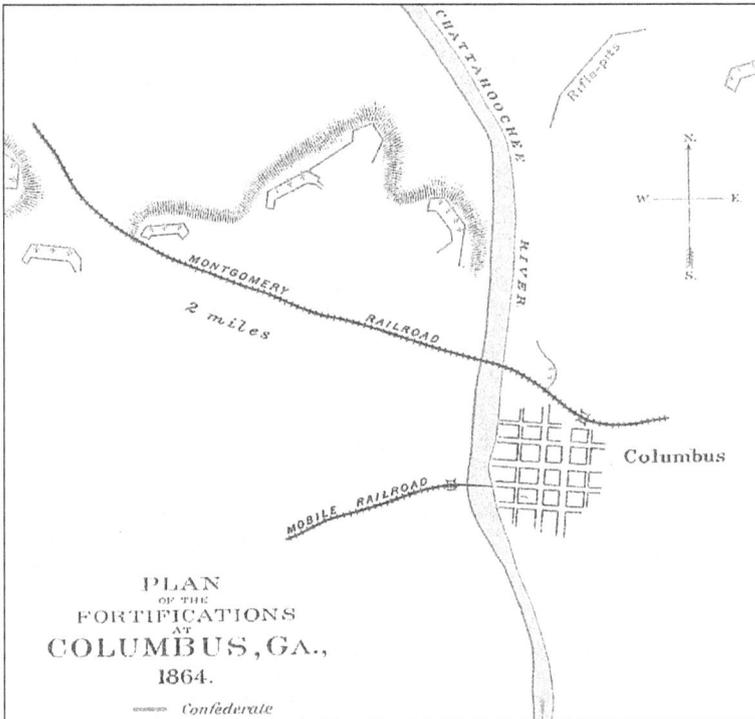

This map first appeared in the atlas that accompanied the *Official Records of the Union and Confederate Armies*. Columbus was captured by Union general James H. Wilson after a brief but spirited evening battle on April 16, 1865. (Courtesy of the Columbus Museum.)

Fort Mitchell was built during the Creek War by the Georgia militia in present-day Russell County, Alabama. At various times, it was a trading house and the location of the U.S. Indian Agency. During the Second Creek War in 1836, the fort once again became an important military outpost. At the conclusion of the conflict, an estimated 2,000 to 3,000 Creeks were concentrated at the fort before beginning their journey west in what became known as the Trail of Tears. This image shows the remnants of the Indian Agency in the early 1900s. (Courtesy of Thomas Foster, Ph.D.)

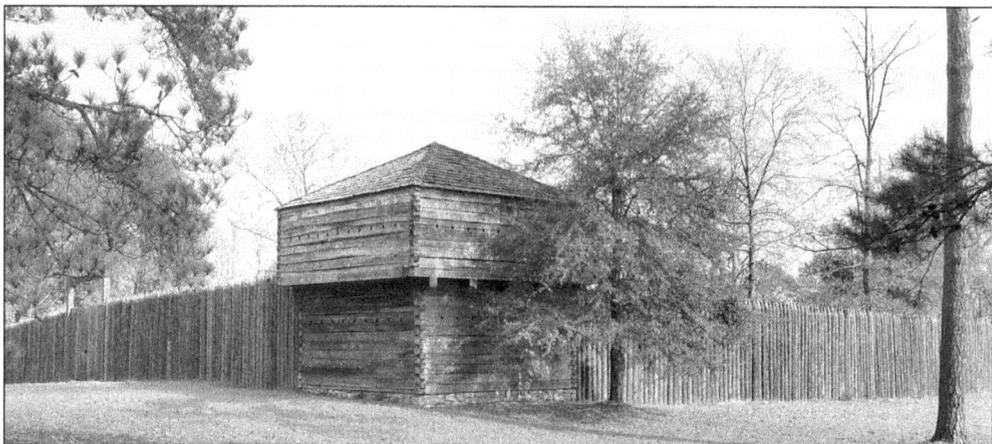

Nothing is left of Fort Mitchell, which was abandoned in 1840. This reconstruction of the historic structure is located near the spot where the original fort stood. Its construction was financed by local governments, corporations, and private individuals with support from a grant by the National Park Service. (Courtesy of the Columbus Museum.)

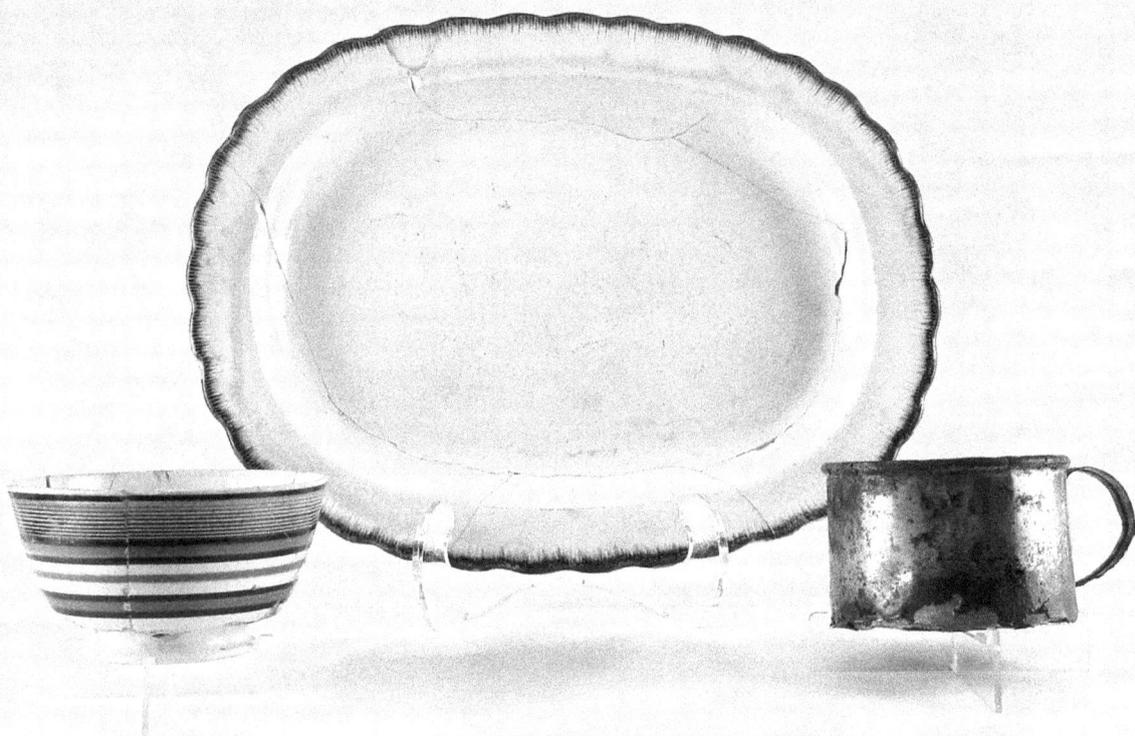

Several notable personalities visited Fort Mitchell, including the Marquis de Lafayette during his visit to America in 1825, lawyer Francis Scott Key while investigating an alleged murder committed by a member of the fort's garrison in 1833, and Winfield Scott during the Second Creek War in 1836. By all accounts, however, daily life for most of the soldiers stationed at the fort was dreary and monotonous. These items are some of the few tangible reminders of their service that remain. (Courtesy of the Columbus Museum.)

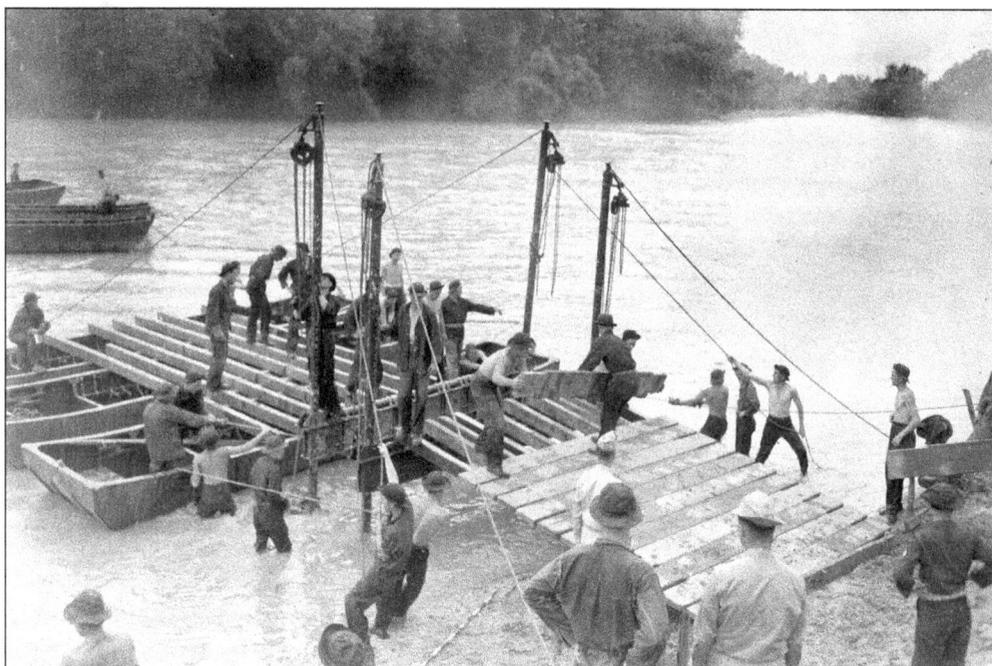

As a result of its location on the banks of the Chattahoochee, the training of troops at Fort Benning has often involved the river. Company A of the 20th Engineers is shown building a light pontoon bridge across the Chattahoochee in this July 1941 image. (Courtesy of the National Infantry Museum.)

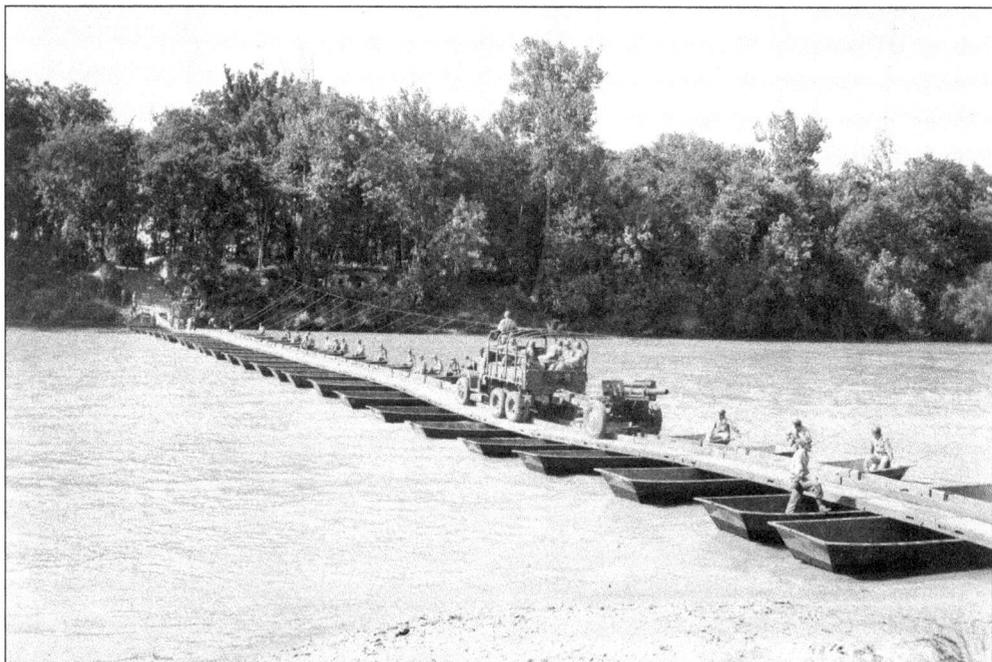

This 1940s image shows a two-and-a-half-ton military truck crossing the Chattahoochee River on a pontoon bridge. The truck is towing a piece of field artillery. (Courtesy of the National Infantry Museum.)

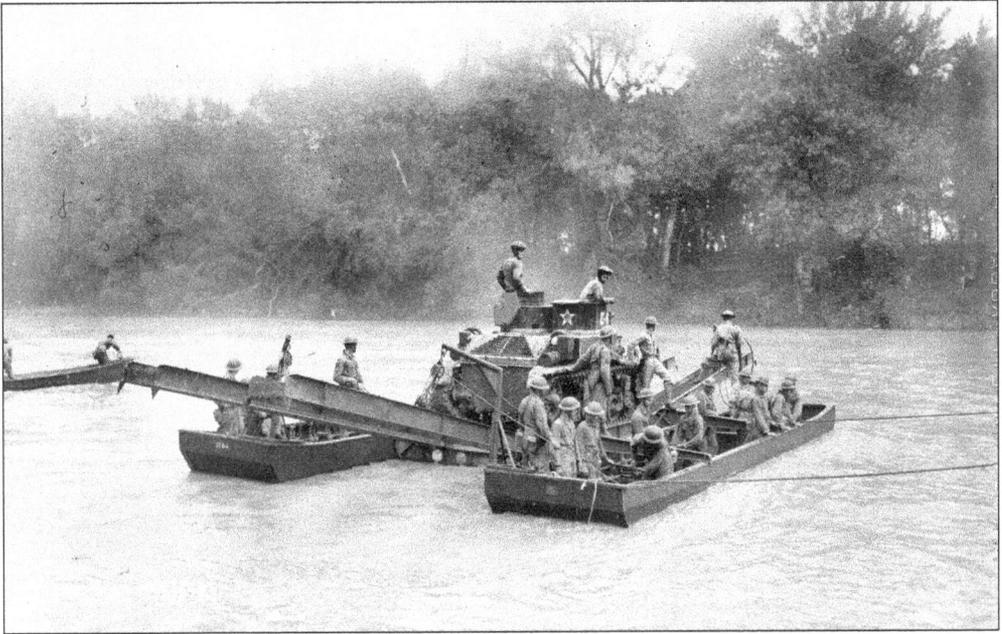

Pictured here are members of Company D of the 20th Engineers, specializing in heavy pontoon construction, pushing a tank across the Chattahoochee by means of a ferry they had built. (Courtesy of the National Infantry Museum.)

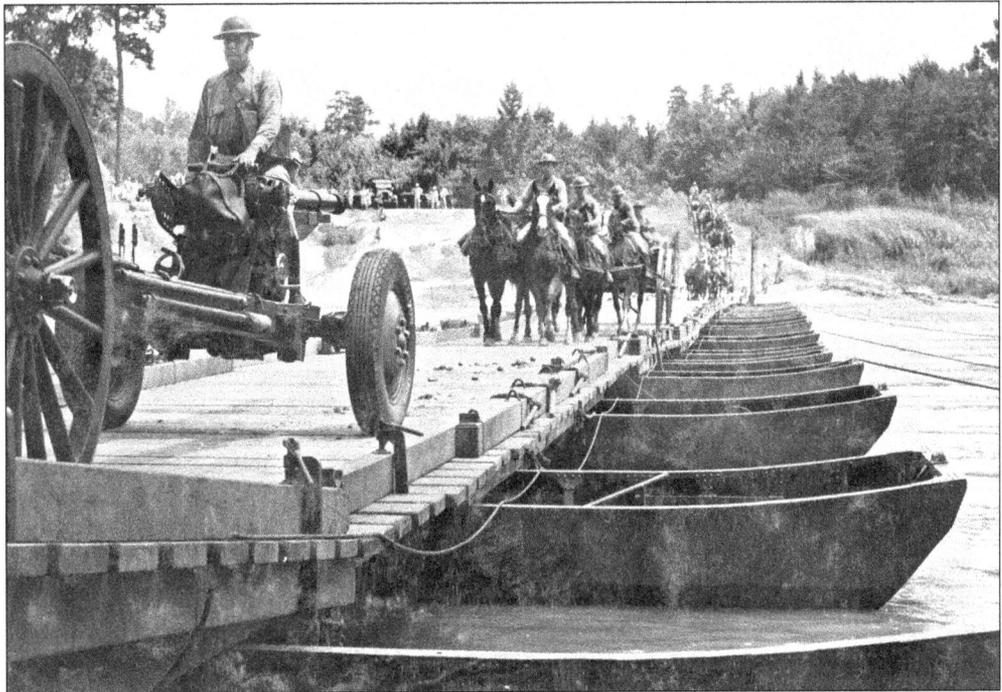

In this 1920s image, troops transport artillery across the river via a specially constructed infantry support bridge. Though the river has played a part in a wide variety of training exercises over the decades, its use as a proving ground for pontoon-bridge-building engineers has been one of the most common. (Courtesy of the National Infantry Museum.)

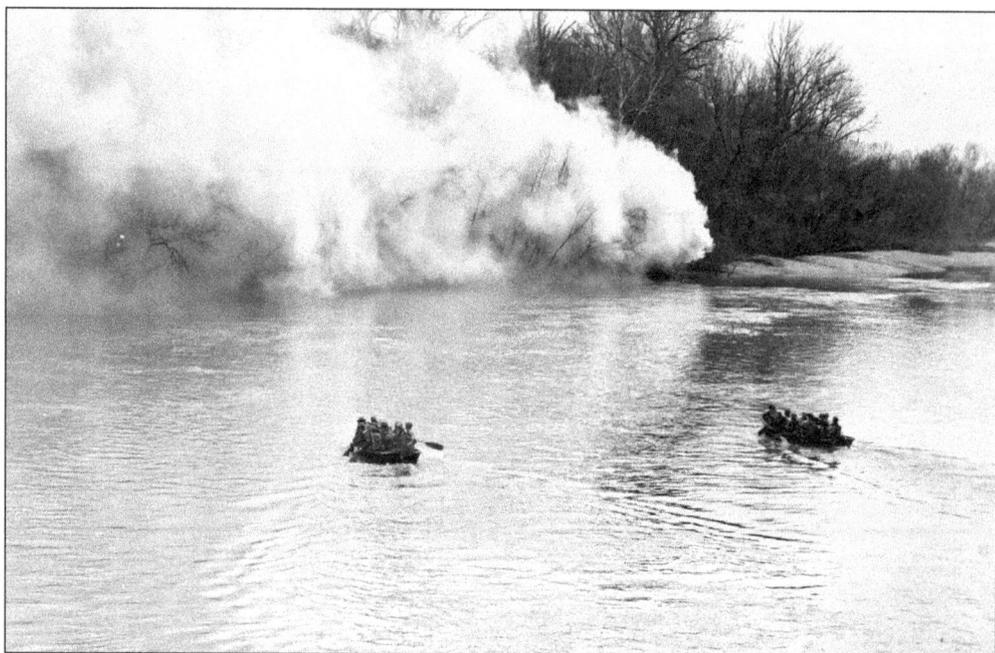

In this photograph, infantry troops at Fort Benning can be seen during a combat training exercise designed to help them secure stream crossings utilizing a smoke screen as protection. (Courtesy of the National Infantry Museum.)

Commandant's Quarters, the Infantry School, Ft. Benning, Ga.

Riverside mansion, built by Columbus businessman Arthur Bussey, serves as the residence of the Fort Benning commandant. The house, the result of a series of additions to a meetinghouse that had been moved from the nearby Woolfolk property on Lumpkin Road, originally served as a summer home for the Bussey family. The 1,800-acre plantation on which the house was located became part of the site of Camp Benning in 1919. (Courtesy of Dennis Jones.)

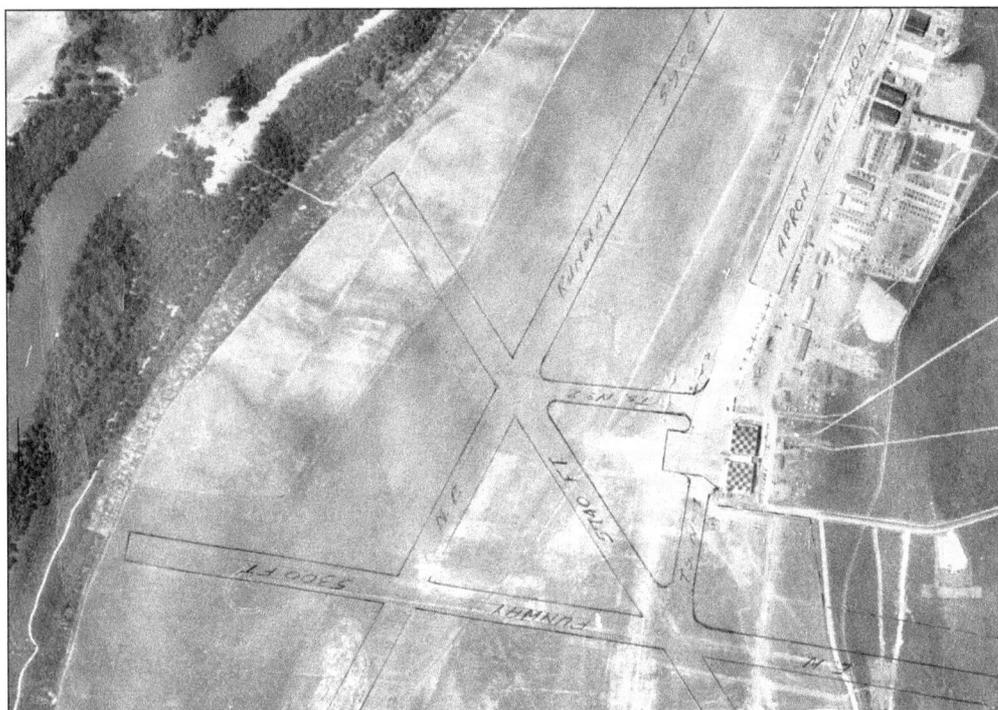

Lawson Army Airfield, the airport for Fort Benning, is named for Georgia native and decorated World War I veteran Capt. Walter Lawson. The airfield, which features two runways, was originally constructed to serve as a balloon landing field in the 1920s. This 1941 image of the field shows its proximity to the river. (Courtesy of Thomas Foster, Ph.D.)

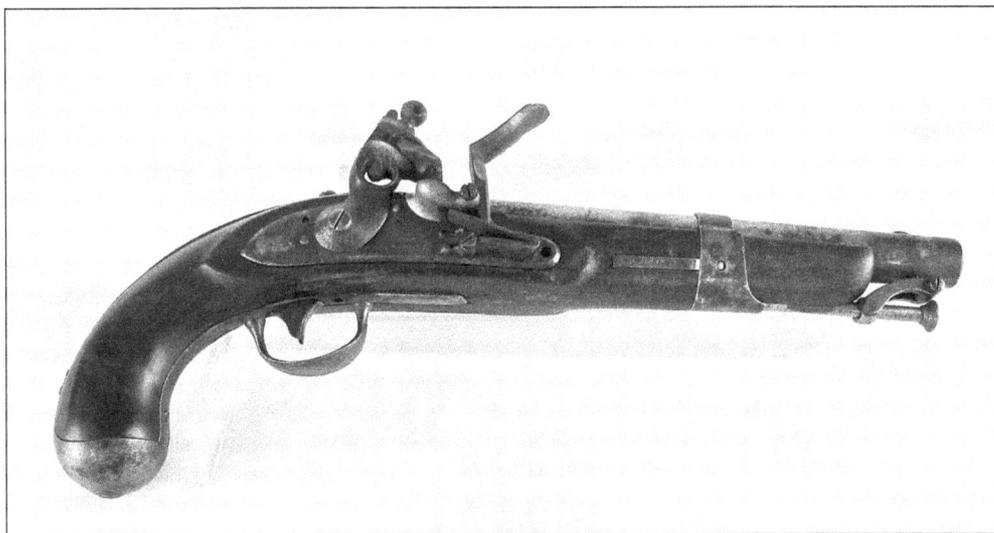

A small town in Stewart County with an estimated population of 600 in 1835, Roanoke played a pivotal role in the Second Creek War. A large group of Creek warriors, angered by constant encroachment on their lands, destroyed the town in a surprise attack on May 15, 1836. This gun, believed to have been used in the confrontation, is one of the few physical remains of Roanoke. Much of the site has been inundated by the waters of Lake Eufaula/Walter F. George. (Courtesy of the Columbus Museum.)

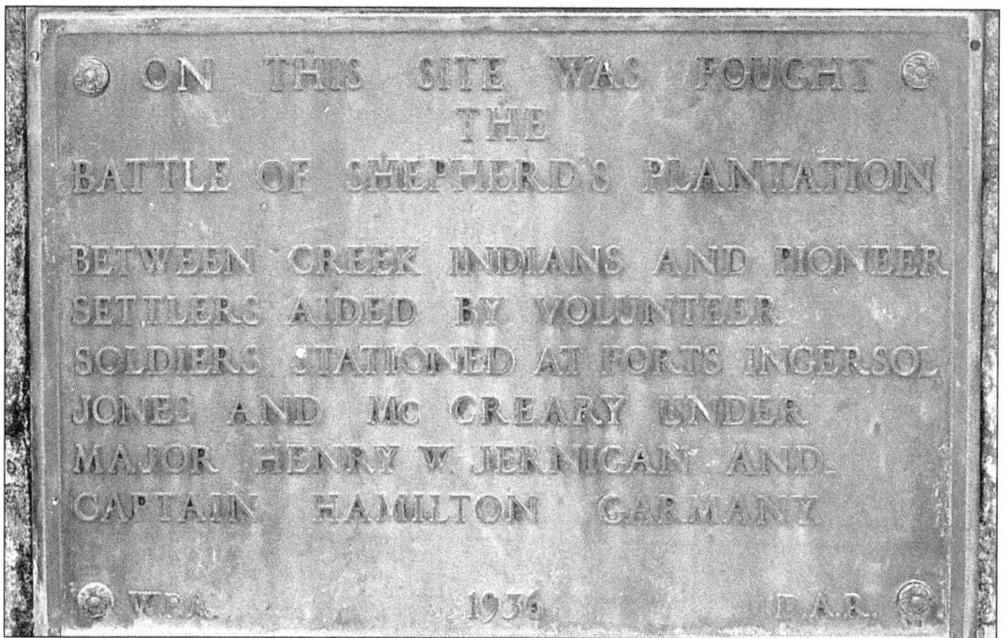

ON THIS SITE WAS FOUGHT
THE
BATTLE OF SHEPHERD'S PLANTATION

BETWEEN CREEK INDIANS AND PIONEER
SETTLERS AIDED BY VOLUNTEER
SOLDIERS STATIONED AT FORTS INGERSOL
JONES AND Mc CREARY UNDER
MAJOR HENRY W. JERNIGAN AND
CAPTAIN HAMILTON GARMANY

W.P.A. 1936 D.A.R.

The Battle of Shepherd's Plantation was fought a short distance from the Chattahoochee on June 9, 1836, between approximately 80 Georgia militiamen and 200 primarily Creek warriors. The battle was one of the largest of the engagements of the Second Creek War, which resulted in defeat of the Hitchiti, Creek, and Yuchi tribes and their removal westward. This marker commemorating the event is located on part of the battlefield near Florence Marina State Park. (Courtesy of the Columbus Museum.)

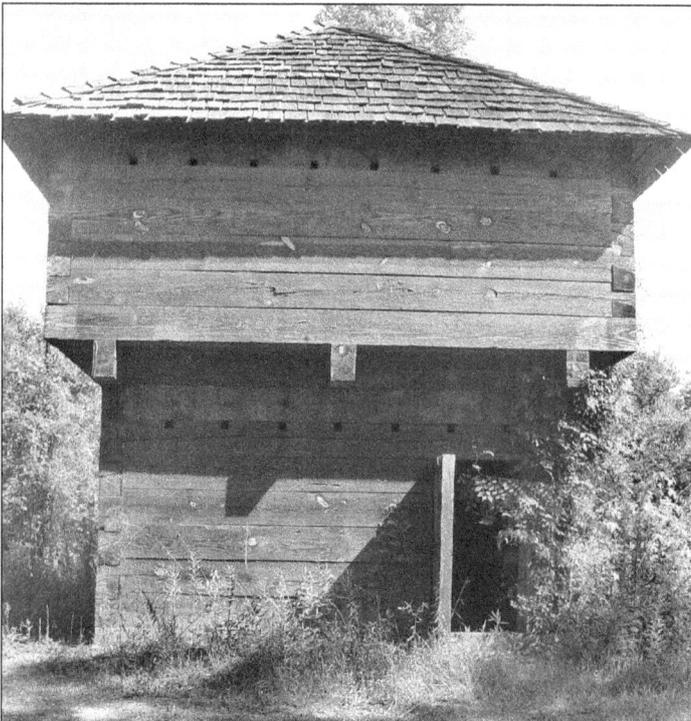

Fort McCreary was built in the 1830s by the Georgia militia near present-day Omaha, Georgia. The fort played a critical role in the Battle of Shepherd's Plantation, as the 20 men stationed there were crucial reinforcements to militiamen already engaged in battle. This modern reconstruction, located on the site of the original fort, was built in 1995 by the Roanoke Chapter of the Daughters of the American Revolution with help from the Stewart County government. (Courtesy of the Columbus Museum.)

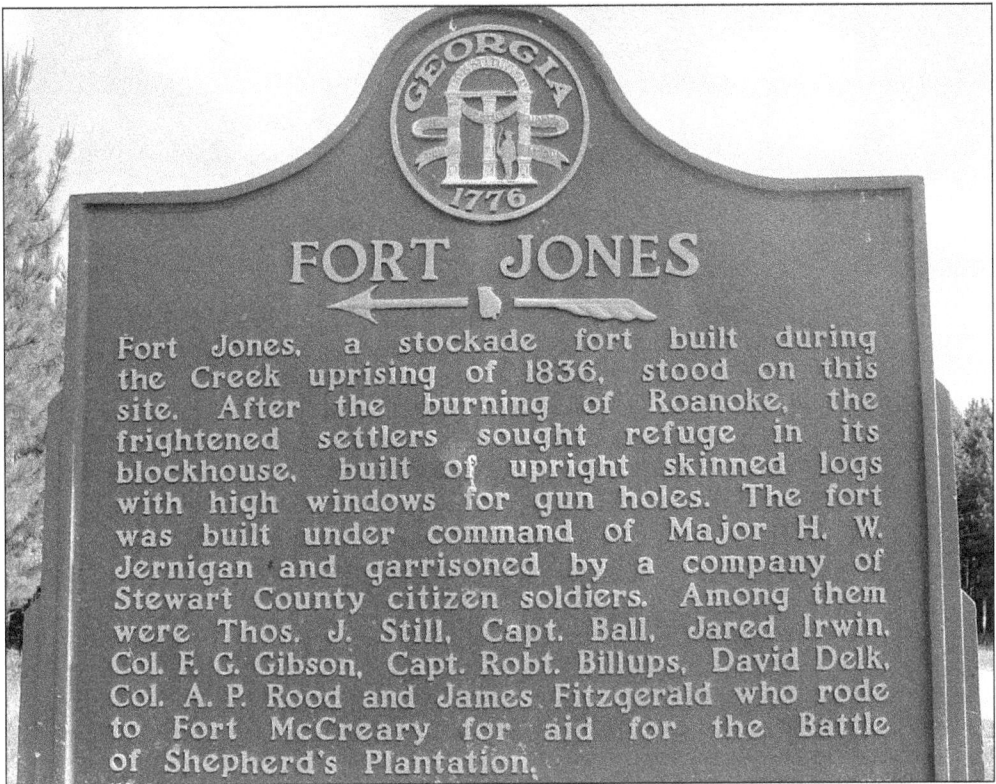

FORT JONES

Fort Jones, a stockade fort built during the Creek uprising of 1836, stood on this site. After the burning of Roanoke, the frightened settlers sought refuge in its blockhouse, built of upright skinned logs with high windows for gun holes. The fort was built under command of Major H. W. Jernigan and garrisoned by a company of Stewart County citizen soldiers. Among them were Thos. J. Still, Capt. Ball, Jared Irwin, Col. F. G. Gibson, Capt. Robt. Billups, David Delk, Col. A. P. Rood and James Fitzgerald who rode to Fort McCreary for aid for the Battle of Shepherd's Plantation.

Nothing remains of Fort Jones, a log fort constructed during the Creek uprising of 1836 and manned by soldiers from Stewart County. This marker, located near the Chattahoochee River on Highway 39, a short distance from Florence Marina State Park, is near the approximate location of the fort. (Courtesy of the Columbus Museum.)

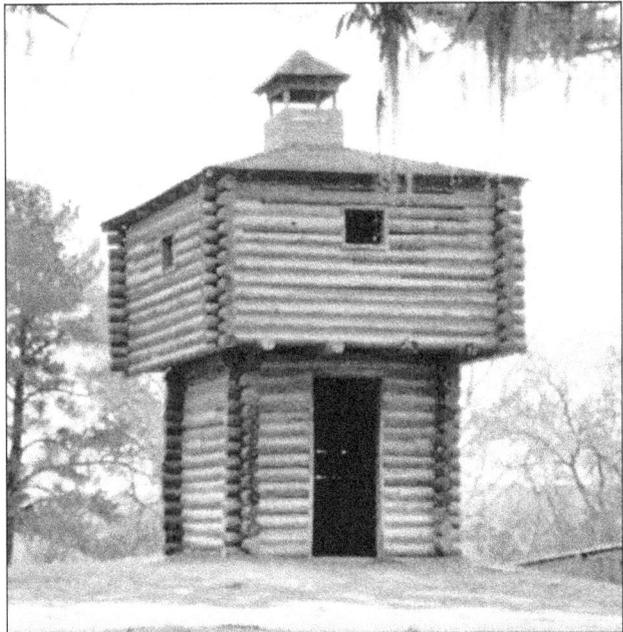

Fort Gaines, for which the town of Fort Gaines is named, was constructed in 1816 on a high bluff overlooking the Chattahoochee for the protection of the area's white settlers. The outpost was named in honor of Gen. Edmund P. Gaines, who used it as his headquarters. This replica of the original blockhouse currently stands on the site. (Courtesy of the Historic Chattahoochee Commission.)

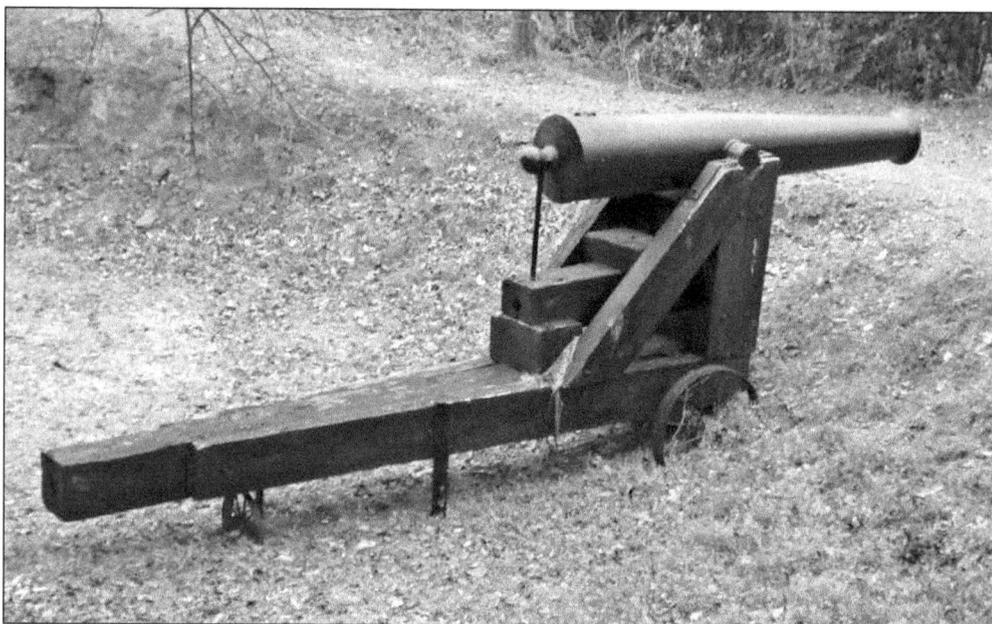

This cannon has rested at this same emplacement overlooking the Chattahoochee River since the Civil War. The fortification, originally containing three guns, was constructed in 1863 to protect the town of Fort Gaines from anticipated federal gunboats that might have moved up the river towards Columbus and other strategic points. The carriage is a reproduction. (Courtesy of the Historic Chattahoochee Commission.)

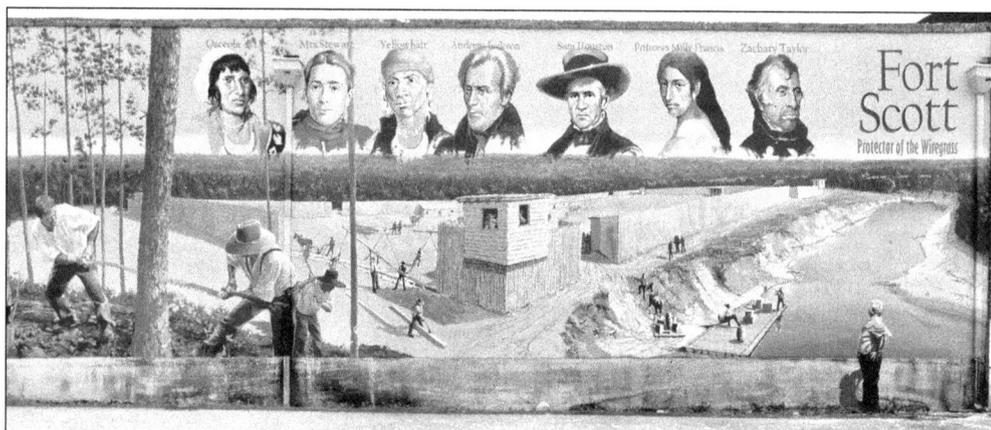

This mural in downtown Dothan, Alabama, celebrates the construction of Fort Scott. Built in 1816, Fort Scott was located near modern-day Bainbridge, Georgia, on the Flint River near its confluence with the Chattahoochee. The outpost was built to protect white settlers in the area from attack by Creek Indians. During its brief existence, the fort was visited by such notables as Andrew Jackson and Zachary Taylor. (Courtesy of Wes Hardin and the Image Agency.)

Eight

PEOPLE AND PLACES

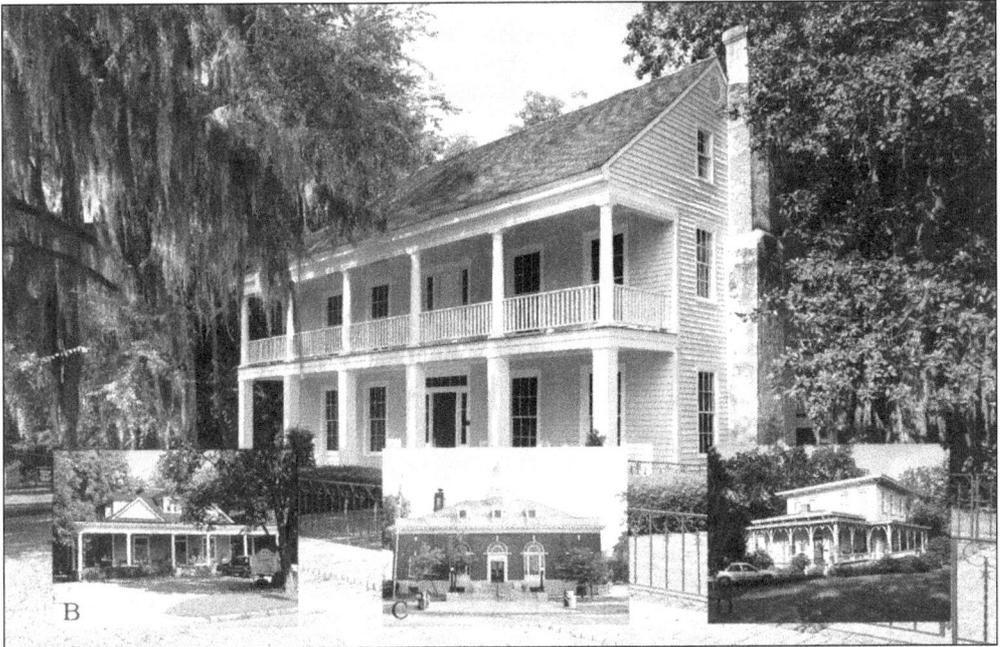

Published in the early 1990s by the Eufaula/Barbour County Tourism Council, this modern postcard displays four of Eufaula's historic buildings. The large center photograph is of the Tavern, built in 1836; it is Eufaula's oldest remaining structure. From the bottom, left to right, are the Conner-Lawrence Real Estate office (*c.* 1895), Old Post Office Building (*c.* 1912), and St. Mary's Bed and Breakfast (*c.* 1850), which is now a private residence. (Courtesy of Maisie Pugh.)

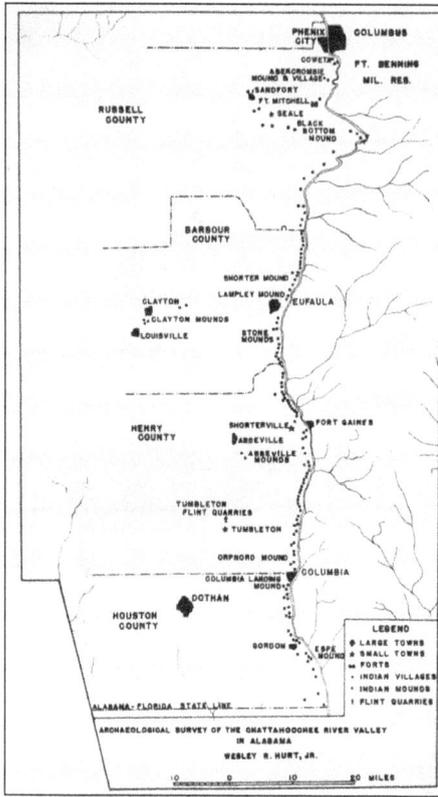

Prior to the creation of Lake Eufaula/Walter F. George in the 1960s by damming the Chattahoochee near Fort Gaines, an intensive survey of the area to be inundated was conducted by archaeologists. This map identifies major sites along the Alabama side of the river and appeared in David L. DeJarnette's summary of the operation, *Archaeological Salvage in the Walter F. George Basin of the Chattahoochee River in Alabama*. (Courtesy of the University of Alabama Press.)

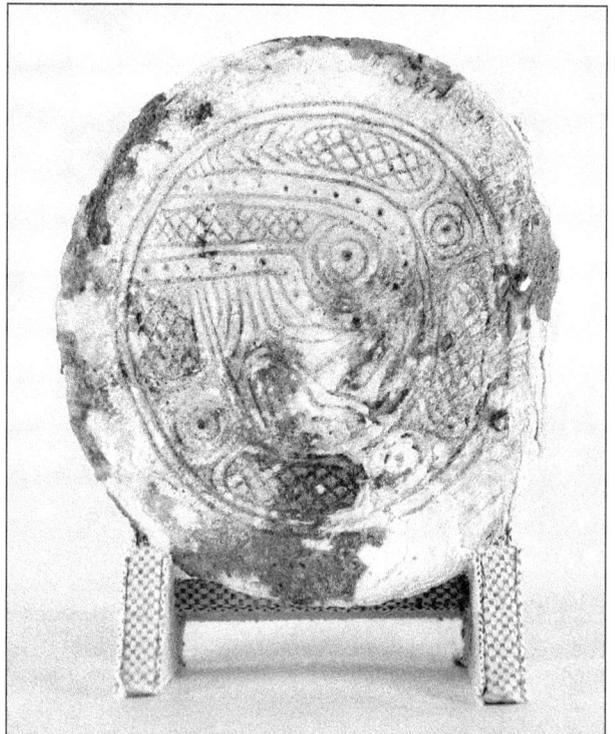

This shell ornament would have likely been worn by a high-ranking member of the riverside village at Abercrombie in present-day Russell County, Alabama. The Muskogee, who are believed to have lived at the site, revered the rattlesnake as the "chief" of all snakes. Like other chiefdom societies, the tribe was led by a powerful individual who inherited the position and served as a religious leader, controlled taxes, and had the power of life and death over subjects. (Courtesy of the Columbus Museum.)

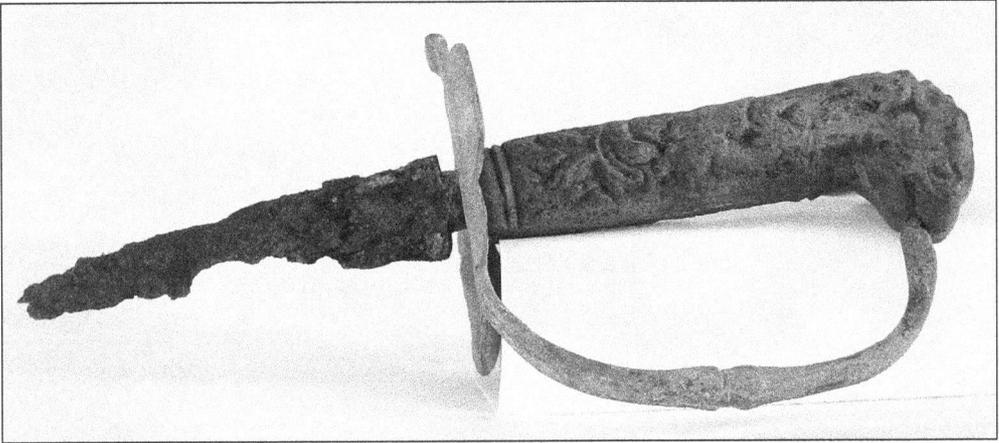

This late-17th-century British sword may have been among the 600 sent to Governor Oglethorpe of Georgia in 1741 to be given to area Native Americans as gifts. This sword was found during archaeological investigation of the lower Creek town site of Coweta Tallahassee in present-day Russell County, Alabama. The town was the major cultural and population center of the Creek confederacy. This alliance of several tribes and chiefdoms from modern-day Georgia and Alabama had an estimated population of nearly 20,000 at the height of its power. (Courtesy of the Columbus Museum.)

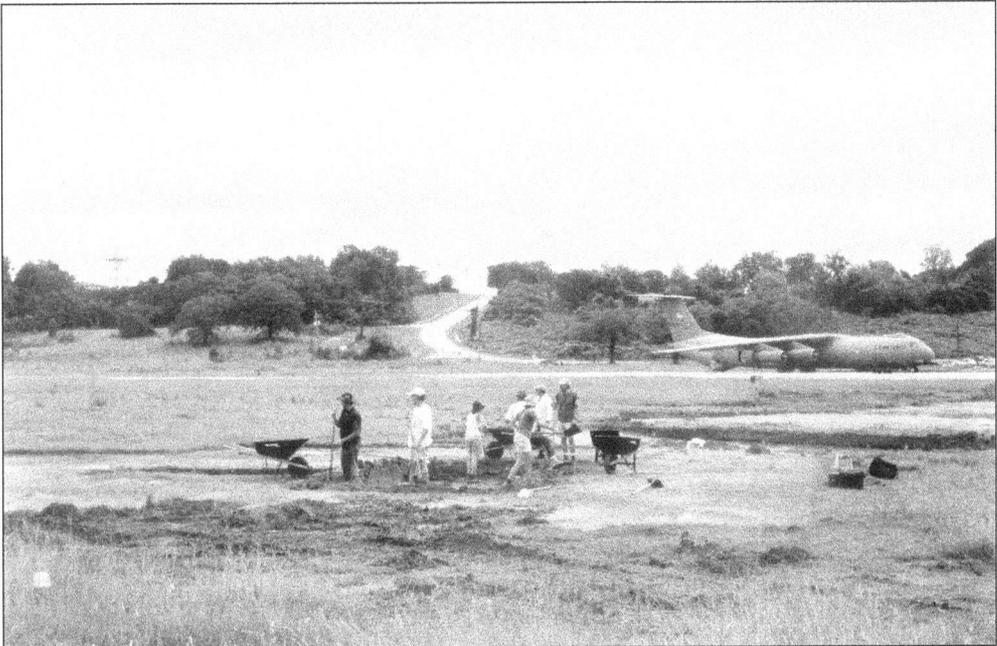

This photograph was taken during an archaeological investigation of Cussetuh, an ancient and "mother" town to the Creeks. The Cusseta and Coweta people spoke Muskogee and migrated from central Alabama to the Chattahoochee River probably around the first half of the 17th century. They settled among the existing Native Americans, who spoke a related, but different, language called Hitchiti. Cussetuh was a town of about 1,000 individuals located on modern-day Lawson Airfield at Fort Benning. (Courtesy of Thomas Foster, Ph.D.)

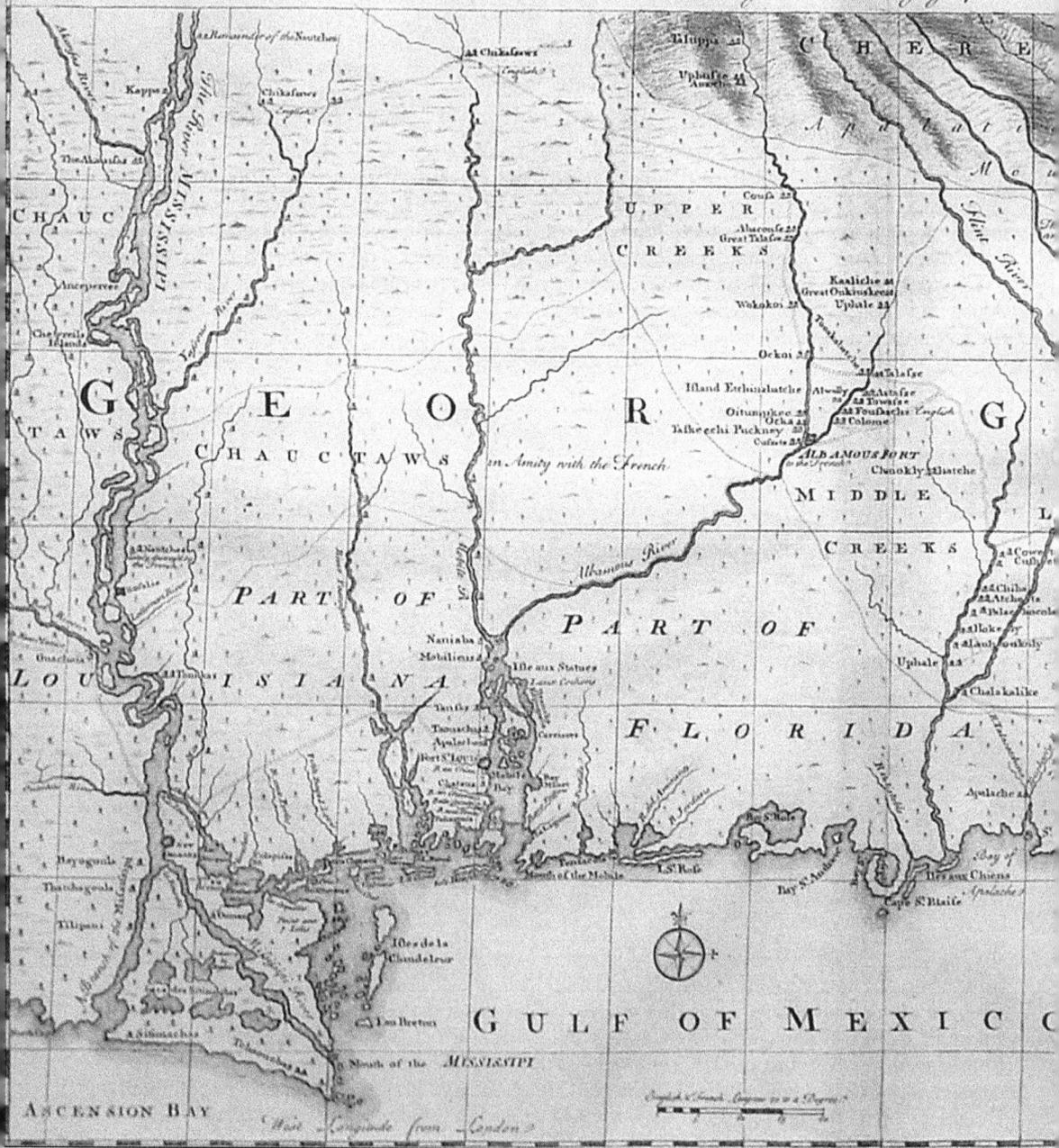

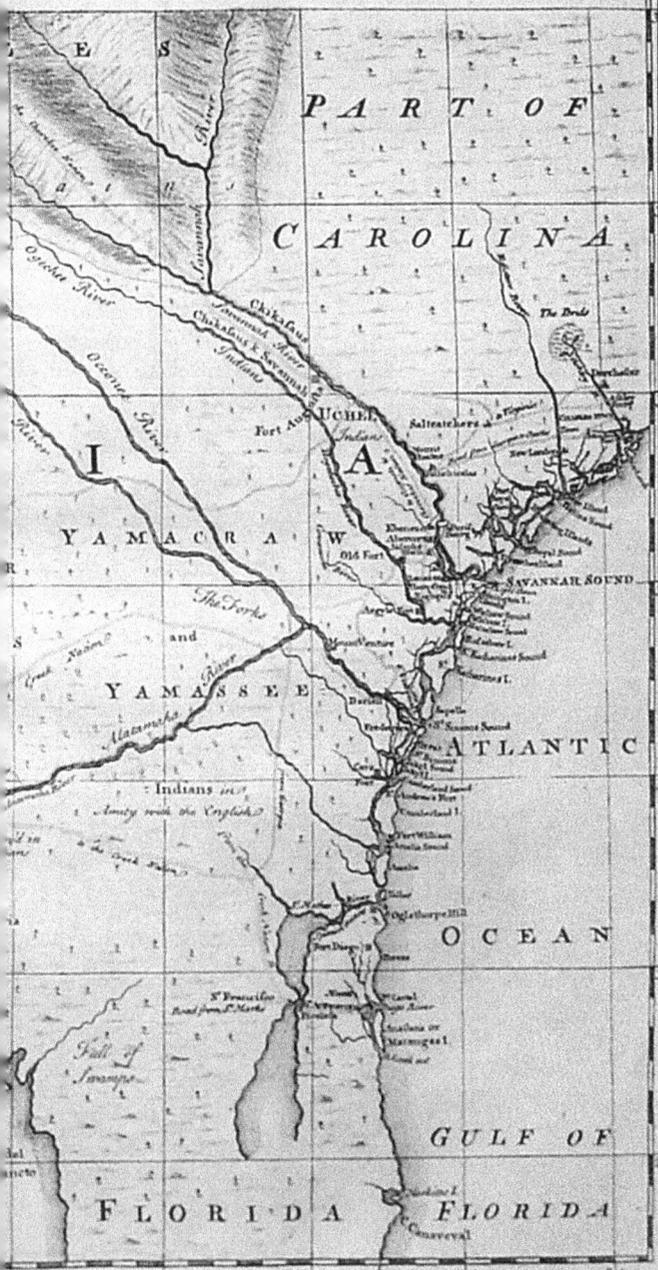

FLORIDA and LOUISIANA.

proved Maps and Charts.

This map, drawn by Emanuel Bowen and originally printed in the second edition of John Harris's *A Complete Collection of Voyages and Travels*, is one of the better maps that include the colony of Georgia and the surrounding region in the 1700s. Its large scale permitted the inclusion of many details other period maps of the region do not include, such as key trading routes and Native American villages. The Lower Creeks then occupied the lower Chattahoochee River region. Shown along the river are some of the major population centers of the area's natives at the time, including the villages of Coweta and Cusseta. (Courtesy of the Columbus Museum.)

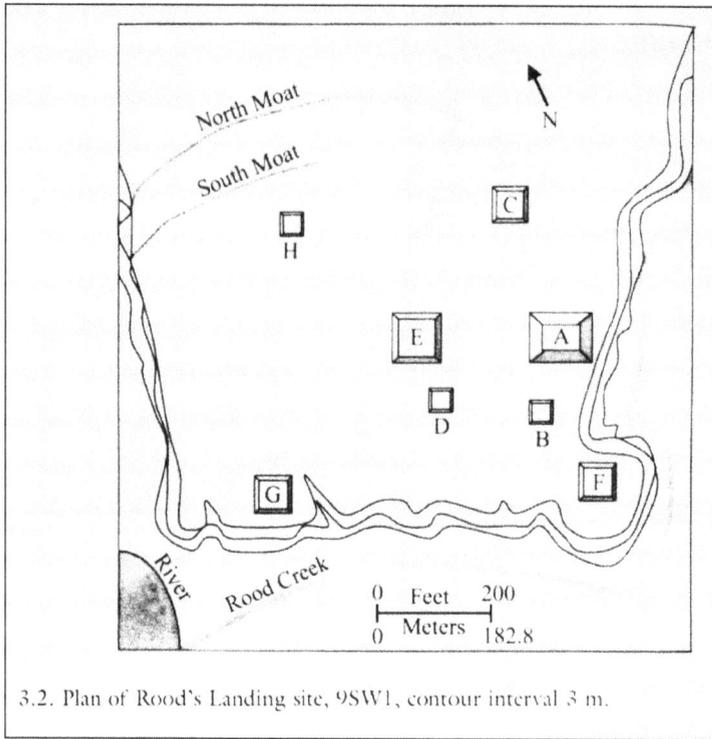

3.2. Plan of Rood's Landing site, 9SW1, contour interval 3 m.

Located along the river in Stewart County, Georgia, the Rood's Landing site may have been the largest population center in the Chattahoochee Valley during the Mississippian period (c. 1000–1600) The site features eight mounds constructed in stages over a period of several hundred years. The site is believed to have been abandoned around 1400, though archaeological investigation indicates it was briefly reoccupied around 1550. (Courtesy of the University of Alabama Press.)

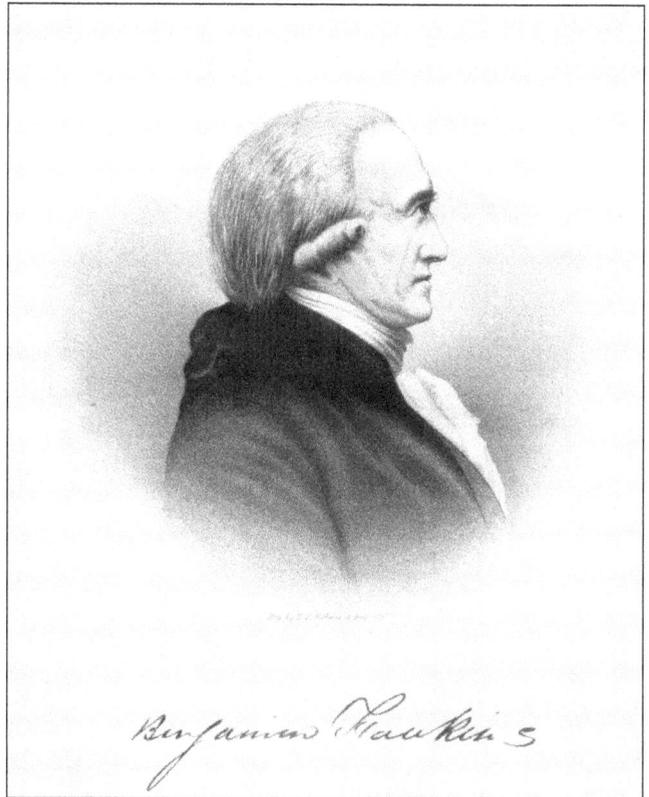

Appointed by George Washington as agent for Indian affairs south of the Ohio River in 1796, Benjamin Hawkins lived among the Creeks of the Chattahoochee Valley region for over three decades. His extensive writings on Creek culture, one of the most complete accounts of their way of life in the time period, are still some of the best sources of information on the tribe's history. (Courtesy of Thomas Foster, Ph.D.)

Philadelphia-born William Bartram, one of the first American naturalists, traveled through the Chattahoochee Valley region in the late 1700s during his efforts to record the plant and animal life of the southeast. His book *Travels through North and South Carolina, Georgia, East and West Florida, the Cherokee Country, etc.*, published in 1791, was the first widely circulated account of the region. Because of his romantic writing style in relating the scenes he witnessed on his journeys, *Travels* became a significant influence on American literature of the day. (Courtesy of Independence National Historic Park.)

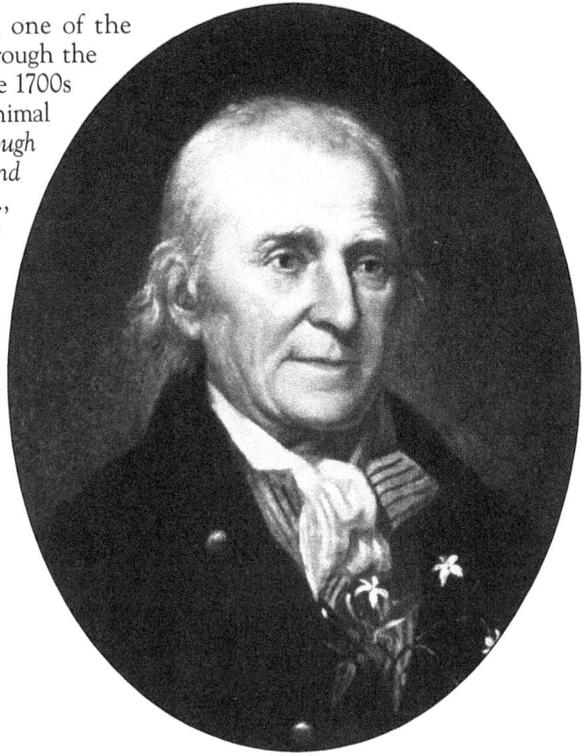

The first known image of the city of Columbus appeared in 1829 in Basil Hall's *Forty Etchings, Made with the Camera Lucida*, a companion volume to his *Travels in North America*. The image shows some of the first structures built in Columbus, a community which was still being carved out of the wilderness when Hall visited. The town, located at the head of navigation on the Chattahoochee River, was created by an act of the Georgia legislature on December 24, 1827. (Courtesy of Columbus State University Archives.)

The village of Summerville was located in the Alabama hills overlooking the Chattahoochee and downtown Columbus. Located in modern-day Phenix City just off Summerville Road, the area was first settled in substantial numbers in the 1830s. It received its name from the wealthy citizens of Columbus, who lived there in the summer months for its supposedly more healthful climate. This image of the area was sketched in the mid-1840s. (From *Georgia Illustrated* by T. Addison Richards, courtesy of the Hargrett Rare Book and Manuscript Library, University of Georgia.)

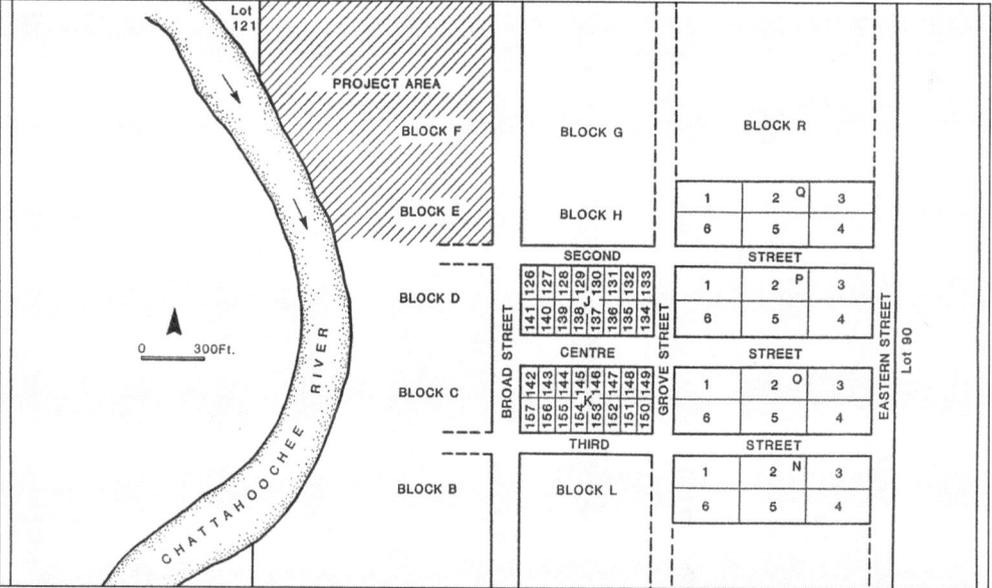

The Stewart County, Georgia, town of Florence was incorporated in December 1837 by survivors of the nearby town of Roanoke, which had been destroyed in the Second Creek War the year before. At its peak, the town was a major shipping point on the Chattahoochee. It was linked to Alabama with a covered bridge and had a newspaper, bank, and hotel. After a flood washed away the bridge in 1846 and it was bypassed by a railroad constructed in the area, the town began to languish, and within a few decades, it virtually ceased to exist. (Courtesy of Florence Marina, Georgia Department of Natural Resources.)

116

Built in the 1840s, the Mott House is Columbus's only remaining antebellum riverfront townhouse. Though it has had several owners, the house is most closely associated with outspoken opponent of secession Randolph Mott. The house served as the headquarters for Union general James H. Wilson in April 1865 and is still known locally as "the only house in Georgia that never left the Union." (Courtesy of the Library of Congress.)

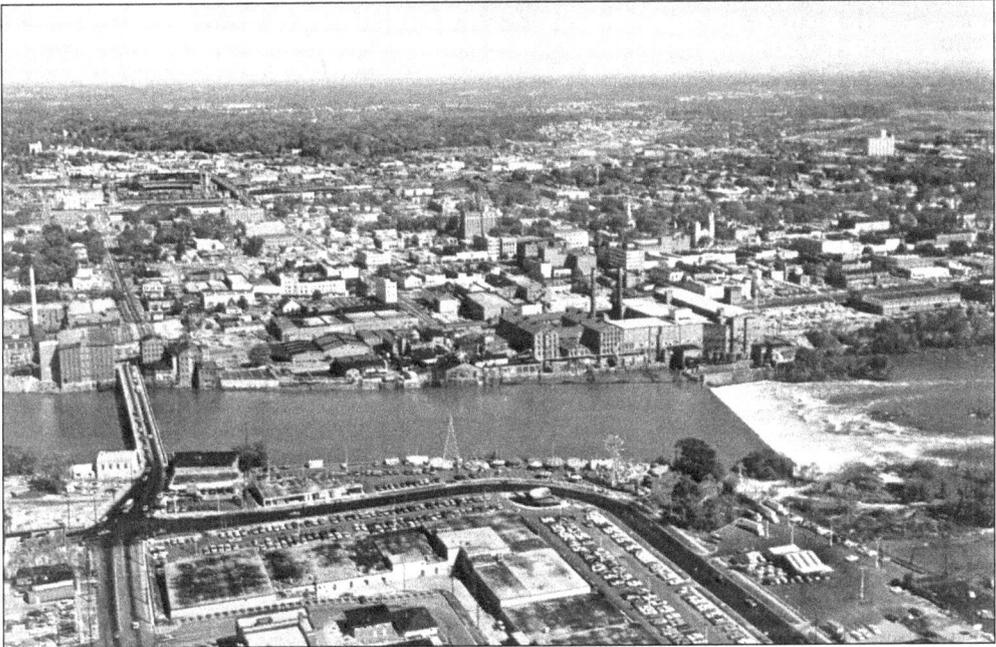

This c. 1970 aerial view shows the Chattahoochee as it flows by downtown Columbus, Georgia, and Phenix City, Alabama. Despite the state border between them, the communities have been very closely connected since their founding nearly two centuries ago. (Courtesy of Dennis Jones.)

Though it had relied heavily on the Chattahoochee for its economic development since its founding, the city of Columbus was not able to adequately harness the river as a source of fresh water until the 20th century. Previous to the construction of the first water treatment facility in 1915, citizens relied on a network of hollowed logs that brought water from a spring a short distance east of downtown. This image shows the treatment facility shortly after its construction. (Courtesy of the Columbus Water Works.)

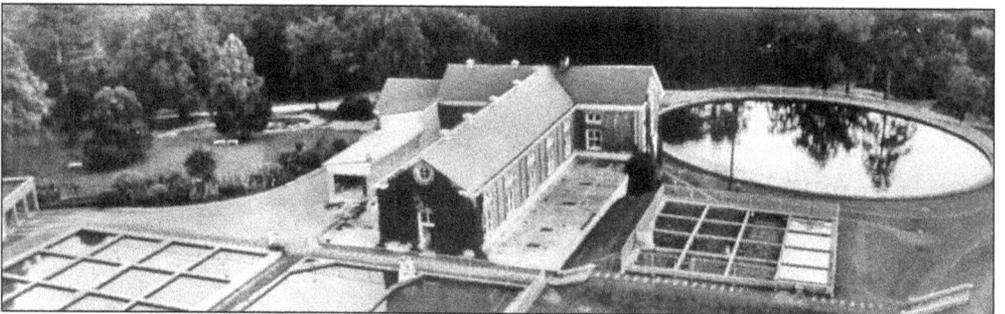

The Columbus Water Works still operates on the site of the original treatment facility. Today the waterworks operates a 42-million-gallon facility that supplies water for nearly 200,000 people with a network of over 900 miles of cast and ductile iron lines. At peak capacity, it can distribute over 60 million gallons of treated river water per day. This image shows the original facility in the 1930s. (Courtesy of the Columbus Water Works.)

118

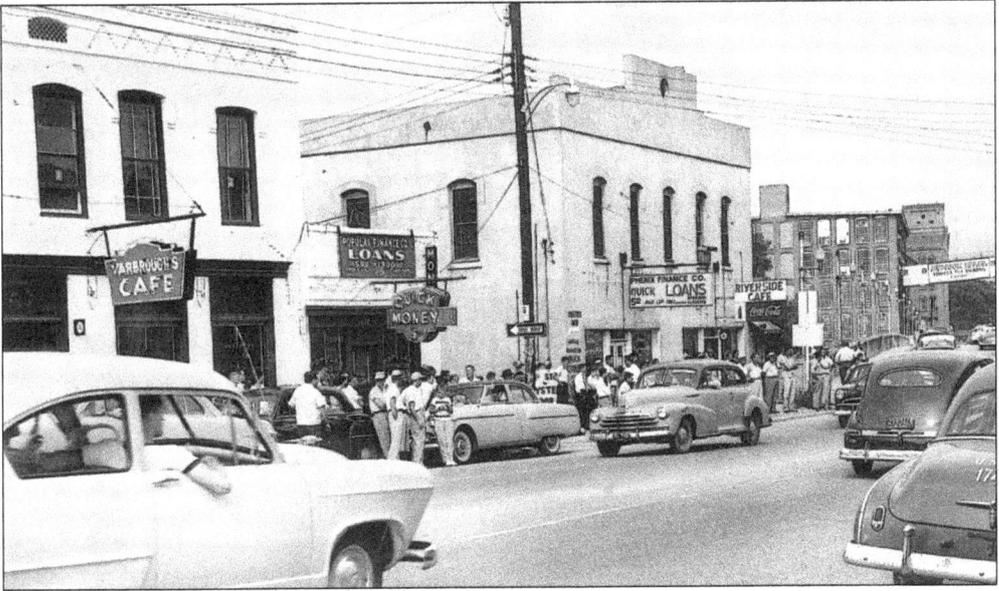

One of the most intriguing chapters in Chattahoochee Valley history unfolded in Phenix City in the 1950s. Several nightclubs and other establishments run by a criminal syndicate were located along the riverfront. Through the revenue they derived from these facilities, this syndicate unfortunately gained a great degree of control in Phenix City's government. After numerous other approaches to solving this problem, a small but vocal group of reformers attempted to reclaim the city by running one of their own reformers for the office of state attorney general. (Courtesy of Jim Cannon.)

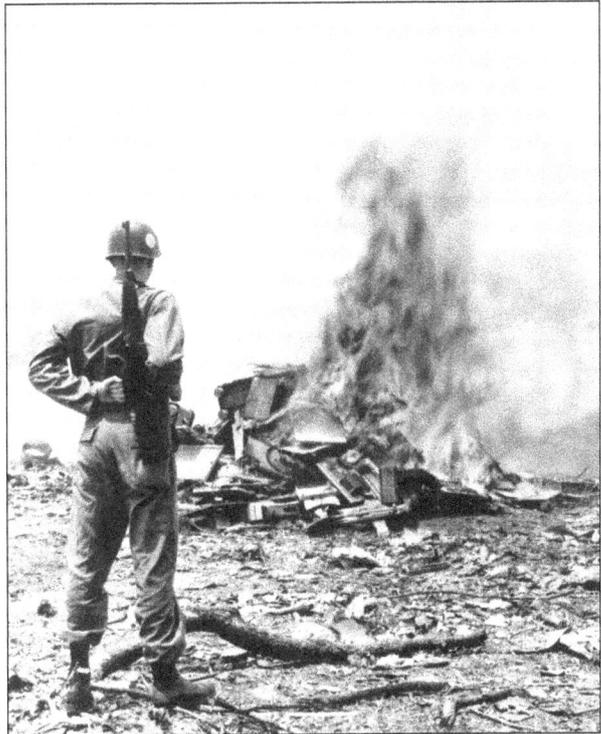

On June 18, 1954, Albert Patterson, winner of the Democratic primary in the race for attorney general, was murdered in downtown Phenix City. His death set in motion a chain of events that would distinctly alter the riverside town's future and become a major turning point in the history of the region. A massive cleanup that revealed the extent to which criminal elements had grown wealthy and influential brought national attention to Phenix City and eliminated widespread corruption in its government. Here a soldier monitors the destruction of gambling equipment seized from some of the gambling establishments. (Courtesy of the *Columbus Ledger-Enquirer.*)

Highlighting the extraordinary progress Phenix City made in a year's time, in 1955 the city was named an All-America City by the National Civic League. Because of a nationally distributed Hollywood movie and several books about what happened there, however, the town is still sometimes associated more with unfortunate events in its past than the modern growth it is currently undergoing. (Courtesy of Jim Cannon.)

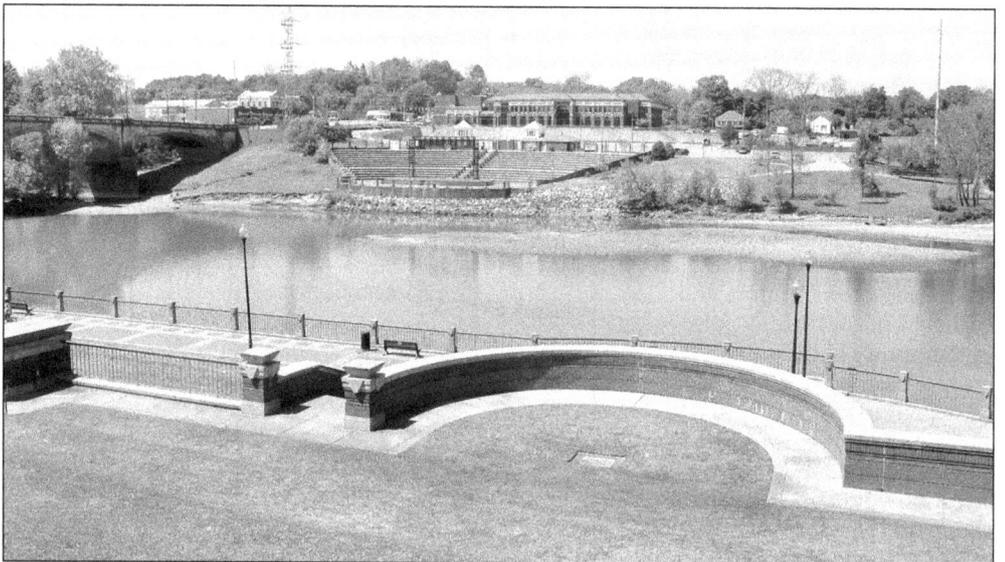

After several years of Columbus outpacing Phenix City in its push to redevelop the Chattahoochee riverfront, today civic leaders are actively reorienting portions of both cities toward the river. In recent years, Columbus has continued its effort to create a continuous riverwalk from Lake Oliver to Fort Benning, and Phenix City has devoted considerable effort to create its own section of riverwalk. (Courtesy of the Columbus Museum.)

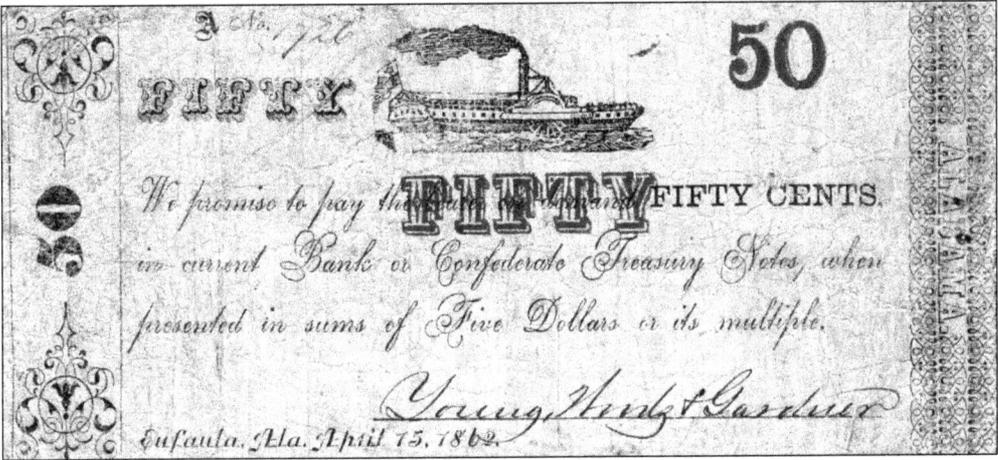

The firm of Young, Woods, and Gardner was founded in 1859 by Edward Young and his partners, merchants Clayton R. Woods and Colin Gardner. Young, a leading Eufaula businessman, loaned money to area planters before formally venturing into the banking business. Unlike most antebellum banks in the region, the institution survived the Civil War and functioned well into the 20th century. The bank printed many notes similar to this one during the war. (Courtesy of the Columbus Museum.)

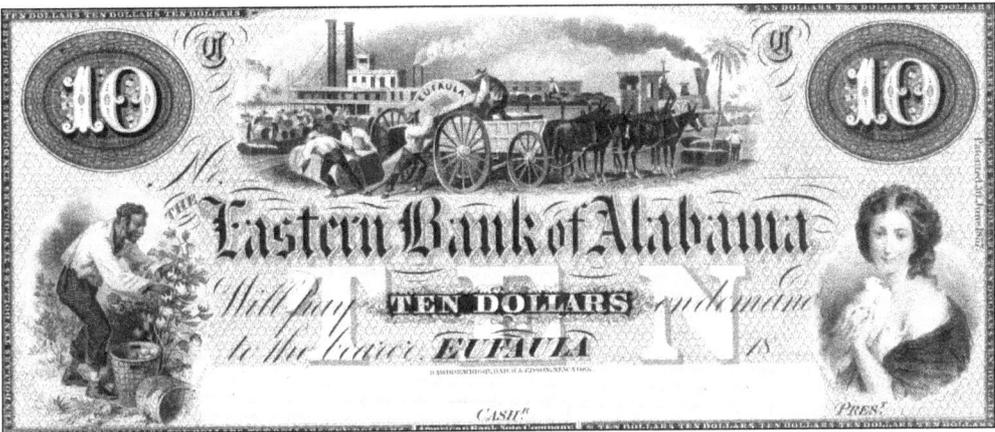

Founded in 1858 by John McNab, the Eastern Bank of Alabama was the first bank to open in Eufaula since the 1830s. Though its original list of stockholders included some of the most prominent and wealthy citizens of the Eufaula area, it was, like many antebellum banks in the region, poorly funded and short-lived. (Courtesy of the Columbus Museum.)

William T. Simpson, a cotton wholesaler, built Dean-Page Hall in Eufaula in 1850. He employed a servant boy to maintain the windows in the belvedere, watching for "weather signs" and steamboats. This Italianate mansion was named by Simpson's daughter Caroline, Mrs. L. Y. Dean. Captain Dean prospered in the mercantile and insurance business. The home features 16 wooden tracery arches hand carved from heart pine. (Courtesy of the Eufaula Heritage Association.)

Fendall Hall in Eufaula, owned by the Alabama Historical Commission, has everything one would expect in a Southern suburban mansion: columns, black and white entrance floor, Italian marble fireplaces, period furnishings, heart-pine flooring, a blooming landscape, and three rooms of the finest Victorian-era murals found in any home in America. The murals were painted in the 1880s. (Courtesy of the Historic Chattahoochee Commission.)

Johnson's Store, near Langdale Mill in the Valley, Alabama, area, was one of the most unique business establishments to ever operate in the lower Chattahoochee Valley. Though situated just a few feet from the Alabama bank of the river, the floating store was actually located entirely on the Chattahoochee, which meant it was technically in the state of Georgia. Through the store's unusual location, Johnson was able to avoid charging his customers Alabama's higher tobacco tax. (Courtesy Wayne Clark and Cobb Memorial Archives.)

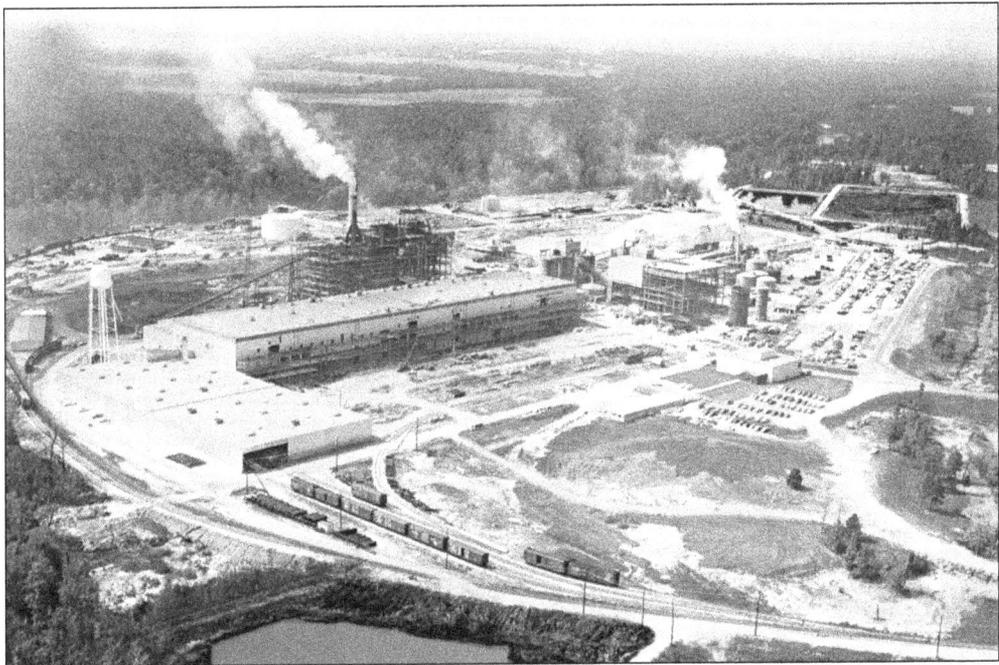

Industrial manufacturing and railroads developed together. Since 1963, the Great Southern Paper Mill at Cedar Springs, Georgia (just east of the Chattahoochee River), has integrated rail service into its total shipping strategy. The Chattahoochee Industrial Railroad brings hoppers of wood chips to the plant and returns with carloads of craft paper. (Courtesy of Reid Smith.)

Construction of docks began in 1957 on the Chattahoochee River at Columbia, Alabama, and was completed in 1962. These facilities became a part of the Alabama Inland Dock system. (Courtesy of the L. H. Adams Collection.)

This *c.* 1960 photograph shows the Alabama State Docks under construction at their location below the railroad bridge. (Courtesy of the L. H. Adams Collection.)

BIBLIOGRAPHY

Blitz, John and Karl Gregory Lorenz. *The Chattahoochee Chiefdoms*. Tuscaloosa: University of Alabama Press, 2006.

Cook, Joe and Monica Cook. *River Song: A Journey Down the Chattahoochee and Apalachicola Rivers*. Tuscaloosa: University of Alabama Press in cooperation with the Historic Chattahoochee Commission, 2000.

Early County Historical Society. *Collections of Early County Historical Society*. Colquitt, GA: Automat Printers, 1971.

Eufaula/Barbour County Chamber and the Eufaula Heritage Association. *Eufaula and Barbour County in Vintage Postcards*. Charleston, SC: Arcadia Publishing, 2004.

Foster, H. Thomas III. *Archaeology of the Lower Muskogee Creek Indians, 1715–1836*. Tuscaloosa: University of Alabama, 2007.

Fretwell, Mark. *This So Remote Frontier: The Chattahoochee Country of Alabama and Georgia*. Eufaula: Historic Chattahoochee Commission, 1987.

Heritage of Chambers County, Alabama. Clanton, AL: Heritage Publication Consultants, 1999.

Heritage of Russell County, Alabama. Clanton, AL: Heritage Publication Consultants, 2003.

King, P. C. Jr. *The Chattahoochee River*. Canton, GA: Industrial Printing Service.

Kyle, Clason. *Images: A Pictorial History of Columbus, Georgia*. Norfolk: Donning, 1986.

Lupold, John S. *Columbus, Georgia, 1828–1978*. Columbus: Columbus Sesquicentennial, Inc., 1978.

Major, Glenda, and Clark Johnson. *Treasures of Troup County: A Pictorial History of Troup County*. LaGrange, GA: Troup County Historical Society, 1993.

Mueller, Edward A. *Perilous Journeys: A History of Steamboating on the Chattahoochee, Apalachicola, and Flint Rivers, 1828–1928*. Eufaula: Historic Chattahoochee Commission, 1990.

Smartt, Eugenia Persons. *History of Eufaula, Alabama*. Eufaula: James S. Clark, 1995.

Terrill, Helen Eliza. *History of Stewart County, Georgia*. Columbus: Columbus Office Supply, 1958.

Turner, Maxine. *Navy Gray: Engineering the Confederate Navy on the Chattahoochee and Apalachicola Rivers*. Tuscaloosa: University of Alabama Press, 1988.

Warren, Hoyt M. *Henry's Heritage: A History of Henry County, Alabama*. Abbeville, AL: Henry County Historical Society, 1978

Watson, Fred S. *Hub of the Wiregrass: A History of Houston County, Alabama*. Anniston, AL: Higginbotham, Inc., 1972.

Willoughby, Lynn. *Flowing Through Time: A History of the Lower Chattahoochee River*. Tuscaloosa: University of Alabama Press, 1999.

Worsley, Etta Blanchard. *Columbus on the Chattahoochee*. Columbus: Columbus Office Supply, 1951.

INDEX

ACROSS AMERICA, PEOPLE ARE DISCOVERING SOMETHING WONDERFUL. *THEIR HERITAGE.*

Arcadia Publishing is the leading local history publisher in the United States. With more than 3,000 titles in print and hundreds of new titles released every year, Arcadia has extensive specialized experience chronicling the history of communities and celebrating America's hidden stories, bringing to life the people, places, and events from the past. To discover the history of other communities across the nation, please visit:

www.arcadiapublishing.com

Customized search tools allow you to find regional history books about the town where you grew up, the cities where your friends and family live, the town where your parents met, or even that retirement spot you've been dreaming about.